K NSTIT

001

REIHE CANTZ

Herausgegeben von / Edited by
Peter Noever, MAK

POSITIONEN ZUR KUNST
POSITIONS IN ART

MAK-Round-Table

**Chris Burden, Kiki Smith, James Turrell,
Franz West, Lebbeus Woods**

im Gespräch mit/in conversation with

Ziva Freiman, Johannes Gachnang,
Jan Hoet, Kyong Park, Joachim Riedl

Diese Publikation ist eine Dokumentation des Round-Table-Gesprächs, das am 2. Mai 1993 anläßlich der Neueröffnung des MAK stattgefunden hat. Es gibt die Gespräche und die nachfolgende Podiumsdiskussion so originalgetreu wie möglich wieder.
This book is a documentation of the round table discussion which took place on May 2nd, 1993 on the occasion of the reopening of the MAK. The conversations and subsequent panel discussion are being reproduced here as accurately as possible.

Idee/idea: Peter Noever
Redaktion/edited by: Jessica Beer, Daniela Zyman
Graphik-Design/graphic-design: Maria-Anna Friedl
Übersetzung/translation: Wolfgang Astelbauer
Transkriptionen/transcriptions: Viktor Bucher, Aleksandra Wagner
Photodokumentation/photographic documentation: Reinhard Mayr/MAK
Photonachweis siehe S. 206/photographic acknowledgements see p. 206

Satz/typesetting: Fotosatz Weyhing, Stuttgart
Lithographien/lithographs: C+S Repro, Filderstadt/Plattenhardt
Buchbinderische Verarbeitung/binding: Kunst- und Verlagsbuchbinderei GmbH, Leipzig

Coverphoto: James Turrell, Roden Crater Series, Fumerole in Black, 1992,
Sammlung/Collection MAK (Ausschnitt/detail)

Veranstaltung und Publikation wurden ermöglicht durch die Unterstützung des Bundesministeriums für Wissenschaft und Forschung, Wien.
The event and the publication have been made possible with the support from the Federal Ministry of Science and Research, Vienna.

Unser besonderer Dank gilt/Special thanks to:
Gesellschaft für Österreichische Kunst/Austrian Art Society; Fawbush Gallery, New York; Gagosian Gallery, New York; Hirshhorn Museum and Sculpture Garden, Washington D.C.; The Israel Museum, Jerusalem; Galerie Peter Pakesch, Wien; Whitney Museum of American Art, New York.

© 1994 by MAK, Wien and Cantz Verlag, Ostfildern
MAK, Stubenring 5, A-1010 Wien
Tel: 1/711 36 (0), Fax: 1/713 10 26

ISBN 3-89322-279-0, Printed in Germany
Cantz Verlag, Senefelderstraße 9, 73760 Ostfildern, Telefon 07 11/44 99 30, Fax 07 11/4 41 45 79

Inhalt

Preface

Each conversation, dialogue or discussion has something peculiarly unpredictable about it: it creates space for the unexpected, for surprise, for open answers. Only direct confrontations can produce positions which are determined by the immediacy of the situation rather than by some deliberate strategy of defense or justification. These positions may lend material presence and emotional life to an abstract point-of-view.

The following conversations are also part of a wider context which is aimed at initiating a dialogue. The present publication wants to continue the examination of contemporary positions which began with inviting various artists to reinstall the exhibition galleries of the museum's permanent collection. This is why it may be seen as part of a program trying to establish the MAK as a forum dedicated to the discussion of present day issues.

The idea to assemble both artists and critics, architects and theoreticians succeeded in triggering a process of mutual requests and reactions, doubts and new approaches. This provided a quality crucial to any intellectual confrontation that tries to identify the artistic intention's actual place within today's reality beyond its self-referential claims.

Peter Noever

Zum Thema

Gerade das Gespräch, der Dialog, die Diskussion verfügen über eine eigene Qualität des Unvorhersehbaren, schaffen einen Raum für das Unerwartete, das Erstaunen, die offene Reaktion auf ein Gegenüber. Nur in der direkten Auseinandersetzung formulieren sich Positionen nicht in einer planvollen Verteidigungs- oder Rechtfertigungsstrategie, sondern in der Unmittelbarkeit der Situation und verleihen so oftmals abstrakten Standpunkten physische Präsenz und emotionales Leben.

Die hier dokumentierten Gespräche aber verstehen sich zudem als Teil eines Gesamtkontextes, dem die Herausforderung zum Dialog konstitutiv ist: Hier wird die Auseinandersetzung mit Positionen der Gegenwart weitergeführt, die mit der Installation der MAK-Schausammlungen durch zeitgenössische Künstler in Gang gesetzt wurde, hier zeigt sich ein weiterer Aspekt der Intention, mit dem MAK einen Ort zu schaffen, der Forum und Auslöser aktueller Auseinandersetzungen sein will.

In der Gegenüberstellung von Künstler und Kritiker, Architekt und Theoretiker ist es gelungen, jenen Prozeß der wechselseitigen Forderungen und Reaktionen, Infragestellungen und Neubestimmungen zu initiieren, der erst die Qualität der intellektuellen Begegnung ausmacht, in der künstlerisches Denken über seine Selbstbezüglichkeit hinaus versucht, seinen Ort in der Gegenwart zu definieren.

Peter Noever

FREIMAN

TURRELL

JAMES TURRELL:
Performing the music of the spheres of light
A conversation with Ziva Freiman

Ziva Freiman: The best way to define the kind of art that Mr. Turrell makes is to quote Robert Hughes, who wrote about his work saying: "It's not about what happens in front of your eyes, but what happens behind them."

James Turrell is currently engaged in some very major projects that are on-site-installations, most notably the *Roden Crater*[1] in Arizona, which was begun with the purchase of the volcano in 1977 and is still ongoing. He has another [large-scale] project underway, the *Irish Sky Garden*[2], in addition to installations in various parts of the world, most recently in Israel. And you are now working on an exhibi-

James Turrell, Roden Crater Series, 1st Contours, 1992

tion in England, I believe, at the Hayward [Gallery]. Why don't we start with that? Can you bring us up-to-date?

James Turrell: I'll start off by saying that my interest is in using light as material, light in its materially felt and tangible qualities. It is a work with the medium of perception and with the direct working of that medium utilizing light as a way to form experience. The work I do is meant to be something that is to be experienced: there is no image, there is no object because perception is the object and objective. And, in fact, there is no particular place to look. So, with no object, no image, no particular focus – what is it that [the viewer] is looking at? I hope it is possible to be looking at one's own looking and in that self-reflective act, of seeing yourself see, there is more about your looking than there is about mine. The subject is not how I see, but how you see.

In terms of the different projects [you mentioned], the one that is completed is this piece in Jerusalem[3], at the Israel Museum. I am also working on pieces of similar size in Ireland on the *Sky Garden* project. The *Roden Crater* is the pro-

JAMES TURRELL:

Die Sphärenmusik des Lichts erklingen lassen

Ein Gespräch mit Ziva Freiman

James Turrell, Irish Sky Garden
(Auschnitt/detail), 1990

Ziva Freiman: Ein Satz von Robert Hughes über das Werk James Turrells scheint mir dessen künstlerisches Schaffen am besten einzuleiten: »Es geht nicht darum, was wir vor Augen haben, sondern darum, was hinter unseren Augen geschieht.«

James Turrell arbeitet zur Zeit an einigen sehr großen ortsspezifischen Installationsprojekten; am *Roden Crater Project*[1] in Arizona, das mit dem Kauf des Vulkans im Jahr 1977 begann und zur Zeit noch nicht abgeschlossen ist. Und – neben einer Reihe von Installationen in verschiedenen Teilen der Welt, und jüngst auch in Israel – am *Irish Sky Garden*[2]. Ich glaube, Sie bereiten zudem gerade eine Ausstellung in England, für die Hayward Gallery vor. Warum fangen wir nicht damit an? Wie weit sind Sie damit?

James Turrell: Ich möchte zunächst einmal festhalten, daß es mir darum geht, Licht als Material zu verwenden, die materiell spürbaren und greifbaren Qualitäten von Licht einzusetzen. Ich arbeite mit Wahrnehmung und deren unmittelbarem Funktionieren und verwende Licht als Medium, um Erfahrungen herzustellen. Meine Arbeit soll etwas sein, das erfahren werden kann: Es gibt kein Abbild und es gibt auch keinen Gegenstand, weil allein die Wahrnehmung der Gegenstand, das Thema der Arbeit ist. Es gibt auch keinen besonderen Ort, auf den sich der Blick richten soll. Was sieht man also, wenn es keinen Gegenstand, kein Abbild, keinen Brennpunkt gibt? Ich hoffe, daß man sein eigenes Sehen sieht und daß dieser Akt der Selbstreflexion, des Sich-Sehen-Sehens, mehr über das Sehen des Betrachters als über mein Sehen als Künstler besagt. Nicht wie ich sehe, sondern wie der Betrachter sieht, darum geht es. Was die einzelnen Projekte betrifft [die Sie angesprochen haben], ist das im Israel Museum in Jerusalem[3]

ject that has been with me for some time. It's a volcano on the western edge of the Painted Desert, in Western United States, near the Grand Canyon area. In this space, that I have selected to emphasize essentially the setting of geologic time, you feel to be immersed in a different time-sense than you are in constructions of mankind. In the stage-set of geologic time I sought to make spaces that engage celestial vaults and light, to some degree performing with the music of the spheres of light.

Ziva Freiman: Can you give us one illustration [of the perceptual phenomena that constitute the basis of your work]? I am asking you to describe the kinds of objectives that you have.

James Turrell: I'd pretty much generally say that light and perception as described before constitute the basis of my work – except maybe for some of my later work, which is similar to some early source work I made and that I turned into smaller pieces that could travel.

Let's take a phenomenon right here. If you pay attention, you will notice that in the light that we have here people's eyes are almost entirely closed. It is only when the light is reduced that people open up and feeling begins to come out of their eyes. This is a very brutal light, and even more so if you were to come to it from a light-reduced area. I am interested in lower amounts of light. There is much better seeing under those conditions. Museums are trying to protect their artifacts by keeping light off the materials which would disintegrate. But I am not interested in museum treasures...

[The later works like] Alien Exam[4], where you lie down on an operating table and are taken up to a dome space, Solitary[5] which is a quiet space that you sit inside of [in total darkness] or the Phonebooths[6] that are a kind of transformative spaces where you get inside of and close the door – these works have a more sculptural aspect in their outside appearance, but they are still works just to get inside of.

Ziva Freiman: These smaller pieces of yours are a departure from the site-bound installations in the sense that now you have these objects that travel. What made me curious about these Perceptual Cells[7] as you describe them and also about the Düsseldorfer Light Salon[8] is whether it was an issue for you to resist their objectivity.

James Turrell: Obviously, it wasn't. These pieces are interesting to me because they have a lot to do with how I came to see the source and the ways of my work.

abgeschlossen. Ähnlich groß ist auch das *Sky Garden* Projekt in Irland, an dem ich noch immer arbeite. Das *Roden Crater Project* begleitet mich nun schon längere Zeit. Der Vulkan liegt am westlichen Rand der Painted Desert im Westen der Vereinigten Staaten, in der Nähe des Grand Canyon. Ich habe den Ort gewählt, weil es ein Ort der geologischen Zeit ist, an dem man ein anderes Zeitgefühl erfährt als in von Menschen geschaffenen Umgebungen. Auf dieser Bühne der geologischen Zeit habe ich versucht Räume zu schaffen, die Himmelsgewölbe und Licht miteinbeziehen, und habe dabei in gewissem Maß die Sphärenmusik des Lichts in diesen Räumen erklingen lassen.

Ziva Freiman: Können Sie [die Wahrnehmungsphänomene, die als Basis Ihrer Arbeit dienen] an einem Beispiel anschaulich machen? Bitte beschreiben Sie ein Phänomen, das Ihren Zielvorstellungen entspricht.

James Turrell: Im großen und ganzen würde ich einmal sagen, daß die Gesamtphänomene von Licht und Wahrnehmung meine Arbeit ausmachen. Einige spätere Arbeiten bilden vielleicht dabei insofern eine Ausnahme, als sie für mich eine Art Quellenbestand darstellen und es mir wichtig erschien, ausgewählte Arbeiten auf die Reise schicken zu können.

Nehmen wir aber als Beispiel ein Lichtphänomen, das auch hier herrscht. Wenn Sie genau aufpassen, so bemerken Sie, daß unsere Augen in diesem Licht fast völlig geschlossen sind. Erst wenn man das Licht zurücknimmt, öffnen sich die Leute, erst dann kommt Gefühl aus ihren Augen. Das Licht hier ist sehr grausam, vor allem für jemanden, der aus einem Bereich mit gedämpftem Licht kommt. Ich beschäftige mich mit viel geringeren Lichtfrequenzen. Man sieht unter diesen Bedingungen viel besser. Museen haben versucht, ihre Kunstgegenstände zu schützen, indem sie empfindliche Materialien nicht beleuchteten. Aber Kunstschätze interessieren mich nicht besonders.

Meine späteren Arbeiten wie *Alien Exam*[4], eine Installation, bei der der Betrachter sich auf einen Operationstisch legt und in einen Kuppelraum hochgefahren wird, *Solitary*[5], ein ruhiger Raum, in dem der Besucher [in völliger Dunkelheit] Platz nimmt, und die *Phonebooths*[6], die eine Art von Transformationsräumen darstellen, in die man sich hineinbegibt und die Tür schließt. Diese Arbeiten wirken von außen eher skulptural, sind aber dennoch Arbeiten, die nur dazu da sind, um betreten zu werden.

Ziva Freiman: Mit diesen kleineren Arbeiten schlagen Sie gewissermaßen einen neuen Weg ein, da Sie nun Objekte haben, die im Unterschied zu den ortsspezifischen Installationen auf Reisen gehen können. Was die von Ihnen beschriebe-

Ziva Freiman: What is the status of the work at the *Roden Crater*? Have you begun any of the constructions of the chambers and tunnels that you've projected?

James Turrell: Yes, but funding has been difficult over the last two years. I don't know who else in art has difficulties in funding, but I have. It's going better this year, so it's coming along well. To answer your question therefore means to say: It is slow. But I want to open a millennium with that piece, and I think it is a reasonable opening date.

Ziva Freiman: You have talked about your work as of "non-vicarious art", that is art that must be experienced directly, by exploring one's own perception. Yet, the irony is that most people have probably seen only a few of your installed works and know about the rest through photographs and books. And here we are, talking about it, which is completely vicarious. What do you think about it, what is the value of the art facsimile?

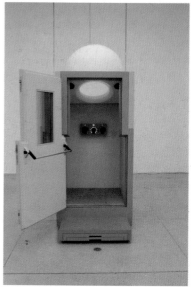

James Turrell, Perceptual Cell, 1992

James Turrell: Well, I am not sure. Without the direct experiencing of this art there is really little for you. There is a lot of art that looks terrific on photographs, in books and magazines, and frankly, mine doesn't. But there is also art which looks terrific only in magazines, while nothing is there 'in real' – so I don't feel too bad about it.

In working with light, you might have the idea for a work but it isn't formed that easily. You don't form [light] with your hands, you don't carve it like wood, or hammer it out like stone, or even build it together like steel or wood. To some degree, you pay attention to and work with everything but with what you are going to look at. The walls for example on the larger pieces I do have to be prepared very carefully, not because I am interested in fetish-finish, but because I want to refine them sufficiently so that you don't look at them. So that what you can see is residing in space, rather then seen on the wall. At first I was making spaces where I could change the volume of the space to get the desired visual effects to occur by putting the walls on wedges. I would move the walls with rollerscates – that's a particularly Californian technique. This allowed me to then change the volume enough to actually regulate the light add-

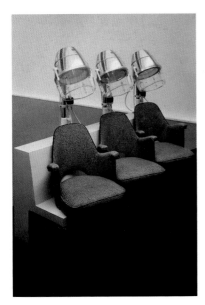

James Turrell, Mind Set, 1992

nen *Perceptual Cells*[7], aber auch den *Düsseldorfer Light Salon*[8] angeht, frage ich mich, ob es für Sie eine Herausforderung war, gegen den Objektcharakter dieser Dinge Widerstand zu leisten.

James Turrell: Nein. Diese Sachen sind für mich interessant, weil sie eine ganze Menge mit dem Ursprung und der Art meines Arbeitens zu tun haben.

Ziva Freiman: Wie ist der Stand der Dinge am *Roden Crater*? Haben Sie mit der Arbeit an den projektierten Kammern und Stollen begonnen?

James Turrell: Ja ... Allerdings hat sich in den letzten zwei Jahren die Finanzierung als schwierig erwiesen. Ich weiß nicht, welche Künstler sich mit der Finanzierung ihrer Vorhaben sonst noch schwertun, ich jedenfalls habe Probleme. Heuer ist es besser, und daher geht auch die Arbeit gut voran. Um also Ihre Frage zu beantworten: Ja, aber langsam. Ich möchte das nächste Jahrtausend mit diesem Projekt eröffnen und halte das für einen vernünftigen Fertigstellungstermin.

Ziva Freiman: Sie haben Ihr Werk als »unmittelbare Kunst« bezeichnet, als Kunst also, die direkt erfahren werden muß, indem man seine eigene Wahrnehmung erkundet. In der Tatsache, daß die meisten Leute nur wenige Ihrer Installationen wirklich gesehen haben und Ihre anderen Arbeiten nur durch Fotografien und Bücher kennen, scheint mir deshalb eine gewisse Ironie zu liegen. Und was tun wir? Wir sitzen hier und reden – der reine Ersatz. Wie sehen Sie das? Worin liegt für Sie der Wert der Vermittlung von Kunst ...?

James Turrell: Ich weiß nicht so recht. Wenn man diese Art von Kunst nicht unmittelbar erfährt, bleibt da wirklich wenig. Es gibt viele Kunstwerke, die auf Fotografien, in Büchern und in Zeitschriften großartig aussehen. Das tun meine Arbeiten, offen gestanden, nicht. Aber es gibt auch Kunstwerke, die nur in Zeitschriften großartig aussehen, und in Wirklichkeit ist dann nichts da. Mich stört das daher nicht besonders.

Wenn man mit Licht arbeitet, hat man vielleicht bald eine Idee für ein Projekt – die Ausführung ist dann aber nicht so einfach: Man kann [Licht] nicht mit Händen formen, man schnitzt Licht auch nicht wie Holz, meißelt es nicht wie Stein, kann es nicht einmal zusammenfügen wie Stahl oder Holz. Worauf sich die Auf-

ed to the space. In fact, light is very similar to sound, in the sense that if you tune it – that's how you get the laser – you actually create a cavity just for one frequency. The light that I use is not at one frequency; it's a complex mixture of light, so there is a more subjective quality in tuning a space. The light looks as if it inhabited the space and not projected on the wall – it doesn't lie on the wall but resides in the space.

In this kind of working that I came to, in this way of forming light I began to look at [light] with the eyes of perceptual psychologists, and was actually even taking courses on the subject. In fact, that was my major at the University. In the same way that people who play violin have the love for the instrument as well as for the music that comes out of it, I came to enjoy the use of devices. The early psychological devices had qualities like the Reichian Orgon boxes, which are rather marvelous. They are almost like early medical devices. So I began making these *Ganzfeld* spheres[9] and pieces that came from what I thought about perception when I first was dealing with it, but not so much as an artist. They really weren't much of an art statement and I didn't see any future in that, at that time. So I did other kinds of work, and now I am returning to that interest and am very interested in these devices.

Ziva Freiman: You see a future in it now, I assume?

James Turrell: One American Be-Bop pianist once made a statement that people never change – they just stand more revealed. To some degree I think it is true. I returned to these things in a second time around.

Ziva Freiman: Speaking of perceptual psychology, we had a chance to talk about it briefly last night. I've been interested lately in some of the theories that were put forth by John Dewey[10] in the 1930s and later by W. H. Ittelson[11] who tried to find a biological foundation for an aesthetic experience. Ittelson's premise was that human beings had a predilection for certain landscape settings based on a pleasure/survival equation, that is, that we find pleasure in certain landscape settings that are conducive to survival. For example, prospect – the ability to see over a large distance from a sheltered place, is an aesthetic [experience] that is genetically programmed to be pleasurable. I wonder whether you find any of these psycho-biological premises applicable, whether you think of it in those terms and whether they are relevant to your work?

James Turrell: Yes and no. First of all, I am interested in people like J. J. Gibson[12] and of course Merleau-Ponty[13]. Gibson talks about affordances[14] of the

merksamkeit [des Künstlers] richtet und womit er arbeitet, ist gewissermaßen alles andere als das, was man schließlich sieht. Was z. B. die Wände bei den größeren Projekten betrifft, gehe ich in deren Bearbeitung sehr sorgfältig vor, und das nicht deshalb, weil ich einen Oberflächentick habe, sondern weil ich Wände haben will, die man nicht sieht. Was man sieht, soll den Raum einnehmen, und nicht an der Wand wahrnehmbar sein. Am Anfang habe ich Räume geschaffen, deren Volumen ich verändern konnte, um die gewünschten Lichtphänomene zu erzeugen. Die Wände ruhten auf Keilen und konnten mit Hilfe von Rollen bewegt werden. So war es mir möglich, das Volumen eines Raums in dem Maße zu verändern, daß ich das Verhältnis von Licht und Raum tatsächlich frei gestalten konnte.

Licht und Klang sind einander ja insofern sehr ähnlich, als daß beide *getuned* werden können: stellt man Licht ein, und darauf beruht auch der Laser, stellt man eigentlich den Raum auf eine bestimmte Frequenz ein. Das Licht, das ich verwende, hat nicht eine bestimmte Frequenz, sondern besteht aus einer differenzierten Lichtmischung, weshalb auch das Tunen des Umraums eine subjektivere Angelegenheit ist. Man muß den Eindruck gewinnen, daß das Licht im Raum lebt und nicht, daß es auf der Wand liegt.

Die Art von Arbeit, die ich nun mache, dieses Formen von Licht, hat damit begonnen, daß ich [Licht] mit den Augen der Wahrnehmungspsychologen zu sehen versuchte und Vorlesungen in diesem Fach belegte. Genaugenommen war das sogar mein Hauptfach an der Universität. Wie Leute, die Geige spielen und das Instrument genauso wie die Musik lieben, die aus dem Instrument kommt, begeisterte ich mich bald für die Geräte und fing an, diese einzusetzen. Vor allem die frühen psychologischen Apparate hatten es mir angetan, die Reichschen Orgon-Akkumulatoren zum Beispiel, die ich wirklich wunderbar finde. Sie haben etwas von frühen medizinischen Instrumenten. So entstanden die *Ganzfeld-Kugeln*[9] und andere Arbeiten, die zum Ausdruck bringen, was ich über Wahrnehmung dachte, als ich mich damit zu beschäftigen begann. Das tat ich aber nicht so sehr als Künstler – diese Arbeiten beziehen nicht wirklich künstlerisch Stellung, und ich sah damals auch keine Zukunft darin. Daher habe ich andere Dinge getan und wende mich erst jetzt wieder diesen Geräten zu, die mich sehr faszinieren.

Ziva Freiman: Und jetzt sehen Sie darin eine Zukunft, nehme ich an?

James Turrell: Ein amerikanischer Bebop-Pianist hat einmal gesagt, daß Menschen sich nicht ändern: sie kommen nur weiter zum Vorschein. Ich glaube, daß

visual array in front of us. Some of this talk is exposing differences between Western seeing and Eastern seeing. Now we are beginning to think that the array responds to seeing, that we create what is before us, which is not too different from the idea of karma that says that what happens in our life is completely determined by what we come to life with, perhaps even by what we deserve. But those are more moral questions. In fact, there is a view that the array is awaiting to be seen. We are not just seeing it, but what we see responds to our seeing.

Another approach to this subject is to think about the lucid dream. [The lucid dream is a form of] vision with closed eyes that has as much clarity and resolution, if not more so, as when the eyes are open. So it creates a fully formed field of vision without outside stimuli. When our eyes are open, [the vision] is quite clear, particularly if there is police [involved] and several witnesses to a crime, or to an event. But still – people looking at the same scene from virtually the same vantage point do not see the same event. What is outside is only part of the creation of what is inside.

This vision of the inside which then meets the vision from the outside, is the land or the territory on which the artist works. We are able to change the affordances or change the array that we select. Now, I think it is clear that the subject of art has never been about what [people] like. Artists have never been much bothered with this. In fact, they are interested in changing peoples views, if anything at all. The changes in how we see, that is something that happens in culture. They don't necessarily have a progression – I don't believe in an art history of progression – but we do have a situation where we now see differently.

Just a small example, and perhaps not the best, would be the nudes of Rodin. There was a period when [Rodin] scandalized people because they thought he was not making nudes any more, but naked pieces. In this context [the pieces] got a clearly different sexual status. Today it is hard for us to see that, which is the evidence of culture having moved from one place to another. There are many more examples of this in art. Certainly [these changes] happen with vision as well and also with the idea of space.

[On the other hand] affordances have a price. As we take on a more sophisticated vision, learning can also mean prejudice so that we can actually have prejudiced perception. There is an early psychological experiment: you take a photo of a window in perspective, a trapezoid, and put it on a stick and rotate it

das in gewisser Weise zutrifft. Ich bin sozusagen bloß in einer zweiten Runde auf diese Dinge zurückgekommen.

Ziva Freiman: Die Wahrnehmungspsychologie haben wir bereits in unserem gestrigen Gespräch angesprochen. Ich habe mich in letzter Zeit mit einigen von John Dewey[10] in den dreißiger Jahren formulierten Theorien beschäftigt, die dann später von W. H. Ittelson[11] wieder aufgegriffen wurden: Ittelson versuchte, eine biologische Grundlage für ästhetische Erfahrungen zu finden. Dabei ging er davon aus, daß Menschen eine Vorliebe für bestimmte Landschaftsformen haben, die auf einer Gleichung von Gefallen und Überleben beruht – das heißt: der Mensch findet Gefallen an jenen Landschaftsformen, die dem Überleben förderlich sind. So begreift er etwa Aussicht, die Möglichkeit, von einem geschützten Ort aus große Entfernungen zu überblicken, als ästhetische Erfahrung, die genetisch als angenehm vorprogrammiert ist. Ich würde nun gerne wissen, ob Sie irgendwelche von den genannten psychobiologischen Theorien für zutreffend erachten und ob diese Ansätze für Ihre Arbeit eine Rolle spielen.

James Turrell: Ja und nein. Natürlich interessiere ich mich für Leute wie J. J. Gibson[12] und vor allem für Merleau-Ponty[13]. Gibson spricht von *affordances*[14] der Anordnungen unseres Gesichtsfelds. An einigen Stellen kommen da Unterschiede zwischen westlichem und östlichem Sehen zutage. Nun beginnt man ja zu denken, daß die Anordnung der Dinge auf unser Sehen reagiert, daß wir erzeugen, was wir vor uns haben – und das ist von der Karma-Idee nicht allzu weit entfernt, nämlich daß sich das, was sich in unserem Leben zuträgt, ganz und gar daraus zusammensetzt, womit wir ins Leben treten, vielleicht sogar daraus, was wir verdienen – aber das berührt moralische Fragen. Man kann sich inzwischen sogar irgendwie vorstellen, daß die Anordnung darauf wartet, gesehen zu werden. Es geht also nicht bloß darum, daß wir sie sehen, sondern darum, daß das, was wir sehen, auf unser Sehen reagiert.

Eine Möglichkeit, sich der Sache zu nähern, ist, an den Tagtraum zu denken. Wir sehen mit geschlossenen Augen ein Bild, das zumindest ebenso klar und deutlich ist wie das, was wir mit offenen Augen sehen. Es handelt sich also um ein voll ausgebildetes, nicht durch äußere Reize ausgelöstes Blickfeld. Sind die Augen offen, ist [das Bild] der Realität recht klar, vor allem wenn z. B. die Polizei anwesend ist und es Zeugen für ein Verbrechen oder sonst einen Vorfall gibt. Aber die Menschen, die denselben Schauplatz von so gut wie demselben Blickwinkel aus betrachten, sehen nicht denselben Vorfall. Was sich draußen abspielt, ist nur Teil der Schöpfung dessen, was drinnen ist. Das innere Bild, das dann auf

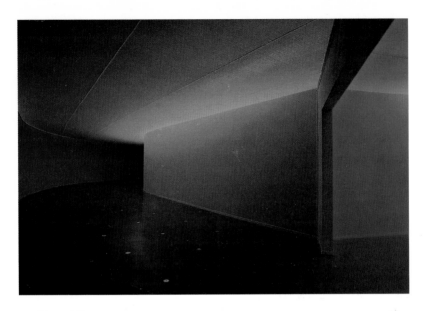

James Turrell, Red Around (night)

against a very flat background. When it is rotated against the flat background and turned back and forth, there is a place where we can't tell whether it is going back and forth, or it is actually turning around. People who don't have the affordances of being able to perceive three dimensions represented in two – as on the photograph – are actually unable to see the illusion. They see what really happens. This [trapezoid experiment] was done with both Zulus and Pygmies who at that time had not learned to see photographs as a representation of three dimensions. They weren't seeing three dimensions represented within two. We, who are able to see [three dimensional representation] were fooled by this stimulus, and couldn't tell the difference of when the trapezoid was rotating and when it was going back and forth.

Another example of prejudiced perception is learning to see colors in a wheel. Now, this [phenomenon] works for painting and comes out of the history of painting. Color has a frequency and the same harmonic relationships as sound does. We have come to look at mixing of yellow and blue [color] to yield green, but if you take yellow and blue light you'll get nearly white light. We have, by some knowledge in one area (the color harmonies), created prejudiced perceptions, or the inability to see in other areas (light). I think that artists are in-

das äußere trifft, das ist das Land oder Territorium, in dem der Künstler arbeitet. Künstler können entweder unsere *affordances* oder auch die gewählten Anordnungen ändern. Ich denke, es liegt auf der Hand, daß Kunst nie das darstellen wollte, was [den Menschen] gefällt. Darum haben sich Künstler kaum je gekümmert. Und wenn, dann wollen sie es eher ändern. Auch innerhalb von Kulturen kommt es zu Veränderungen der Sichtweisen, aber das ist nicht unbedingt mit Fortschritt gleichzusetzen. Ich sehe die Geschichte der Kunst nicht als Fortschritt, daran glaube ich nicht – und dennoch befinden wir uns in einer Situation, in der wir die Dinge anders als früher sehen.

Ein Beispiel dafür, wenn auch vielleicht nicht das beste, sind die Akte Rodins. Es gab eine Zeit, da waren die Leute schockiert, weil sie keine Akte mehr sahen, sondern nackte Körper. Der sexuelle Stellenwert [der Werke] war damals ein ganz anderer. Daß es uns heute schwerfällt, das zu verstehen, verweist auf den kulturellen Wandel, den wir durchgemacht haben. Dafür gibt es zahlreiche Beispiele in der Kunst. Und diese Veränderungen betreffen auch unser Sehen und unsere Vorstellung des Raums.

Affordances haben eben ihren Preis. Gewinnt man ein differenzierteres »Sehen«, kann der Lernprozeß auch mit Vorurteilen einhergehen, so daß es zu voreingenommenen Wahrnehmungen kommt. Es gibt da ein frühes psychologisches Experiment: Das Bild eines perspektivisch zu einem Trapez verkürzten Fensters wird vor einem sehr flachen Hintergrund auf einem Stock gedreht beziehungsweise vor und zurück bewegt. An einem bestimmten Punkt ist man nicht imstande zu erkennen, ob sich das Bild nur vor und zurück bewegt oder ob es sich tatsächlich dreht. Menschen jedoch, die die »angebotene Leistung«, drei Dimensionen, die – wie im Fall der Fotografie – zweidimensional dargestellt sind, nicht wahrnehmen können, sind tatsächlich nicht in der Lage, diese Täuschung zu sehen. Sie sehen nur, was wirklich geschieht. Das Experiment wurde mit Zulus und Pygmäen durchgeführt, die damals noch nicht gelernt hatten, Fotografien als Abbilder einer dreidimensionalen Welt zu verstehen. Sie sahen daher nicht drei, sondern nur zwei Dimensionen. Kann man aber hingegen drei Dimensionen, die zweidimensional dargestellt sind, wahrnehmen, so läßt man sich von dem Reiz täuschen und kann nicht auseinanderhalten, ob sich das Trapez dreht oder ob es nur vor und zurück bewegt wird.

Der Farbenkreisel bietet weitere Beispiele für voreingenommene Wahrnehmungen. [Dieses Phänomen] spielt in der Malerei eine große Rolle und ist auch aus der Malerei entstanden. Farbe ist eine Frequenz und hat dieselben harmonischen

volved with these questions as well, not just with the physical aspects, as I have sort of dealt with, but also with the psychological aspects of seeing.

Ziva Freiman: There is an interesting implication to what you are saying: We have different predilections, not only prejudices but perceptual predilections which are cultural[ly determined]. That means that other cultures – the Pygmies and the Zulu – are probably seeing a lot of things that we are missing. Are you curious about that? Are you making any investigations of that kind?

James Turrell: That is what most of my investigation is about. Work that I do takes place on the limits of perception – that is where we can really see and not see on one hand and where there are those limits that we create by prejudiced perception on the other hand. Any held opinion is at times attractive, but it is also a limitation of other opinion. I think a good example of this is my working in Los Angeles versus San Francisco. Los Angeles has no taste. This is clear. If you realize that taste can be a restriction you get interested in working in a place where such restriction doesn't exist. Although you don't have the same attraction in pushing off opinions as you would, say, in San Francisco.

Ziva Freiman: In the 60es when you were working at the Mendota Hotel and years thereafter when you worked on the site-bound installations you were kind of removed from the more conventional art circuit. Is the non-vicarious work of yours in any way a critique of the art world as we know it? If so, in what ways?

James Turrell: I think that everyone's work exists in that manner – because it is one thing and not something different. If you want large, rusted steel, I am not your man. I do certain work, and it does have a certain place.

In terms of what I feel [about the art world] – my only criticism would be that I am not interested in art as a treasure. America does have a very strong entrepreneurial support for art. Art is being supported by collectors and collections, and not so much by institutions directly. There I might have an edge: the work of mine which is in the Los Angeles Museum [of Contemporary Art] was all bought from an Italian collector[15], and it's the same for the work which is in the Guggenheim [Museum in New York]. America still gets a lot of art from Europe, even the art of its own artists. I don't know how this [situation] connects to my choice of work. I only know that I was interested in dealing with issues of perception and not too much worried about whether my works make it into an elevator and then up to an East Side apartment in New York.

Ziva Freiman: This makes me enter where I promised myself I wouldn't go, and that is into architecture and urbanism. Your work provokes the question wheth-

Eigenschaften wie Klang. Wir haben uns daran gewöhnt, die Mischung von Gelb und Blau [von gelber und blauer Farbe] als Grün zu sehen, wenn wir aber gelbes und blaues Licht mischen, entsteht fast weißes Licht. Durch gewisse Kenntnisse in einem bestimmten Bereich (dem der Farbharmonie) haben sich voreingenommene Wahrnehmungsmuster entwickelt – und damit die Unfähigkeit, in anderen Bereichen (wie dem des Lichts) zu sehen. Ich meine, daß das auch Künstler betrifft, und zwar nicht nur was die angedeuteten physischen, sondern auch was die psychologischen Aspekte des Sehens angeht.

Ziva Freiman: Was Sie da sagen, scheint mir interessante Implikationen zu haben. Es gibt also unterschiedliche Neigungen, nicht nur Voreingenommenheiten, sondern Wahrnehmungsneigungen kultureller Art. Das bedeutet doch, daß Angehörige anderer Kulturen, die Pygmäen und Zulus etwa, wahrscheinlich eine Reihe von Dingen sehen, die uns entgehen. Beschäftigt Sie dieser Aspekt? Stellen Sie in diesem Bereich Untersuchungen an?

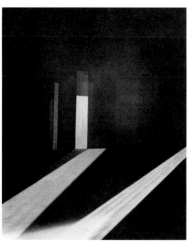

James Turrell, Mendota Stoppages, 1969-74

James Turrell: Genau damit beschäftige ich mich am meisten. Meine Arbeit findet im Grenzbereich der Wahrnehmung statt, also dort, wo man sieht und nicht sieht, an den Grenzen, die wir uns durch voreingenommene Wahrnehmungen schaffen. Jede Ansicht hat einmal etwas für sich, aber sie schließt auch jede andere Ansicht aus.

Warum arbeite ich lieber in Los Angeles und nicht in San Francisco? Daß Los Angeles keinen Geschmack hat, ist bekannt. Begreift man einmal, daß Geschmack einen einschränken kann, arbeitet man lieber dort, wo es eine solche Einschränkung nicht gibt, wenn man es auch vermissen mag, sich gegen andere Meinungen zur Wehr setzen zu müssen wie etwa in San Francisco.

Ziva Freiman: In den sechziger Jahren, als Sie im *Mendota Hotel* arbeiteten, und in den Jahren danach, der Zeit ihrer ortsgebundenen Installationen, sind Sie dem konventionelleren Kunstbetrieb eher ferngeblieben. Ist Ihre unmittelbare Kunst auch als Kritik des herkömmlichen Kunstbetriebs zu verstehen, und wenn ja, in welcher Weise?

James Turrell: Ich denke, daß das auf jede Arbeit zutrifft – weil sie eben so ist, wie sie ist, und nicht anders. Wenn Sie sich zum Beispiel für große, verrostete

er there are lessons that we can learn from your investigations of the last thirty years. What are the implications for the ways in which we deal with our cities and our buildings?

James Turrell: I don't know whether they are so much my ideas. But I agree very much with Leonardo da Vinci who is also involved in contemporary art, because remember that contemporary art can only be made when it is now. So, all the art that we are dealing with is contemporary art. [Da Vinci] liked to make his work with reduced levels of light. He felt we were not made for this [bright] light [J. T. refers to the spotlights and projectors illuminating the MAK-lecture hall].

One of the things in architecture [that I find intriguing] is that, generally, people are making forms and not spaces. There was a time when "space" was created. One would just have to look at Gothic cathedrals to get an idea of the pretty amazing marriage of space and light. Or the stadiums – the football stadiums in America – really deal with space in a very naive and non-directed way. They essentially are about erecting a protection for the fans from the area where the game is played. But as I said before, people make space by making forms and then they stick the lights in. That doesn't get you the working of light into space and often the openings – the way light is let into a space – are completely arbitrary or oriented toward a view or the amount of light to come in. It is rarely done in the way that light activates the space and makes it alive – so that you get space filled with atmosphere.

In terms of urban situations, one of the biggest mistakes I feel is that by using light to lite the night we close off our perception of the universe. If you have strong light on the stage [like here], the actors don't see people in the audience, i. e. they don't have a visual penetration into that area. As you put light around us – it's just like having the lights on inside of a house – you don't see out into the dark.

This lack of vision to the stars – ostensibly to protect people from crime – really cuts off their very powerful psychological access to a larger sense of territory. To reduce the sense of territory of the human has dangerous psychological effects and I feel that this is happening now by lighting the sky. I must say, however, that light pollution is a rather low priority when compared to all other kinds of pollution.

These things might be something for architecture. I am involved in art, as opposed to architecture, although what I do is a structuring of reality by building.

24

Stahlkonstruktionen interessieren, sind Sie bei mir an der falschen Adresse. Meine Arbeit ist meine Arbeit und sie hat ihren bestimmten Ort.

Was nun Ihre Frage betrifft, kann nur eine einzige Kritik anbringen: mich interessiert Kunst als Wertanlage und Kostbarkeit nicht. Die Kunst wird in Amerika sehr stark von den Unternehmen gefördert. Sie wird von Sammlern und Sammlungen und nicht so sehr unmittelbar von Institutionen getragen. Vielleicht verschafft mir das einen gewissen Vorteil: Alle meine Arbeiten im Los Angeles Museum [of Contemporary Art] wurden von einem italienischen Sammler erworben, und das gilt auch für meine Sachen im Guggenheim [Museum in New York].[15] Amerika bezieht noch immer viel Kunst aus Europa, sogar viele Werke amerikanischer Künstler. Ob das mit der Art meiner Projekte und Arbeiten zu tun hat, weiß ich nicht. Ich weiß nur, daß ich mich mit Fragen der Wahrnehmung auseinandersetzen wollte und mir nicht wirklich überlegt habe, ob die Arbeiten in einen Aufzug passen, um in irgendeiner New Yorker East-Side-Wohnung zu landen.

Ziva Freiman: Das berührt einen Bereich, den ich eigentlich aussparen wollte: den Bereich der Architektur und des Städtebaus. Ihre Arbeiten scheinen mir die Frage heraufzubeschwören, ob Ihre Tätigkeit in den letzten dreißig Jahren in diesen Bereichen zu Ergebnissen geführt hat, von denen wir lernen können. Was bedeutet Ihre Arbeit im Hinblick auf unseren Umgang mit Städten und Gebäuden?

James Turrell: Wenn ich auch nicht weiß, ob das wirklich meine Gedanken sind ... Ich stimme jedenfalls ganz und gar mit Leonardo da Vinci überein, der für mich ein zeitgenössischer Künstler ist, entstammt doch alle zeitgenössische Kunst – Sie erinnern sich? – einem Jetzt, das war. Jede Kunst, mit der wir uns auseinandersetzen, ist zeitgenössische Kunst. [Leonardo] hat in seiner Arbeit das Licht sehr zurückgenommen, weil er meinte, daß wir für dieses [helle] Licht nicht geschaffen sind [J. T. bezieht sich auf die Scheinwerfer und Projektoren, die den MAK-Vortragssaal erleuchten].

Nun, um auf Architektur zurückzukommen, da fällt mir eines besonders auf: Im allgemeinen geht es heute um Formen und nicht um Räume. Es gab einmal eine Zeit, in der »Raum« geschaffen wurde. Man muß sich nur einmal die verblüffende Verbindung von Raum und Licht in gotischen Kathedralen anschauen. Oder sich ein amerikanisches Fußballstadion vergegenwärtigen – da wird mit Raum wirklich sehr naiv und zufällig umgegangen, einfach als Trennung von Zuschauern und Spielfeld. Aber wie gesagt, es werden eben Räume erzeugt, indem man

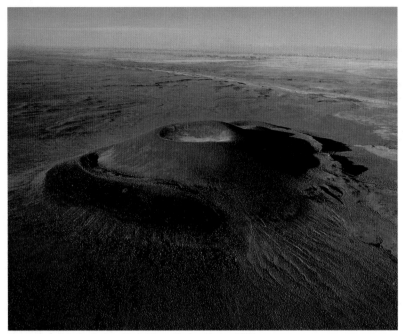

*James Turrell, **Luftaufnahme**/Aerial View, Roden Crater, 1982*

Architects do that too, and there we have some of the same aims. There are people who do that as well in different modes, if not better, as I do.

Ziva Freiman: The point that you made is quite fascinating and opens up a whole vista of ideas about how to make a public realm. That is something that is bedeviling not only the architectural community. I am also very curious to learn about your work-process. How do you improve and push forward what you are doing? Do you anticipate, do you experiment? How do you balance between some rational hypothesis based upon what you experienced already and what might come to you intuitively?

James Turrell: I think my work would be the closest to someone who works in acoustics, who is designing stages and things like that. Some of the worst theaters and stages have been designed in the name of acoustical engineering. [Acoustical engineering] turns out to be much more of an art than we have ever expected it to be. For me, building with light is a little bit along the same lines. It is like architecture in a sense that I think [a project] up, and then structure it, build it, realize it. But [my work] has a lot more of a trial-and-error in it

Formen bildet und sich dann irgendwie ums Licht kümmert. Das kann natürlich kein Zusammenspiel von Licht und Raum ergeben, und die Plazierung der Öffnungen, durch die Licht einfällt, ist entweder vollkommen willkürlich oder ergibt sich durch die Aussicht oder die gewünschte Lichtmenge. Es kommt selten vor, daß das Licht den Raum belebt, aktiviert – den Raum mit Atmosphäre füllt. Was unsere Städte betrifft, halte ich es für einen der größten Fehler, daß man die Nächte erleuchtet und so das Universum unserer Wahrnehmung entzieht. Wenn man ein Podium hell ausleuchtet [wie hier], sehen die Menschen auf dem Podium die Menschen im Publikum nicht, der Blick kann diesen Bereich nicht durchdringen. Sobald man uns mit Licht umgibt, verhält es sich genauso, wie wenn man in einem Haus die Lichter aufdreht: man sieht nicht mehr in die Nacht hinaus. Und indem man uns – angeblich um uns vor Verbrechen zu schützen – den Blick auf die Sterne nimmt, verstellt man uns einen ganz starken psychologischen Zugang zu einem größeren Raumempfinden. Die Einschränkung des menschlichen Raumempfindens hat immer gefährliche psychologische Auswirkungen, und ich meine, daß das heute durch das Erleuchten des Himmels mit ziemlichem Tempo vorangetrieben wird. Natürlich spielt die Lichtverschmutzung im Vergleich zu allen anderen Arten der Verschmutzung eine untergeordnete Rolle.

Diese Aspekte scheinen mir für die Architektur relevant zu sein. Mir geht es um Kunst, nicht um Architektur, auch wenn es bei dem, was ich tue, um die strukturierte Erschaffung von Realität geht. Das gilt auch für Architekten, und da haben wir auch teils gemeinsame Ziele. Und es gibt auch Leute, die es anders und vielleicht sogar besser machen als ich.

Ziva Freiman: Was Sie da sagen, scheint mir sehr interessant zu sein, da es eine ganze Reihe von Ideen darüber enthält, wie öffentliche Bereiche beschaffen sein sollten. Das ist ja eine Frage, von der nicht nur die Architekten besessen sind. Ich habe mich immer gefragt, wie Ihr Arbeitsprozeß tatsächlich aussieht. Woher beziehen Sie die für Ihr Tun notwendigen Kenntnisse und wie treiben Sie Ihre Projekte voran? Nehmen Sie da Dinge vorweg, experimentieren Sie? Wie wägen Sie ab zwischen rationalen, auf bereits gewonnenen Einsichten beruhenden Ansätzen und ihren intuitiven Einfällen?

James Turrell: Ich glaube, meine Tätigkeit ist am ehesten mit Arbeiten im akustischen Bereich zu vergleichen, mit der Planung von Bühnen und ähnlichen Dingen. Einige der schlimmsten Theater und Bühnen sind im Namen der Akustik entstanden, und es hat sich gezeigt, daß [die Akustik] eine viel größere Kunst

than does building with forms. For me it's more like painting: you have a shape [in mind] and that shape or form painted on the two-dimensional surface can be held by one color better than by the other. So when you try one color [the shape] does one thing and then you try another color and it would do a very different thing. In the same way, light in a space can hold that space or can nearly evacuate it of any sense of atmosphere.

This would be very similar to deciding to build a shower, that, when you got in it and sang one particular note, your voice would let resonate the cavity of the shower. That's possible to do. But then, if you got into this shower and sang and it did not resonate at that note, what do you do then? Well, you have ways to change the shape.

That would be the way to explain how I go about [my work]: somewhat with the trial-error aspect, somehow like working with paintings and drawings, and a bit like in architecture.

Ziva Freiman: Is there something you would like to add, that we didn't touch on?

James Turrell: I think the main idea is that the work with light is an emotional work. Light has great power, and because I am not dealing with image, or intellectual reference, or literal reference, and because of the way light has a similar action on us as it does to a deer in headlights – [my work] affords a medium that is powerful in its directness. For this reason it is almost unavoidable that it provokes emotional responses. I feel ideal with the work... It's coming a bit out of my raising as a strict Quaker, and is a really tough approach to the sublime.

1 The *Roden Crater Project*, Turrell's largest land art project and principal artistic statement, attempts to transform an extinct volcano near Flagstaff in Arizona into a complex system of perceptual spaces where celestial and differentiated light phenomena become visible due to the artist's changes.
2 In the *Irish Sky Garden*, his second comprehensive land art project realized in a nature reserve in West Cork, Ireland, Turrell works at developing already existing land formations into "observation spaces" that open up certain views of celestial phenomena.
3 *The Space that Sees* is a permanent outdoor sculpture located in the *Billy Rose Art Garden* designed by Isamu Noguchi for the Israel Museum in Jerusalem. It belongs to the series of skyspace works dealing wirh the function of interior space and space outside. The sculpture, located on one of the four semi-circular terraces built of Jerusalem blocks of stone, is a white concrete chamber of 100 square meters and 7 meters in height. It has a square opening in the center of the roof that is 5 x 5 meters. The room is painted white and lit after sunset by neon tubes installed behind the upper edges of pink stone benches.
4 *Alien Exam*, one of Turrell's *Perceptual Cells* (see note 7) belonging to the series of *Operating Rooms*, was first realized in a Security Pacific Bank building in California in 1989. In order to

ist, als man je angenommen hat. Für mich ist Lichtarchitektur irgendwie ähnlich. Um Architektur handelt es sich insofern, als ich mir etwas ausdenke, eine Vorstellung habe, die ich dann strukturiere, baue, verwirkliche. Aber ich habe natürlich viel mehr Möglichkeiten, etwas auszuprobieren, als man das beim Bauen von Formen hat. Es ist eher wie bei einem Gemälde: da hat man einen Körper, und dieser Körper, diese Form läßt sich zweidimensional mit einer bestimmten Farbe besser festhalten als mit einer anderen. So versucht man eben eine Farbe, und diese Farbe bewirkt etwas, und dann nimmt man eine andere Farbe, und die bewirkt etwas ganz anderes. In gleicher Weise kann Licht einen Raum bewahren oder fast seiner gesamten Atmosphäre berauben. Stellen Sie sich einmal vor, Sie wollen eine Dusche bauen, deren Hohlraum für einen bestimmten Ton, den Sie singen, einen Resonanzkörper abgeben soll. Das ist möglich. Wenn Sie aber jetzt in die Dusche steigen und diesen einen Ton singen, und es klappt nicht, was tun Sie dann? Nun, Sie müßten die Form der Dusche ändern ...

Ich hoffe, ich habe damit erklärt, wie ich [bei meiner Arbeit] vorgehe – teils indem ich Verschiedenes ausprobiere, teils so, wie man in der Architektur mit Entwürfen und Zeichnungen arbeitet.

Ziva Freiman: Gibt es etwas, das wir nicht berührt haben und das Sie noch gern ergänzen wollen?

James Turrell: Wichtig ist, daß die Arbeit mit Licht eine Sache des Gefühls ist. Licht hat eine ungeheure Kraft, und da ich mich nicht mit Bildern, nicht mit gedanklichen oder sprachlichen Bezügen beschäftige und da Licht auf uns ähnlich wirkt wie auf ein Tier im Scheinwerferkegel – bietet [meine Arbeit] ein in seiner Unmittelbarkeit kraftvolles Medium. Aus diesem Grund ist es auch fast unvermeidlich, daß sie emotionelle Reaktionen oder eine emotionelle Qualität erzeugt. Ich neige dazu, mich völlig mit meiner Arbeit identifizieren ... Das hat wahrscheinlich auch ein wenig mit meiner strengen Quäker-Erziehung zu tun und das ist ein dorniger Weg zur Erlösung.

1 Das *Roden Crater Project,* Turrells künstlerisches Hauptwerk und größtes Landschaftsarchitektur-Projekt besteht aus der Umwandlung eines erloschenen Vulkans bei Flagstaff in Arizona in ein in die Landschaft eingebundenes komplexes System von Wahrnehmungsräumen mit verschiedenen Lichtqualitäten und sichtbar werdenden Himmelsphänomenen.
2 Im *Irish Sky Garden,* dem zweiten umfassenden Land-art-Projekt Turrells, werden in einem Naturpark in West Cork, Irland, ausgehend von vorgefundenen Landschaftsformen, "Observationsräume" zur Beobachtung von Himmelsphänomenen geschaffen.
3 *Der sehende Raum (The Space that Sees),* eine für den Außenraum geschaffene Skulptur, befindet sich im *Billy Rose Art Garden,* einer von Isamu Noguchi für das Israel Museum in Jerusa-

immerse himself in the perceptual process conceived by the artist, the visitor lies down on a hydraulic "operating table" to be taken up into a circular dome in the ceiling where he is exposed to alternating red and blue lights by a "nurse" for 15 minutes.

5 In *Solitary* (Düsseldorfer Kunstverein, 1992) Turrell does not work with colored light-zones, as he does in most *Perceptual Cells*, but with darkness only. Here, the visitor experiences total darkness and absolute isolation which descend as soon as one has shut the door and taken seat in the soundproofed chamber for a duration of twenty minutes up to four hours.

6 Turrell's *Telephone Booths*, an autonomous work group within the series *Perceptual Cells*, are closed wooden cells with an opaque plastic or glass dome. After having entered the booth the visitor remains standing to experience various light and sound impressions. In the cell *Change of State* for example, three control switches enable the visitor to regulate both composition and intensity of the red and blue lights shining down on him from the dome while being exposed to a barely audible, yet constant wind noise. In *Close Call* on the other hand, the visitor can control the intensity of light and noise, but not the flashes produced by the strobe light installed in the cell. Turrell suggests a ten minutes' stay for most of his *Telephone Booths*.

7 Turrell's *Perceptual Cells* are directly related to his earlier experiments during the *Art & Technology Program* in Los Angeles. These cells can be set up in any standard room and aim at making the visitor experience certain light and sound phenomena. They are not to be misunderstood as works of art to be contemplated but are spaces of experience to be entered, machines that examine, question, and maybe expand the visitor's visual and auditive capabilities.

8 For his exhibition at the Düsseldorfer Kunstverein (4 April–14 June 1992)Turrell developed *Mind Set*, a *Perceptual Cell* belonging to the *Helmet Series* and realized in 1991, into the *Düsseldorf Light Salon*. The installation consisted of six hairdryers with chairs and two glass showcases in which lightbulbs of various shapes and sizes were exhibited. Once seated under one of the dryers, the visitor was surrounded by red, blue, green, yellow, pink or indigo-coloured light which he could control with a converted temperature switch.

9 In the late sixties, James Turrell, together with Robert Irwin and Edward Wortz, conducted a series of further experiments which were directly connected with the *Art & Technology Program* investigations (see note 7). These experiments aimed at developing homogeneous fields of light. With the aid of a semispherical bowl, Turrell succeeded in producing a uniform white "mist of light" which obscured the actual surroundings. This all encompassing visual field saturated with light or *Ganzfeld*, as it was called, provided an ideal basis for stimulating a person's perceptual awareness. Subsequently, Turrell created colored *Ganzfelds* in which light appeared to be a space-generating substance that could literally be entered.

10 The American philosopher, pedagogue and psychologist John Dewey (1859–1952) is regarded as one of the principal representatives of American pragmatism. Concerning Turrell's theories of perception, it is above all Dewey's psychological approach that is of relevance here, which - in functionalist manner - always focusses on the interaction with the (social) context.

11 W. H. Ittelson is one of the most significant representatives of American environmental psychology which is mainly concerned with exploring the interaction between man and environment as a dynamic process. It not only deals with environmental influences on man but also with the ways man structures and changes his particular environment. Always considering the actual human surroundings first and never starting out from experimental situations, environmental psychology emphasizes its investigational commitment to the methods of a wide range of disciplines.

12 The American psychologist James J. Gibson's investigational approaches center upon combining perceptional psychology and environmental theory. This combination resulted in the development of a "theory of information pick-up" which considers the process of taking in information as a continuous and interminable activity, the "eventful environment" incessantly conveying information to the viewer's consciousness. Gibson's theory aims at systematizing this transfer and its assimilation.

lem konzipierten Anlage. Die Arbeit ist Teil einer Reihe von »Himmelsraum«-Projekten, die sich mit der Funktion von Innen- und Außenraum auseinandersetzen. Es handelt sich um eine 100 m^2 große und 10 m hohe Kammer aus weißem Beton, die auf einer der vier halbkreisförmigen, aus Jerusalemer Steinblöcken errichteten Terrassen des Museums ruht. Das Dach weist in der Mitte eine quadratische, 5 mal 5 m große Öffnung auf. Nach Sonnenuntergang wird der weiße Innenraum durch Neonröhren beleuchtet, die hinter den Oberkanten rosafarbener Steinbänke angebracht sind.

4 *Alien Exam* ist eine *Perceptual Cell* (vgl. FN 7) aus der Serie *Operating Rooms* (Operationsräume) und wurde erstmals 1989 in einer Filiale der Security Pacific Bank in Kalifornien realisiert. Um in den von Turrell konzipierten Wahrnehmungsprozeß einzutauchen, wird der Besucher, nachdem er sich auf einen hydraulisch betriebenen »Operationstisch« gelegt hat, zu einer runden Deckenkuppel emporgefahren, wo er während 15 Minuten einem von einer »Krankenschwester« gesteuerten Lichtwechsel zwischen Rot und Blau ausgesetzt ist.

5 *Solitary* (Düsseldorfer Kunstverein, 1992) unterscheidet sich von den meisten anderen *Perceptual Cells* insofern, als Turrell hier nicht mit farbigen Lichtfeldern, sondern auschließlich mit Dunkelheit arbeitet. Intendiert ist das Wahrnehmungserlebnis völliger Dunkelheit und absoluter Isolation, das sich einstellt, sobald der Besucher in der schallgedämpften Zelle Platz genommen und die Tür geschlossen hat. Vorgesehen ist ein Aufenthalt von 20 Minuten bis zu vier Stunden.

6 Die innerhalb der *Perceptual Cells* eine autonome Serie bildenden *Telephone Booths* bestehen aus geschlossenen hölzernen Zellen mit einer undurchsichtigen Plastik- oder Glaskuppel, in denen der Besucher stehend Licht- und Tonwahrnehmungen ausgesetzt ist, die jeweils unterschiedlich konzipiert sind: In der Zelle *Change of State* beispielsweise kann der Besucher zwar mittels dreier Regler Mischungsgrad und Intensität des roten und blauen Lichts, das aus der Kuppel auf ihn herabstrahlt, steuern, ist aber zusätzlich einem konstanten, kaum hörbaren Windgeräusch ausgesetzt. In *Close Call* hat der Besucher die Möglichkeit, die Intensität von Geräusch und Licht zu steuern, nicht aber die Lichtblitze eines in der Zelle installierten Stroboskops. In den meisten *Telephone Booths* ist eine Aufenthaltsdauer von 10 Minuten vorgesehen.

7 Die *Perceptual Cells* – Wahrnehmungszellen, in denen verschiedene Licht- und Tonerlebnisse erfahrbar sind – knüpfen an Turrells frühe Experimente im Rahmen des *Art & Technology Programs* in Los Angeles an. *Perceptual Cells* können in jedem Raum normaler Größe aufgebaut werden und verstehen sich nicht als zu betrachtende Kunstwerke, sondern als Erlebnisräume, in die sich der Benützer begibt, als Maschinen, mittels derer die visuelle und auditive Perzeption überprüft, in Frage gestellt oder auch erweitert werden kann.

8 Anläßlich der Ausstellung im Düsseldorfer Kunstverein (4. 4. bis 14. 6. 1992) hat Turrell die 1991 entstandene Wahrnehmungszelle *Mind Set* aus der Werkgruppe der *Helmet Series* (Helmserie) zum *Düsseldorfer Light Salon* erweitert. Die Installation besteht aus sechs Haartrocknern mit dazugehörigen Sitzen sowie zwei Vitrinen, in denen Glühbirnen unterschiedlicher Form und Größe ausgestellt sind. Sobald der Besucher unter einem der Haartrockner Platz genommen hat, ist er von rotem, blauem, grünem, gelbem, rosafarbenem oder marineblauem Licht umgeben, das er mittels des umfunktionierten Wärmereglers in seiner Intensität steuern kann.

9 In direktem Zusammenhang mit dem *Art & Technology Program* (vgl. FN 7) standen weitere Laborexperimente, die Turrell Ende der sechziger Jahre gemeinsam mit Robert Irwin und Edward Wortz unternahm. Ihr Ziel war es, komplexe homogene Lichtfelder zu erzeugen. In einer halbkugelförmigen Schale produzierte sie einen gleichmäßigen weißen »Licht-Nebel«, der die realen räumlichen Gegebenheiten verschleierte. Das derart entstandene *Ganzfeld* – ein mit Licht angefülltes, allumfassendes Gesichtsfeld – bildete eine ideale Voraussetzung für die Stimulation des Wahrnehmungsbewußtseins. Später realisierte Turrell farbige Ganzfelder, in denen Licht als eine raumbildende Substanz erscheint, in die man eintreten kann.

10 Der amerikanische Philosoph, Pädagoge und Psychologe John Dewey (1859-1952) gilt als einer der bedeutendsten Vertreter des amerikanischen Pragmatismus. Im Zusammenhang zu Turrells Wahrnehmungstheorien ist vor allem Deweys psychologischer Ansatz wichtig, der sich

13 The French philosopher Maurice Jean-Jacques Merleau-Ponty (1908–1961) is regarded as one of the main protagonists of French existentialism. Under the influence of Edmund Husserl's phenomenology, Merleau-Ponty tried to develop an original theory of consciousness and perception and to found an existentialistic anthropology based on this approach.

14 James J. Gibson coined the term "affordances" when trying to describe the concept of "attensity". The "attensity" of an object or event reflects the degree of urgency of the need to attend to it the event triggers in the human organism. Ecological events, incidents affording food or shelter or presenting the organism with some danger, range in terms of their "attensity" which varies according to the nature and extent of their "affordances". As works of art are also characterized by varying degrees of "attensity", it is possible to use these terms in an aesthetic context. Turrell's "light works" aim at a highly intensive perceptual experience, yet do appeal to the organism through very specific "affordances". Containing almost no information for the organism, the unfocussed light of the *Ganzfelds* for example has a very low "attensity level", whereas other light experiments trigger a rather high degree of attention.

15 Both remarks refer to the Italian collector Giuseppe Panza di Biumo in whose collection near Varese in Lombardy Turrell realized various light installations. Significant parts of Panza's collection of minimal and concept art were acquired by the Los Angeles Museum of Contemporary Art and the Guggenheim.

funktionalistisch auf die Interaktion mit der (sozialen) Umwelt konzentriert.

11 W. H. Ittelson ist einer der wichtigsten Vetreter der amerikanischen Umweltpsychologie, in deren Zentrum die psychologische Erforschung der Mensch-Umweltinteraktion als einer dynamischen Wechselwirkung steht: nicht nur die Einflüsse der Umwelt auf den Menschen werden thematisiert, sondern auch die gestaltende und verändernde Funktion des Menschen in Bezug auf seine Umwelt. Die umweltpsychologische Forschung versteht sich als multidisziplinär und problemorientiert, insofern sie immer von der realen Lebensumwelt des Menschen und nicht von experimentellen Sitationen ausgeht.

12 Der amerikanische Psychologe James J. Gibson stellt die Verbindung von Wahrnehmungspsychologie und Umwelttheorie in das Zentrum seiner Forschungsansätze, die ihn zu einer »Theorie der Informationsaufnahme« (pick up) führten. Die Informationsaufnahme wird als eine kontinuierliche, unabschließbare Aktivität aufgefaßt, wobei die »ereignisreiche Umwelt« beständig Informationen an das Bewußtsein des Betrachters vermittelt. Diese Vermittlung und ihre Verarbeitung im Bewußtsein zu systematisieren, ist das Ziel von Gibsons Theorie.

13 Der französische Philosoph Maurice Jean-Jacques Merleau-Ponty (1908-1961) gilt als einer der Hauptvertreter des französischen Existentialismus. Unter dem Einfluß von Edmund Husserls Phänomenologie versuchte Merleau-Ponty eine eigene Theorie des Bewußtseins und der Wahrnehmung zu entwickeln und darauf eine existentialistische Anthropologie zu begründen.

14 Der Begriff der *affordances* (in etwa: angebotene Leistungen) wurde von James J. Gibson zur Beschreibung der *attensity* geprägt. Die *attensity* eines Objekts oder eines Ereignisses bezeichnet den Grad der Notwendigkeit oder Dringlichkeit des Bedürfnisses, ihm Aufmerksamkeit zu schenken, das es im menschlichen Organismus auslöst. Ökologische Ereignisse, die Nahrung, Schutz oder Gefahr bieten, haben für den Organismus verschiedene Grade an *attensity*, die von der Art und dem Ausmaß ihrer *affordances* abhängen. In einen ästhetischen Kontext kann diese Terminologie insofern übertragen werden, als auch Kunstwerke über unterschiedliche Grade an *attensity* verfügen. Turrells Lichtarbeiten ermöglichen ein hochgradig intensives Wahrnehmungserlebnis, sprechen allerdings den Organismus über ganz spezifische *affordances* an. Das unfokussierte Licht der Ganzfelder beispielsweise hat einen sehr geringen Grad an *attensity*, da es nahezu keine Informationen für den Organismus enthält, andere Lichtexperimente wiederum lösen ein sehr hohes Maß an Aufmerksamkeit aus.

15 Beides bezieht sich auf den italienischen Kunstsammler Giuseppe Panza di Biumo, in dessen Villa in der Nähe von Varese bei Mailand Turrell einige Lichtinstallationen durchgeführt hat. Wichtige Teile von Panzas Minimal- und Concept-art Sammlung wurden vom Museum of Contemporary Art von Los Angeles und vom Guggenheim Museum angekauft.

GACHNANG

WEST

FRANZ WEST:
A few little dirty tricks
A conversation with Johannes Gachnang

Johannes Gachnang: You are witnessing a première: Franz West and Johannes Gachnang. We know of each other but we have never met before. We've come together for the first time here and we will speak German. This is Vienna after all, Central Europe, and I guess that the German language is adequate [for the occasion]. But before going ahead I want to make some presents. Here's number one: Günther Förg sends his best regards to Franz West. Number two: Since they don't serve us any wine here, I brought a nice Kirsch from Switzerland. And I got two snifters at the airport so that it won't get too boring up here. Fifty-six shillings a piece, it says here on the label. Please notice that I have learnt a lot from the Vienna Aktionisten and from Marcel Broodthaers[1].

Vienna being a highly intellectual city, one must never forget to mention Derrida, Baudrillard and Foucault and I've actually done my homework to be able to offer you some quotes. Cheers!

Franz West: Cheers, cheers!

Johannes Gachnang: Santé! A nice kirsch! It's from Zug, a Zuger kirsch …

In order to start off in the right Viennese mood I thought it would be good to remember Konrad Bayer and his beautiful passage: ›La-la-la, sang Goldenberg. Bla-bla-bla, replied Braunschweiger. Hereupon both, Braunschweiger and Goldenberg, felt happy for several minutes.[2] That was in the fifties and it is what I would suggest for an introduction to this conversation from where we can take off now. It was Franz West who suggested that we introduce ourselves.

Franz West: In case you don't know me, I am Franz West and I am a sculptor, I think, and I recently started teaching in the bitter city of Frankfurt. And on the side I occasionally make things to sit on. As [today's] subject is „Positions [in Art"] I would like to define my position: The simplest position is to make sitting facilities in which one can take up a position again, the sitting position. A seat being a negative nude drawing, the position becomes a matter of proportions.

FRANZ WEST:
Eine kleine Schweinerei
Ein Gespräch mit Johannes Gachnang

Johannes Gachnang: Was sie jetzt hier erleben werden, ist eine Premiere: Franz West und Johannes Gachnang. Vielleicht kennen wir uns, aber wir hatten nie etwas miteinander zu tun. Wir sitzen also zum ersten Mal zusammen und wir sprechen deutsch. Wir sind ja hier in Wien, in Mitteleuropa, und ich denke, die deutsche Sprache ist [dieser Situation] angepaßt. Aber bevor man beginnt, muß man ja auch einige Geschenke machen. Ich habe zuerst einen Gruß von Günther Förg an Franz West auszurichten, und da es hier keinen Wein gibt, habe ich Franz West aus der Schweiz was mitgebracht, nämlich einen anständigen Kirsch, und damit es nicht so langweilig wird auf der Bühne, habe ich gleich zwei Stamperl mitgebracht. 56 Schilling steht hier noch am Schild, direkt vom Flughafen. Also Sie sehen, ich habe schon sehr viel gelernt von den Wiener Aktionisten - aber auch von Marcel Broodthaers.[1] Da können wir ja gleich mal einen einschenken. Wien ist ja eine hochintellektuelle Stadt, und da muß man immer sehr viel von Derrida, Baudrillard, Foucault sprechen und in diesem Sinn habe ich auch einige Sachen vorbereitet, denn in Wien muß man mit Zitaten aufwarten. Prosit!

Franz West: Prost, Prost!

Johannes Gachnang: Santé! – Das ist ein guter Zuger Kirsch – Kirschwasser... Damit wir in Wien auch richtig anfangen, hab ich gedacht, erinnern wir uns Konrad Bayers mit seinem schönen Zitat: »La-la-la, sang Goldenberg, Bla-bla-bla, antwortete Braunschweiger. Hierauf waren beide, Braunschweiger und Goldenberg minutenlang glücklich.«[2] Also das war in den fünfziger Jahren und hier können wir jetzt vielleicht gleich einsteigen. Franz West hat nämlich vorgeschlagen, daß wir uns vorstellen.

Franz West: Also, falls Sie mich nicht kennen, ich bin Franz West und Bildhauer, glaube ich, und unterrichte in letzter Zeit auch noch im bitteren Frankfurt. Nebenbei mache ich gelegentlich Sitzgelegenheiten. Weil es [hier heute] um Positionen [zur Kunst] geht: Die simpelste Form der Position wäre, daß man Sitzgelegenheiten macht, in denen man wieder eine Position einnimmt, nämlich die

There is [nude] photography after all and there are mountains of really good nude drawings. If I were a real amateur like a philatelist I might probably still be drawing nudes because this is something that was dismissed for quite a long time. But I for my part decided to use proportions in their negative form – which is where sculpturing actually comes from: proportion.[3]

Just a moment! I guess one should ask the essential question first: What does a sculptor do with proportions? I would very much like an art historian offer his view regarding this question.

Johannes Gachnang: Unfortunately, I'm not an art historian, I'm just a structural engineering draughtsman. But I had a very good teacher by the name of Scharoun. Hans Scharoun[4] has certainly helped me find access to what Franz West does. I realized this various times, once [at an exhibition] in the Secession here, and also at the Kunsthalle in Bern[5]. I was very impressed by how the same pieces presented themselves quite differently in different spaces, at different places, first in Vienna, then in the away match in Bern. I'd very much like to seize the opportunity and thank Franz West for the great installation he created for the visitors of the *documenta IX* in Kassel[6]. I saw it on quite a lively day and watched how your benches had to be covered and freed from the covers again and again, as the wheather kept changing from sun to rain to sun to clouds to rain … It was an exceptional pleasure to have an opportunity to get an understanding of what sculpture can be, sculpture in the spirit of Franz West.

Franz West: People are often unaware of the fact that it was actually impossible to present the Kassel piece. The way it was presented was the outmost limit. There was a very simple problem to be dealt with: Which material should be used for the seats? We decided to use carpets, and so each time it started to rain there was a catastrophe in the air. But this was not a joke, no joke at all, it was the extension of the proportions, which in this case had to be placed outside.

Franz West, Freilichtkino/open air cinema, documenta IX, 1992

What was of interest to me about it was that it was a ready-made. Today's ready-mades don't have anything to do with those of Duchamp for example, who used objects that were finished more or less. The ready-made of today is the artist himself in a way [, is the artistic concept]. [The artist] becomes a tran-

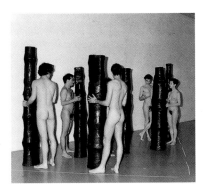

Franz West, 7 Säulen, 1989

Position des Sitzens. Und da eine Sitzgelegenheit eine negative Aktzeichnung ist, geht es hier genauso um Proportionen. Wir haben ja schließlich und endlich die [Akt]fotografie und wirklich gute Aktzeichnungen en masse. Ein Liebhaber im Sinn eines Briefmarkensammlers könnte vielleicht heute weiterhin aktzeichnen, weil ja das übliche Aktzeichnen längere Zeit mehr oder weniger weggewischt war. Ich jedenfalls habe mir gedacht, ich verwende die negative Form der Proportionen, woher die Bildhauerei eigentlich kommt – von der Proportion.[3]

Einen Moment, vielleicht sollte man die prinzipielle Frage stellen: Was macht man mit den Proportionen als Bildhauer? Dürfte ich Sie als Kunstgeschichtler vielleicht da fragen?

Johannes Gachnang: Leider bin ich kein Kunstgeschichtler, sondern lediglich Hochbauzeichner. Aber ich hatte einen sehr guten Lehrer, das war Scharoun. Hans Scharoun[4] hat mir sehr viel auf den Weg geholfen, das Werk von Franz West vielleicht ein bißchen zu verstehen. Ich konnte das öfter beobachten, einmal [in seiner Ausstellung] in der Sezession in Wien und dann nochmals in der Kunsthalle in Bern.[5] Ich war sehr beeindruckt von der Unterschiedlichkeit, mit der sich die gleichen Stücke in den unterschiedlichen Räumen, an unterschiedlichen Stellen präsentieren – erst in Wien, dann im Auswärtsspiel in Bern. Bei dieser Gelegenheit möchte ich zuerst noch danken für diese großartige Installation, die Franz West für uns, die Besucher der *documenta IX*, in Kassel geschaffen hat[6]. Ich sah sie an einem sehr lebendigen Tag, wo man ständig Ihre Stühle bedecken mußte und die Abdeckungen dann wieder entfernte, weil die Sonne, die Wolken und die Regenschauer einander folgten. So kam ich in den großartigen Genuß, ein Verständnis von dem zu bekommen, was Plastik sein könnte – vor allem im Sinne von Franz West.

Franz West: Bei diesem Kasseler Stück wird häufig übersehen, daß es eigentlich unmöglich zu präsentieren war. Das heißt, man hat es in dem Maße präsentiert, indem es überhaupt noch möglich war. Es gab da nämlich ein ganz simples Problem: Woraus sollen die Sitzflächen gemacht werden? So haben wir Teppiche genommen, und jedesmal wenn's geregnet hat, war eine Katastrophe zu befürchten. Das war aber kein Gag, sondern das war einfach die Verlängerung der Proportionen, die in diesem Fall draußen zu stehen hatten.

sitory stage, something like a relay, a medium. Something is said and then this something finds a form and you sit somewhere in-between and have to cope with an idea while sitting in-between. The real difficulty is finding the idea to cope with – and that's what the ready-made looks like today. This may sound kind of confused but it isn't. It's just following the way ideas come into being. This is how I would define the making-of-a-ready-made-today. And the materialization of this idea means the creating of a seat within a – I don't want to use the word space, as all those conceptions of space have got me kind of confused …

What I am interested in are proportions and the state of proportion, but then there are also sculptures. I find this interesting, [as] today the making of sculptures appears to be something highly criticizable. This I am certainly aware of, but doesn't that hold true for our very existence? The interesting thing about it is the question how simply making [sculptures] would be like. Of course there is quality as a measure but that's no longer valid today. On the other hand sculpturing does kind of happen by itself which is the really astounding thing about it. That's why I mean that one can continue to make sculptures: [it's something] finding its authentic form all from within itself. This is possibly the only answer to all the objections there are. What do you think?

Johannes Gachnang: It's true that there are many arguments teamed up against painting and sculpture at the moment, but I don't think that [these are reasons] to forget about those things. I'd like to remind artists that from an economic point of view painting and sculpturing are still the most cost efficient ways to produce art today and articulate aesthetic arguments. Just think of videos: the tapes of Michael Jackson and those people being much more efficient than anything an artist can do, all the people in the arts have to rewind and that's devouring millions. But if you take what you find in front of you and put it together, it may possibly result in a sculpture or a painting, and that's why all these traditional things may demonstrate what artists always tried to keep going. So here we are, faced with the problem: how to transport those things into the twenty-first century.

Franz West: There is another significant aspect of why one might make sculptures that just occurred to me, and that's the [process of their] making. You don't need any industry, you can find the material anywhere. With other things you always become directly dependent on some private or public institution, whereas sculpture and painting do guarantee a certain form of autonomy. You

Für mich war an diesem Stück interessant, daß es ein Ready-made war. Ready-mades heute entsprechen nicht mehr den Ready-mades, die beispielsweise Duchamp gemacht hat, denn der hat mehr oder weniger einen fertigen Gegenstand genommen. Das heutige Ready-made ist sozusagen der Künstler selbst, [der Kunstgedanke]. [Der Künstler ist] dann überhaupt nur mehr eine Durchgangsstation oder so [etwas] wie ein Relais, wie eine Übersetzung. Etwas wird gesprochen und materialisiert sich, und man sitzt irgendwo dazwischen und muß beim Dazwischensitzen mit einem Gedanken fertig werden. Und die eigentliche Schwierigkeit ist, den Gedanken zu finden, mit dem man fertig zu werden hätte – und das ist eben das Ready-made, wie's heute aussieht. Das klingt vielleicht etwas wirr, ist aber nicht wirr, sondern folgt nur jenem Weg, wie sich Gedanken bilden. Das wäre sozusagen: ein Ready-made-heute-machen! Und die Materialisierung des Gedankens sieht dann so aus, daß eine Sitzgelegenheit geschaffen wird in einem – ich möchte gar nicht sagen in einem Raum, weil ich verwirrt bin von den verschiedenen Raumbegriffen ...

Mich interessieren die Proportionen und die Befindlichkeit der Proportion, aber dann ist auch wiederum die Skulptur da. Ich finde das interessant, [denn] im allgemeinen wäre ja heute das Skulpturenmachen etwas stark Kritizibles. Das weiß ich natürlich, aber das ist die ganze Existenz, die man führt, sowieso auch. Das Interessante daran ist nur die Frage, wie das jetzt aussähe, wenn man ganz einfach [Skulpturen] machte.

Es gäbe da zwar auch das Kriterium der Qualität, aber momentan gilt das kaum noch. Andererseits setzt sich [das Skulpturenmachen] aber wirklich von selbst zusammen und das ist das Verblüffende dran. Darum meine ich, daß man weiterhin Skulpturen produzieren kann, weil es [etwas ist, das] sich authentisch aus sich heraus bildet. Das ist vielleicht die einzige Erwiderung auf alle Argumente, die dagegen sprechen. Wie sehen Sie das?

Johannes Gachnang: Ja, es spielen zur Zeit sehr viel Argumente gegen die Malerei wie auch gegen die Skulptur, aber ich habe nicht das Gefühl, daß man diese Dinge [deswegen] vergessen sollte. Ich möchte auch die Künstler daran erinnern, daß das immer noch die beiden kostengünstigsten Angebote sind, wie man heute Kunst produzieren und künstlerische Argumente artikulieren kann. Denken Sie nur einmal an das Video: Jetzt müssen die ganzen Künstler umspulen, denn die Videos von Michael Jackson und diesen Leuten sind selbstverständlich viel effizienter als jeder Künstler sein kann, und das kostet natürlich Millionen. Aber wenn Sie das nehmen, was Sie vor sich finden und es zusammenstellen,

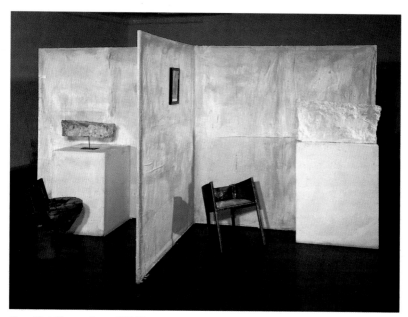

Franz West, Wegener Raum, 1988/89

don't even have to have a film developed or need an equipment to do that – you can just leave the house, look around you and you'll have found the material you need to start with a sculpture if that's what you want. I consider this quite an interesting aspect.

Though autonomy has been totally discredited, sculpturing does grant you some kind of autonomy. And even if that may already touch the realm of sociology: sculpture is actually something allowing you to exclude yourself from competition. That is not so much from competition but from production, from its traditional and institutionalized ways.

Or you are outside anyway and do it in order to do something. That's another possibility, another way of looking at it. Which is also very nice.

Johannes Gachnang: Also very nice. Doesn't that recall Kurt Schwitters who discovered these things for us and was the last to put them together? Maybe we are not able to do this anymore, to bring everything together, to put everything together, but we can create fragments that might have some importance enabling us to continue discussing things into the next millenium. I find it significant for example that a painting exhibition will soon be shown here in Vienna[7] which has been put together with profundity by Kasper König and Hans-Ulrich

dann ergibt das möglicherweise eine Skulptur oder ein Stück Malerei, und in diesem Sinne haben natürlich diese alten traditionellen Dinge immer wieder die Möglichkeit, das vorzuführen, was eben immer von Künstlern weitergeführt wurde. Nur jetzt haben wir das Problem: Wie transportieren wir diese Dinge ins 21. Jahrhundert?

Franz West: Dazu fällt mir etwas ein, was auch ein wichtiger Punkt ist, warum man Skulpturen machen könnte: nämlich die [Art ihrer] Herstellung. Man braucht keine Industrie dazu, man findet das Material überall. Bei anderen Sachen gerät man immer in direkte Abhängigkeit, sei's von privaten oder öffentlichen Institutionen, während das Skulpturenmachen oder Bildermalen in einer gewissen Beziehung eine Form von Autonomie gewährt. Man braucht nicht einmal mehr einen Film entwickeln lassen oder einen Apparat dazu, sondern man könnte einfach aus dem Haus rausgehen, eine halbe Stunde sehr intensiv herumschauen und dann das Material für den Beginn einer Skulptur haben – wenn man wollte. Und das, finde ich, ist ein ganz interessanter Aspekt dabei. Wenn Autonomie schon so und so außer Rede gestellt wird, hat man bei der Skulptur [trotzdem] eine Form von Autonomie. Darum ist sie eigentlich schon etwas – und das ist jetzt vielleicht ein zum Soziologischen hinreichender Aspekt –, mit dem man sich aus dem Bewerb ausschließen kann. Also [eigentlich] nicht aus dem Bewerb, sondern aus der Produktionsweise, aus der üblichen institutionalisierten Produktionsweise.

Oder man steht überhaupt außerhalb und macht eben das, um überhaupt was zu machen. Das geht auch. Das ist die andere Sicht. Die ist auch sehr hübsch.

Johannes Gachnang: Das ist auch sehr hübsch. Das ist vielleicht auch die Erinnerung an Kurt Schwitters, der diese Dinge für uns gefunden und auch zum letzten Mal zusammengesetzt hat. Vielleicht können wir nicht mehr alles zusammenbringen, alles zusammensetzen, aber wir können doch Fragmente schaffen, die möglicherweise eine Wichtigkeit haben, mit der wir über das Jahrtausend hinweg diskutieren können. Ich denke, daß es z. B. ein sehr signifikantes Moment ist, daß gerade jetzt in Wien eine Malereiausstellung[7] stattfinden wird und daß zwei Leute wie Kasper König und Hans-Ulrich Obrist, die erwiesenermaßen wenig mit Malerei zu tun haben, diese hier profund vorstellen. Ich habe eigentlich den Namen West vermißt, weil er doch zwar als Bildhauer...

Franz West: Na, na, ich mal´ nix!

Johannes Gachnang: Aber Ihre Skulpturen haben eine hohe malerische Qualität.

Franz West: Naja gut – wenn man so sagen will oder gesagt hat, in einer gewis-

Obrist who – as has been proved beyond doubt – have little to do with painting. I missed the name West ... though a sculptor he –

Franz West: I don't paint.

Johannes Gachnang: But there's a lot of painting in your sculptures.

Franz West: Maybe – if that's what they say or have said. During a certain period of my sculpture-making I actually found paintings more interesting than sculptures ... that is sculpture as painting –

Johannes Gachnang: »What at least, it may be demanded, did the soprano sing.«[8] Samuel Beckett.

Franz West: There's a good joke for an answer: If you read something, I'll read something, too. An old trick, but why must a trick be new? Well then [begins to read from the MAK press release]: ›Lebbeus Woods is primarily regarded as a theoretician and philosopher who considers design as working hypotheses ...‹

Johannes Gachnang: There you are, that's searching for meaning ... and what about the validity in regard to meaning, what does it mean?

Franz West: No, really – so far so good, but if we have to act in front of the audience and with regard to it, there's a certain point when one should try to withdraw to the mere basis of thought, that is to disengage ...

Johannes Gachnang: We won't reveal a thing. If this was a television program we'd have gotten paid and our only responsibility would be to entertain.

Franz West: I think that's interesting though, I think that one should try to do away with the commercial aspect of art that was so important in the eighties. At the moment it has done away with itself, has done itself in ...

Johannes Gachnang: You believe that the age of Hollywood has been overcome?

Franz West: No, it out-competed itself. But you have to pretend it's still lasting and continue to negate it, that is preferably not talk about it anymore!

Johannes Gachnang: Am I right to presume you think we will be able to talk about art again soon, about sculpture and painting?

Franz West: Well, maybe.

Johannes Gachnang: I'd be delighted. Yes, I would.

Franz West: The point is whether it does make sense at the moment or whether it might be more reasonable to concentrate on the mere facts of marketing – which is the essential dividing line. On the one hand the artist is seen as working within the frame of his circumstances – and some people think that refers to a whole city, and with the artist working in a city the things he does would be

sen Phase des Skulpturenmachens haben mich dann Bilder eigentlich mehr interessiert als Skulpturen, also Skulptur als Bild –

Johannes Gachnang: »Was, so mag man zumindest fragen, sang der Sopran?«[8]; Samuel Beckett.

Franz West: Da weiß ich einen guten Schmäh dazu: Wenn Sie was vorlesen, kann ich dann auch willkürlich irgendeinen Satz lesen – als Antwort. Das ist ein alter Schmäh, aber warum immer neue Schmähs – also: [liest aus dem Pressetext] »Lebbeus Woods gilt in erster Linie als Theoretiker und Philosoph, der den Entwurf als Denkmodell versteht ...«

Johannes Gachnang: Na sehen Sie, das wäre also die Jagd nach der Bedeutung ... und die Gültigkeit gegenüber der Bedeutung, was bedeutet sie?

Franz West: Nein, also – so weit, so gut, aber wenn wir uns jetzt schon vor dem Publikum, zu einem Publikum verhalten sollen, muß man ja doch an irgendeinem Punkt versuchen, sich bloß auf die Grundlagen des Gedankens zurückzuziehen, d. h. zurückzustellen...

Johannes Gachnang: Wir geben nichts preis. Wenn wir vom Fernsehen angestellt wären, dann hätten wir eine Gage gekriegt und dann ginge es nur um den Unterhaltungswert.

Franz West: Aber gerade das interessiert mich schon, denn ich finde, daß man den kommerziellen Teil der Kunst, der in den achtziger Jahren so in den Vordergrund getreten ist, verdrängen möge. Momentan hat er sich ja eh von selbst verdrängt, sich selbst weggedrängt...

Johannes Gachnang: So, Sie meinen die Zeit von Hollywood ist überwunden?

Franz West: Nein, die hat sich selbst verdrängt. Aber man muß das konsequent weiterverdrängen, so als ob es noch präsent wär, also am besten nicht mehr darüber sprechen!

Johannes Gachnang: Also wenn ich Sie jetzt richtig verstehe, kann man bald wieder über Kunst sprechen, über Skulpturen und Malerei.

Franz West: Na ja, das könnte sein.

Johannes Gachnang: Also das würde mich freuen!

Franz West: Ob das jetzt einen Sinn hat oder ob man nur die kalten Tatsachen des Marketings betrachten soll – das ist nämlich die prinzipielle Trennlinie. Einerseits wird gesagt, der Künstler produziert im Rahmen seiner Gegebenheiten – und manche Leute meinen, die bezögen sich dann auf eine ganze Stadt – und er arbeitet in einer Stadt und das wäre dann repräsentativ für diese Stadt, oder man versucht, es als repräsentativ zu nehmen. Die Probleme, die daraus entstehen,

representative for this city, or at least people try to accept it as representative. This results in some tough difficulties, but you do gain an artist's life, and this is the only remarkable thing about it.

Evaluating an artist from the outside was considered harmful for artists in the past, as it was supposed to lift them off the hinges of what they were doing. But that's past as today everything's become so weird again that it's become good if you are a better known artist: it makes you set out to look for another field...

Johannes Gachnang: It forces them to improve their performance!

Franz West: ... In order to find an adequate environment, [regardless of] what you fill it with, [regardless of] whether you put in a sculpture or a chair. That's another way of talking about positions. And I'm not talking about spaces, I'm talking about planes – because what stands upright is the plane – and I'm talking about horizontal planes. Usually artists are considered as caught in the vertical, but I'm talking about the horizontal here, the horizontal and nothing else. And there's a reason for that: What's the use of a free plane if it's upright? Vertical freedom doesn't do you any good! Keep to the vertical and you'll never get horizontal freedom! But that's just concepts, concepts of art: sculpture, our proportions, our presence …

Johannes Gachnang: That's Giacometti!

Franz West: … something to sit on or stand on! That's gravity!

Johannes Gachnang: Well, that's a Swiss chair we are sitting on right now. If I'm not mistaken this chair was invented for the Schweizerische Landesausstellung of 1939. Please notice how modern it is. Even older things can continue to be modern! And we stick with them…

Franz West: Well, that's the problem with the modern … Take our immediate surroundings for example: on the one hand you got buildings from the fifties and sixties like the station in Landstraße, on the other there are buildings like this [museum] which are lovingly tended to. The discrepancy between these two neighbouring spaces reminds me of this chair here because the rooms are nicer here, higher and cooler, [though] the station over there's also got a hall that is quite large and cool.

That's an aspect I'm interested in: Here and anywhere else a person lives in a space, that is in rooms for which you got [the most divergent] possibilities. Dealing with these things is trivial, but this is what I really do! I seriously try [to see] rooms as horizontal planes, since walls don't matter to me because

46

sind zwar wirklich hart, aber andererseits gewinnt man dadurch wiederum ein Künstlerleben, und das ist das einzig Bemerkenswerte daran.

Früher wurde gesagt, es wäre sehr schlecht für Künstler, wenn sie von außen betrachtet werden, weil sie das aus den Angeln ihrer bisherigen Arbeit hebt. Aber jetzt kann man sagen, daß das wirklich eine alte Mode ist, denn heute ist alles schon wieder so überdreht, daß es schon wieder gut ist, wenn man als Künstler bekannter ist, weil einen das dann wieder ein anderes Feld suchen lassen muß...

Johannes Gachnang: Also Sie werden zu höheren Leistungen gezwungen!

Franz West, Eo Ipso, 1987

Franz West: ...um ein Umfeld zu finden, [unabhängig davon], was man da reinstellt, sei das eine Skulptur oder ein Sessel. So kann man das auch sagen, wenn's um Positionen geht. Ich spreche nicht vom Raum, sondern von der Fläche, denn das, was steht, das ist die Fläche – also ich spreche von der Horizontalen. Üblicherweise wird gesagt, Künstler befänden sich in der Vertikalen, aber ich spreche vom rein Horizontalen. Weil: was haben Sie von einer freien Fläche, wenn sie vertikal steht? Dann nützt Ihnen die vertikale Freiheit einen Schmarrn! Sind Sie aber in der Vertikalen, ist die Freiheit horizontal! Aber das ist so ein Kunstbegriff: Skulptur, unsere Proportionen, unsere Präsenz...

Johannes Gachnang: Ja, das ist Giacometti!

Franz West: ... auf dem man sitzt oder steht! Das ist die Schwerkraft!

Johannes Gachnang: Also wir sitzen jetzt auf einem Schweizer Stuhl. Wenn ich mich recht erinnere, wurde der für die Schweizerische Landesausstellung 1939 erfunden – Sie sehen, wie modern der ist. Das heißt, auch diese Dinge, die länger zurückliegen, können weiterhin modern bleiben. Und wir bleiben ja dran.

Franz West: Na ja, das ist ja das Problem mit dem Modernen ... Wenn Sie zum Beispiel gleich hier in der Nähe die Gebäude nehmen, [dann gibt es einerseits die], die in den fünfziger und sechziger Jahre gebaut wurden wie der Bahnhof in der Landstraße, und andererseits Gebäude wie das hier [das Museum], die liebevoll gepflegt werden. Die Diskrepanz dieser beiden nebeneinander liegenden Dinge läßt mich zurückdenken an den Sessel, weil die Räume hier angenehmer, höher und kühler sind, [obwohl es] drüben im Bahnhof Landstraße auch eine Halle gibt, die ganz schön groß und kühl ist.

Das ist ein Punkt, der mich interessiert: Als Person lebt man hier oder sonstwo

they're vertical – and so I try to find a plane, to create a plane, a bearable plane. And that's not easy at all! It's a different definition for art, similar to the art of the ready-made and such things – it's the art of evocation. And that's what I mean when talking about planes: the non-vertical, being able to evoke the horizontal. No doubt, the vertical changes the fastest, the greater the vertical inclination the faster it skids away.

Johannes Gachnang: Let's keep to the horizontal then, let's remain at the horizon!

Franz West: Let's keep to the gliding plane!

Johannes Gachnang: I once prepared an exhibition I called *The Curved Horizon*[9]. I really liked the title because it contains all deviations: things we perceive as horizontal are curved actually.

Franz West: This is the moment I'd like to try another of my skills. It occurred to me that we could ask someone from the audience whether he'd object if we did something with him, no matter what: touch him, make him change seats … This would be such an impudent infringement! May I kindly ask you to support our suggestion or to reject it by bending the subject so to speak?

Johannes Gachnang: Around the curve?

Franz West: No, around the corner, naturally!

Johannes Gachnang: Forgive me, around the corner then.

Franz West: Would you please … the one with the light-blue shirt, please … the one sitting, please …

Johannes Gachnang: You there! Get up and come here!

Franz West: Not you, not you! The gentleman over there – would you please … please! [The man asked to come to the front seems to be an American.] Oh, ohhh – sorry, sorry … well, let's forget about it –

Johannes Gachnang: Forget about it? Should we still go on with our conversation?

Franz West: Well, let's carry on a bit!

I am not a professional talker, but I quite enjoy this –

Johannes Gachnang: May I just express my opinion that we wouldn't pass for good Americans!

Franz West: Please don't start to be patronizing! You sound almost ›animosistic‹. My lecture ought to be, should be sucking you in. I am interested in attraction, whereas the American way essentially is penetrating, didactic, is to pass things on. I want to take you in. That's two different approaches [to communi-

in Räumen, d. h. Zimmern, und da gibts dann die [verschiedensten] Möglichkeiten. Sich mit dem zu befassen, ist das Triviale, aber das tue ich wirklich! Ich versuche wirklich, einen Raum als eine horizontale Fläche [zu sehen], denn die Wände sind mir egal, weil die vertikal sind, ich versuche also, eine Fläche zu finden, eine Fläche zu kreieren – eine erträgliche Fläche. Und das ist wirklich schwer! Das ist eine andere Definition von Kunst, ähnlich der Kunst der Readymades oder dieserlei Dinge – das ist die Kunst des Evozieren-Könnens. Und das meine ich mit Fläche: das Nicht-Vertikale, das Evozieren-Können der Horizontalen. Natürlich wandelt sich das Vertikale am raschesten, je vertikaler, desto rascher rutscht es weg.

Johannes Gachnang: Dann bleiben wir eben in der Horizontalen, am Horizont!

Franz West: In der Gleitenden!

Johannes Gachnang: *Der gekrümmte Horizont*[9] nannte ich mal eine Ausstellung. Das fand ich sehr schön, weil da alle Abweichungen schon drin sind: Was wir horizontal sehen, ist wissentlicherweise eigentlich gekrümmt.

Franz West: An dieser Stelle möchte ich einen anderen Teil von meinen Künsten ausprobieren: Ich hab mir gedacht, vielleicht könnten wir den einen oder anderen Besucher fragen, mit dem man irgend etwas machen könnte, egal was: berühren, oder hin und her oder setzen ... Das wär jetzt dieser Übergriff ins Unverschämte! Bitte, darf ich Sie ersuchen, uns ʃetzt eventuell in dem Sinne zu bestärken oder zu schwächen, als Sie die Thematik jetzt sozusagen umbiegen?

Johannes Gachnang: So um die Kurve ?

Franz West: Nein, nein – um die Ecke!

Johannes Gachnang: Um die Ecke, Entschuldigung.

Franz West: Könnten Sie das bitte – Sie mit dem hellblauen Hemd, bitte? Bitte – Sie dort, sitzend!

Johannes Gachnang: Stehen Sie mal auf! Kommen Sie mal raus!

Franz West: Nicht du, nicht du! Der Herr da – Könnten Sie uns... Bitte! [der Gefragte ist anscheinend Amerikaner] Oh, ohhh – sorry, sorry – na gut, dann laß ma's-

Johannes Gachnang: Laß ma's? Sollen wir überhaupt noch weitermachen?

Franz West: Na, ja – ein bißchen!

Ich zumindest bin kein Redeprofi, aber das mach ich schon ganz gern –

Johannes Gachnang: Darf ich nur sagen: Wir wären keine guten Amerikaner!

Franz West: Nein, werden Sie nicht belehrend! Das klingt schon fast »animosistisch«. Mein Vortrag sollte, müßte »ansaugend« sein. Mich interessiert das

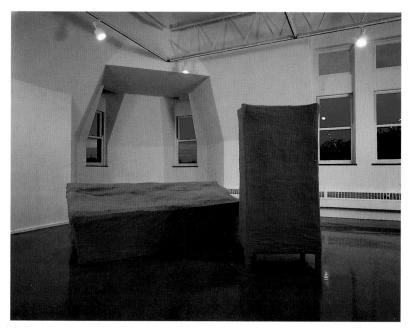

Franz West, Aberration, 1990

cation], and I guess it's no problem at all [that both] are used simultaneously in this unfamiliar way without appearing bizarre. This is a philosophical question, but that doesn't matter, as it isn't the point. The position of the artist compared with the philosopher's position seems to have changed in the American understanding of art, whereas here we have this free field that comes into being whenever there's a real possibility for use and revelation – here it's planes and verticals that matter. That's really the point. We occupy different positions. My predecessor [James Turrell] didn't behave quite the way I do, and we are curious now how the next couple will behave.

Johannes Gachnang: Twenty-five minutes to go!

Franz West: I'm also accustomed to giving lectures. And this is perhaps what we should have done. *The American professors, they give always lectures, yes. The interaction-activity!*

Here [in Vienna], *as a teacher – you don't have to give lectures, you have to build the presence of your name and your label. This* [explanation] *is just for Americans, because they don't understand me. This here is not a lecture, it's no lecture! So you don't need to hear – it's to see!*

50

Saugende, während das Amerikanische mehr oder minder das Eindringende, das Belehrende, die Weitergabe ist. Mich interessiert das Hereinnehmen. Das sind eben zwei verschiedene Arten [der Vermittlung], und ich finde, es stört überhaupt nicht, [daß sie] so ungewohnt nebeneinander stehen, ohne daß man was merkwürdig daran findet. Das ist eine philosophische Frage, aber das ist ja gleichgültig, weil um das geht's eben nicht. Die Position des Künstlers im Unterschied zum Philosophen dürfte sich in der amerikanischen Kunstauffassung verändert haben, während das hier eher so ist: Bei diesem freien Feld, das bei einer tatsächlichen Benütz- und Aushebbarkeit entsteht, da gehts wirklich um Fläche und Vertikale.

Das trifft's ja wirklich: Wir stehen in differenten Positionen. Der Herr Vorgänger [James Turrell] war etwas anders als ich und jetzt sind wir gespannt, welches Gesprächspaar als nächstes wie sein wird.

Johannes Gachnang: Wir haben noch 25 Minuten!

Franz West: Auch ich bin es gewohnt, *lectures* zu geben und das ist vielleicht das, worauf wir hinauswollten. The American professors, they give always lectures, yes. The interaction-activity!

Here [in Vienna], as a teacher – you don't have to give lectures, you have to build the presence of your name and your label. This [explanation] is just for Americans, because they don't understand me. This here is not a lecture, it's no lecture! So you don't need to hear – it's to see!

Johannes Gachnang: Soll ich auch was auf englisch sagen? Ja, das von Fassbinder – sein Lieblingsspruch! Life is so beautiful – even right now!

Ladies and gentlemen! It was a nice evening. I hope to see you again!

Franz West: Das war nur eine schauspielerische Leistung des Herrn. [Der Vortrag] hört ja noch nicht auf!

Wir machen eine Publikumsbefragung. Wollen Sie, daß wir noch eine Zeit hier sitzen bleiben und versuchen, Sie zu unterhalten? Was meinen Sie? Sagen wir, im Falle eines kleinen Applauses werden wir versuchen, das Programm fortzuführen.

Johannes Gachnang: Das ist ja wie im russischen Parlament!

Franz West: Sie haben vorhin über Videos gesprochen. Ich habe ja auch einmal eine Zeitlang Videos gemacht, und die waren so wie das Schild mit meinem Namen hier, die sind zur Gänze unter den Tisch gefallen ...

Johannes Gachnang: Es gibt ein Video, das Sie über Ihren Bruder[10] gemacht haben.

Johannes Gachnang: Shall I say something in English, too? What about Fassbinder's favourite phrase? – *Life is so beautiful – even right now!*
Ladies and gentleman! It was a nice evening. I hope to see you again!

Franz West: That was just a little performance by this gentleman! We haven't come to an end yet!

We'll make an audience survey. Do you want us to stay a bit longer and try to entertain you? What do you think? Let's see … in case we get a little applause we will try to continue with the program.

Johannes Gachnang: Where are we here? Is this the Russian parliament?

Franz West: Didn't you mention videos before? I also made some for a while: they were very much like this tag here with my name on it, they just dropped out of sight …

Johannes Gachnang: There is a video you did about your brother[10].

Franz West: I don't want to talk about my brother!

But these videos are another example for for how things function in the arts. The dilemma is: on the one hand you got a lot of weaknesses, on the other hand there is function. That's the position I occupy: one talks about bad videos [for example] and reality just takes its own independent course.

Johannes Gachnang: But aren't you trying to put yourself to the test?

Franz West: No, I don't, never! [All I want is to] develop and unfold the very vision of my days at school – that is idleness, the position of idleness, otium. I once had an exhibition together with Pistoletto, called »Otium«[11]. And that's the only thing I remember from my Latin classes at school: *Mihi otium est!* Which means: ›Mine is the idleness!‹ Whose is it actually?

Johannes Gachnang: That's a Catholic turn! With me it was *Non sine linea!* No day without line!

Franz West: This is quite exhausting if you just take it literally … if you just want to have peace and quiet, want less tension, don't [want to achieve] first-class performances all the time, trapeze acts without a net …

This gentleman's remark about my brother who was one of the members of the Vienna First Working Group Motion makes me think of something: These guys took their seats on a stage for example and started reading newspapers – that was the play. Not bad for emergencies … So if the two of us aren't into anything special right now, there's no need to get bored – just consider it as a performance of that kind! It's just two people doing something. You feel silly, we feel silly! The point is it shouldn't get too trivial psychologically.

Franz West: Über meinen Bruder möchte ich nicht sprechen!

Aber das mit den Videos ist wieder ein Beispiel dafür, wie das mit den Künsten funktioniert. Man hat das Problem, daß es da [einerseits] viele Angriffspunkte gibt, und andererseits ist dann wieder die Funktion da. Das ist die Position, die ich inne hab: Man spricht [zum Beispiel] über schlechte Videos und da wird die Wirklichkeit dann selbsttätig.

Johannes Gachnang: Aber man sagt, Sie wollten auch versuchen, sich selbst zu prüfen!

Franz West: Nein, überhaupt nicht! [Es geht mir um] die Ausarbeitung und die Ausbreitung dessen, was mir auch in der Schulzeit schon vorgeschwebt ist, nämlich des Müßiggangs, die Position des Müßiggangs, das otium . Ich habe mit Pistoletto einmal eine Ausstellung gehabt zum Wort »Otium«[11], und das ist auch das einzige, was ich mir aus der Schulzeit in Latein gemerkt habe: *Mihi otium est!*, das heißt: Mir ist Muße! Wem ist Muße eigentlich?

Johannes Gachnang: Das ist katholisch! Bei mir war das *Non sine linea* – Kein Tag ohne Linie!

Franz West: Das ist dermaßen strapaziös! Wenn man jetzt nur dem gemeinen Sinn nachgeht, daß man Ruhe haben will, daß man nicht so angespannt sein will, nicht immer Hochleistungen oder Trapezakte ohne Netz [vollbringen will] ...

Weil der Herr eben über meinen Bruder gesprochen hat, der bei der Vienna First Working Group Motion[10] mitgearbeitet hat, fällt mir etwas ein: Die sind z. B. auf einer Bühne gesessen und haben dann als Theaterstück Zeitung gelesen und das ist schon ganz gut für Notfälle. Wenn wir jetzt also nichts Besonderes machen, braucht [dem Publikum] nicht fad zu sein, sondern dann betrachten Sie das als eine Vorführung in diesem Sinne! Da sitzen ein paar Leute und machen irgendwas. Sie schaun blöd – wir schaun blöd! Es soll halt nicht zu vulgärpsychologisch sein.

Johannes Gachnang: Aber wo wollen wir eigentlich hin? Das mit dem Sitzen und dem Müßiggang gefällt mir sehr gut!

Franz West: Na, weil Sie doch das zitiert haben. Jetzt haben wir's eigentlich eh relativ leger. Aber was haben Sie vorher gelesen, wen zitierten Sie denn da?

Johannes Gachnang: Den Beckett.

Franz West: Ah so, Beckett eben. Was sagen Sie zur Aktualität Becketts? Ich meine, geben Sie Ihre Position bekannt! Man kann ja auch theoretisieren!

Johannes Gachnang: Da gibt's ja den schönsten Satz für Künstler: »Sie kleideten mich und gaben mir Geld. Ich wußte, wozu das Geld dienen sollte, es sollte dazu

Johannes Gachnang: But what are we up to? I liked the part about sitting and being idle.

Franz West: You were the one quoting things! It's quite easygoing for us now. May I ask you what you read earlier on, whom were you quoting?

Johannes Gachnang: Beckett.

Franz West: Beckett. I see. What do you think about his relevance to the present situation? I mean, declare your position! What about a theoretical turn?

Johannes Gachnang: There's the most beautiful passage for artists: »They clothed me and gave me money. I knew what the money was for, it was to get me started. When it was gone I would have to get more, if I wanted to go on.«[12] Amazing, isn't it?

Franz West: Did you understand this?

Johannes Gachnang: Well then, what's the line in »The Magnificent Seven« ...

Franz West: Oh, not that too! He's really not bad!

Johannes Gachnang: A joke. Jump bareassed into a cactus! That's from the vertical into the horizontal!

Franz West: Herr Gachnang!

Johannes Gachnang: Yessir. – How did Lawrence Weiner put it? – Vienna – the Wild West of East of Eden! Thank you very much!

Franz West: Was this your imitation of a TV announcer? This evening's program has come to an end. Thank you very much. But there's the night ahead! Evening turns into night, the night is still to come. Blackness. We don't see anything anymore, just the others, nothing else. How do you put it? Dusk is falling.

Johannes Gachnang: Blitzeshelle – in Mitteln gestaltloser Nacht. Paul Hindemith.[13]

Franz West: Now he's dishing up Hindemith!

Johannes Gachnang: Schönberg's still to come.

Franz West: It's not that bad, but you're coming with suspicious attributes – trivialities.

Johannes Gachnang: Absolutely!

Franz West: Hindemith! I am not trying to say that Hindemith was bad. Not at all. I am not the one to judge, but what you generally hear about him there's certainly worse – but why here and now!

Bringing up Hindemith now ... please. I would like to ask someone from the public – I see my galerist Peter Pakesch – let's give him some applause!

dienen, mir auf die Beine zu helfen. Sobald ich es ausgegeben hätte – müßte ich mir neues beschaffen, wenn ich weitermachen wollte.«[12] Das ist doch der schönste Spruch, nicht?

Franz West: Haben Sie das verstanden?

Johannes Gachnang: Also – wie hieß das in den »Glorreichen Sieben«?

Franz West: Oh je, das auch noch! Er is nicht schlecht!

Johannes Gachnang: Ein Kalauer: Spring nackten Arsches in den Kaktus! – Das ist von der Vertikalen in die Horizontale!

Franz West: Herr Gachnang!

Johannes Gachnang: Bitteschön. – Oder wie sagte Lawrence Weiner? Vienna – the Wild-West of East of Eden! Thank you very much!

Franz West: Das »Thank you very much« war aber auch nur die Imitation eines Fernsehansagers, nicht? Das Abendprogramm ist beendet. Danke vielmals. Aber es gibt ja noch die Nacht! Es bleibt ja nicht bloß ein Abend, es beginnt ja noch die Nacht. Schwärze. Wir sehen nichts mehr, gerade noch die anderen, sonst kaum noch was. Also wie sagt man da? Es ist der Beginn der Nacht.

Johannes Gachnang: Blitzeshelle – in Mitteln gestaltloser Nacht; Paul Hindemith [13].

Franz West: Jetzt kommt er uns mit dem Hindemith daher!

Johannes Gachnang: Ich habe aber den Schönberg auch noch.

Franz West: Er is ja nicht schlecht, aber Sie kommen mit verdächtigen Attributen daher – mit Nebensätzlichkeiten.

Johannes Gachnang: Absolut!

Franz West: Hindemith! Ich möchte nicht sagen, daß Hindemith schlecht wäre, keineswegs. Ich kann das nicht beurteilen, aber was man so von ihm hört, ist Hindemith nicht das Schlimmste, aber doch nicht hier und heute!

Jetzt kommen Sie uns mit Ihrem Hindemith daher. Bitte, hat eine der anwesenden Personen – ich sehe da meinen Galeristen Peter Pakesch – einen kleinen Applaus! – kannst Du bitte – Du hast sicher eine Idee über Hindemith, eine Position zu Hindemith, die du kurz beschreiben könntest? Du bist ja sehr musikverständig.

Zu Hindemith nicht! Es ist schwierig, denn man muß ja nicht irgendeinen Künstler beleidigen, dessen Arbeit vielleicht gar nicht schlecht ist. Hindemith in Wien, das ist wie mit Brahms –

Johannes Gachnang: Wie Brahms und Bruckner!

Franz West: Nein, es geht nur um Hindemith, der ist interessant, aber hauptsäch-

Would you please ... You certainly have an idea concerning Hindemith, a position you could outline in a few words. You do know a lot about music. – What? Not about Hindemith! It's not that easy because one does not want to insult an artist whose work isn't perhaps that bad. Hindemith in Vienna, that's just like Brahms –

Johannes Gachnang: Like Brahms and Bruckner!

Franz West: No, we are talking about Hindemith and nobody else but him, he is an interesting composer, though mainly for old hags. An old man writing music for old women.

Johannes Gachnang: I thought that was Gustav Mahler ...

Franz West: That's the way things are in Vienna. It happened to me too: getting old and making paintings and sculptures for old hags.

Franz West, Paßstück, 1990

Johannes Gachnang: Can you pull that off?

Franz West: That's where my work comes from and it's something very Viennese. Certain things are just dominant. The families here obey the principle of patriarchy, but at a certain age things turn around and it's old hags that take control, that become the source of life. And that's why one might say that it's neither patriarchy nor matriarchy but – as the saying goes – a »regime of old hags« you got to adapt yourself to.

Johannes Gachnang: ›The Old Lady Vienna‹, is that it? I once used this term in a press release. You know what happened? The Austrian Embassador to Switzerland made me come by [to explain to him] what the phrase was supposed to mean. This ended in a wonderful evening.

Franz West: One has to be provocative from time to time, otherwise people get bored.

Johannes Gachnang: And use a few little dirty tricks!

Franz West: Yes, indeed, because the audience gets easily bored. You are no exception and certainly prefer listening to something gripping than to some rather boring stuff. It's the same with me: I also prefer reasonably interesting things. Yesterday at the opening [of the MAK] there were some interesting speeches. Oh, the art of rhetoric – that might be something worth studying. I

Franz West, Hummel, 1983

lich für alte Weiber. Der hat als alter Mann für alte Weiber geschrieben.

Johannes Gachnang: Ich dachte, das sei Mahler?

Franz West: Das ist so in Wien, das habe ich auch gemacht: als alter Mann für alte Weiber malen oder Skulpturen machen.

Johannes Gachnang: Kriegen Sie das hin?

Franz West: Von da kommt doch meine Arbeit und das ist sehr wienerisch! Da gibts eben Dominanzen. Die Familien funktionieren nach dem Prinzip des Patriarchats, aber in einem gewissen Alter schnappt das um und dann ist das Bestimmende das alte Weib – das alte Weib, das einem das Leben gibt. Und daher könnte man sagen, es ist weder Patriarchat noch Matriarchat, sondern – das ist eine alte Redensart – eine Altweiberwirtschaft, der man sich anzupassen hat.

Johannes Gachnang: Also »die Alte Dame Wien«! Ich habe das mal in einem Pressekommuniqué geschrieben. Daraufhin wurde ich vom österreichischen Botschafter in der Schweiz herzitiert, [um zu erläutern] was das bedeuten soll. Das ergab dann einen wunderbaren Abend.

Franz West: Man muß ab und zu was Provokatives sagen, sonst fadisieren sich ja die Leute!

Johannes Gachnang: Eine kleine Schweinerei!

Franz West: Ja, sonst fadisiert sich das Publikum. Sie wollen ja auch lieber was Fesselndes hören als was ganz Fades. Mir geht's ja auch so: Wenn ich dasitz, hör ich auch lieber was halbwegs Interessantes. Gestern bei der Eröffnung [des MAK] waren interessante Reden. Ja, das ist die Kunst der Rhetorik und die könnte man vielleicht studieren. Ich habe mir da so ein kleines Reclam-Büchl gekauft, in dem es um Rhetorik geht, von den Griechen bis jetzt, in beschreibenden Kapiteln. Nur war ich dann zu faul, um mir irgendwas davon zu merken, weil ich es für überflüssig gehalten hab, und jetzt stehen wir da ohne Rhetorik. Wir sitzen da und wissen nicht, wie wir das Gerüst langsam, Leiter um Leiter umkippen, um Sie und uns zu einem Ausgang zu führen.

Johannes Gachnang: Die wollen gar nicht gehen! Sie können wirklich rausgehen. Wir kränken uns bestimmt nicht. Lieber wäre es uns schon, wenn Sie noch ein paar Minuten blieben, aber ...

bought one of those booklets published by Reclam dealing with rhetoric, from the Greeks up to the present day, in a series of descriptive chapters. Pity, I was too lazy to keep anything. I just thought it wasn't important. And now we're left with no rhetoric. Now we don't know how to dismantle the scaffolding, ladder by ladder, and find a way out for ourselves and for you.

Johannes Gachnang: But these people don't want to leave! – You may leave, really! You won't hurt our feelings. Of course we'd prefer you to stay for a few more minutes, but ...

Franz West: Maybe we produce another idea! That's the point here, isn't it? Let me think: introducing ourselves to each other, some chitchat in the afternoon ... And it really doesn't matter to you to be forced to spend this beautiful afternoon indoors?

Johannes Gachnang: It does, as a punishment for art!

Franz West: Or don't you even leave your place when the weather is fine?

Johannes Gachnang: Of course I do, I go out and visit the Donauinsel[14]!

Franz West: Good, good. And what do you – culturally speaking – think of the culture offered there? Is it music mainly? They say that this new heavy metal stuff is even quite good sometimes. And what's your position regarding these new forms of music if I may ask?

Johannes Gachnang: I think it's our duty to remain open-minded so that we can stay on the ball.

Franz West: This was an absolute must for some time. When I was younger I went out every night on principle because I couldn't stand it at home. This went on for years. Music in discotheques night after night: I was listening to such a din eight hours a day for five years. I was simply impregnated by that music. Even walking the streets in the afternoons I had to listen to the latest numbers. And then rapidely I turned to classical music, the first classical music I hit on. I thought I could use it to erase the other stuff. And I succeeded! Today I'm almost neutral. Classical music also gets on my nerves a bit somehow. But it was the right treatment for the unnerving disco sound of those days. Today the situation's different, there's much rougher stuff and even some rather good clubs.

Johannes Gachnang: Could you suggest a place where we could meet tonight?

Franz West: There's the »Flex«[14], which is quite loud at least. Wouldn't you also prefer some loud music right now?

Well, an afternoon like this is fine if you want to rest, you'd rather not fall under

Franz West: Vielleicht fällt uns noch irgendeine Idee ein! Um das gehts ja! Also wie immer: sich einander vorstellen und irgendso ein Nachmittagsgeschwätz... Und Ihnen macht es nichts aus, daß Sie an einem so schönen Nachmittag hier drinnen sitzen müssen?

Johannes Gachnang: Doch, zur Strafe für die Kunst!

Franz West: Oder gehen Sie auch sonst bei Schönwetter nicht aus dem Haus?

Johannes Gachnang: Schon, auf die Donauinsel![14]

Franz West: Na gut. Und wie stehen Sie im kulturellen Sinne zum Kulturangebot auf der Donauinsel? Ist es hauptsächlich musikalisch? Diese neuen Heavy Metal-Konzerte sind ja oft sogar angeblich ganz gut . Und wie stehen Sie zu diesen neueren Musikformen, wenn man fragen kann?

Johannes Gachnang: Ich glaube, wir müssen aufgeschlossen bleiben, damit wir dabeibleiben.

Franz West: Ich glaube, das war eine Zeitlang so ein Muß. Ich bin als jüngerer Mensch prinzipiell jeden Abend weggegangen, weil ich es zu Haus nicht ausgehalten hätte, und das jahrelang. Da hat man jeden Abend in Diskotheken Musik gehört: Fünf Jahre lang habe ich mir jeden Tag acht Stunden irgendso ein Getöse angehört. Ich war schlicht von der Musik imprägniert. Schon wenn ich am Nachmittag auf der Straße gegangen bin, mußte ich mir die neuesten Musiknummern anhören. Und da bin ich dann rasch zur Klassik, zur nächstbesten Klassik übergegangen, weil ich mir gedacht habe, mit dem kann ich das vielleicht löschen! Und das ist mir tatsächlich gelungen! Jetzt bin ich fast neutral! Klassik geht mir fast auch ein bißchen auf die Nerven. Aber das war dennoch gut, zur Entnervung von diesem Disco-Sound, den es damals gegeben hat. Heute gibt's ja ganz andere Sachen – heute gibt's viel härtere Sachen, sogar ganz gute Clubs.

Johannes Gachnang: Haben Sie einen Tip, wo wir uns heute abend wieder treffen könnten?

Franz West: Ja, also »Flex«[14] heißt eins, das ist wenigstens laut. Ihnen wär's ja auch angenehmer, wenn jetzt laute Musik gespielt werden würde!

Na gut – so ein Nachmittag ist gut zum Ausruhen, da wird man nicht gern so in den Bann gezogen, da hat man's lieb, wenn man in Ruhe gelassen wird von einem Vortrag. Also eigentlich ist das unfair, daß wir da vor uns hintrinken, als wärs drei Uhr früh. Einerseits ist das vielleicht unschön, aber andererseits sind wir auch scheu. Stellen Sie sich vor, Sie müßten jetzt da sitzen und an die 50 Minuten über das, was Sie machen, reden – das ist ja auch nicht so einfach, wenn man kein Profi ist.

somebody's spell, you'd rather be left in peace and not have to listen to some lecture. It isn't fair really that we are drinking here as if it were three in the morning. That may not be very nice perhaps, but in fact we are quite shy. Just imagine sitting here and talking about what you do for fifty minutes – that's not that simple if you are no professional.

Please stay for a few more minutes! You'll find it even more boring outside. Well, I am very grateful and want to thank those that stayed on - we've almost done it, the fifty minutes are almost over. I don't know whether you found it –

Johannes Gachnang: I'm with you!

Franz West: ... worthwhile, but I think you were a very agreeable audience.

1 The Belgian artist Marcel Broodthaers (1924–1976) is regarded as one of the most important representatives of the European postwar avantgarde. His objects, assemblages, drawings, books and films explore the interaction of visual and verbal elements and the possibilities of introducing language as a material into the visual arts.

2 See: Konrad Bayer, *Der sechste Sinn*, published (posthumously) in 1969.

3 West sees both his *Fitting Pieces* – "wearable" sculptures made of papier-mâché, plaster and wood which are suited for the human body – and his seating objects as negative nude drawings depicting physical outlines that can only be experienced by using them.

4 Hans Scharoun (1893–1972) is considered as one of the most important representatives of German »organic« expressionist architecture. Johannes Gachnang freelanced for Scharoun's office in the early sixties. Scharoun's later central works are the Berlin Philharmonic Hall, the German Embassy in Brasilia and the Staatsbibliothek Preußischer Kulturbesitz in Berlin finished by his partner (1964–1978).

5 Gachnang refers to the exhibitions *Ansicht* ("View") at the Secession in Vienna and Franz West's solo exhibition at the Kunsthalle Bern in 1988.

6 West's installation for the *documenta IX* in 1992 consisted of sixty metal benches covered with old oriental rugs. The difficulties were due to the fact that the benches were assembled to form an open-air cinema in the former schoolyard.

7 This remark refers to the exhibition *Der zerbrochene Spiegel* ("The Broken Mirror") conceived by Kasper König and Hans-Ulrich Obrist which was on show in Vienna from 26 May to 25 July 1993. The exhibition intended to give a survey of contemporary paintings without establishing any hierarchical classifications.

8 Samuel Beckett, Watt, 1953.

9 *Der gekrümmte Horizont – Kunst in Berlin 1945–1967* ("The Curved Horizon – Art in Berlin 1945–1967") was an exhibition organized by Johannes Gachnang for the Akademie der Künste in West Berlin in 1980.

10 West's brother Otto Kobalek.

11 *Otium* ("Leisure"), the exhibition which presented West's work together with that of Michelangelo Pistoletto, was shown at the Sala Boccioni in Milan in 1990.

12 Samuel Beckett, *The End*, 1954.

13 Paul Hindemith (1895–1963), composer and violist, began his career as a concertmaster in Frankfort before he held various professorships, e. g. at the Musikhochschule in Berlin 1927–1937, at Yale University 1940–1953 and in Zurich in the fifties. Hindemith worked at developing a universally binding language based on the "natural premises" of music. His work includes operas, ballets, compositions for choir, music for orchestra and chamber music.

14 The *Donauinsel* is a large recreation area, the *Flex* a rock concert place.

Ein paar Minuterln bleibt's noch ! – Draußen ist noch fader als herinnen. Also ich bin Ihnen sehr dankbar – denen, die da sitzen geblieben sind – denn wir nähern uns den 50 Minuten. Ich weiß nicht, ob es Ihnen ...

Johannes Gachnang: Voll dabei!

Franz West: ... gelohnt hat, aber mir waren Sie ein sehr ein angenehmes Publikum.

1 Die Objekte, Assemblagen, Zeichnungen, Bücher und Filme des belgischen Künstlers Marcel Broodthaers (1924-1976), eines der wichtigsten Vetreter der europäischen Nachkriegsavantgarde, erforschen die Wechselwirkungen von Visuellem und Verbalem und die Einführung des sprachlichen Materials in die visuellen Künste.

2 Aus: Konrad Bayer, Der sechste Sinn, erschienen (posthum) 1969.

3 Sowohl Wests »Paßstücke« – aus Papier-maché, Gips und Holz angefertigte, an den menschlichen Körper angepaßte »tragbare« Skulpturen – als auch seine Sitzobjekte verstehen sich auch als negative Aktabbildungen, d. h. negative Körperformen, die erst durch die Benutzung erfahrbar werden.

4 Hans Scharoun (1893-1972) gilt als bedeutender Vertreter der »organischen« expressionistischen Architektur in Deutschland. In den sechziger Jahren ist Johannes Gachnang in Scharouns Architekturbüro als freier Mitarbeiter tätig. Die wichtigsten Bauten aus Scharouns späteren Jahren sind die Philharmonie in Berlin, die Deutsche Botschaft in Brasilia und die von seinem Partner vollendete Staatsbibliothek Preußischer Kulturbesitz in Berlin (1964-1978).

5 Gachnang bezieht sich auf die Ausstellungen *Ansicht,* 1987 in der Wiener Secession und Franz Wests Einzelausstellung 1988 in der Kunsthalle Bern.

6 Wests Installation auf der *documenta IX* von 1992 bestand aus 60 von alten orientalischen Teppichen abgedeckten Sitzbänken aus Metall, die im einstigen Schulhof zu einem Freilichtkino aufgebaut waren – woraus sich die beschriebenen Schwierigkeiten ergaben.

7 Gemeint sie die von Kasper König und Hans-Ulrich Obrist konzipierte Ausstellung *Der zerbrochene Spiegel,* die von 26. Mai bis 25. Juli 1993 in Wien zu sehen war. Die Ausstellung hatte es sich zum Ziel gesetzt, zeitgenössiche Malerei überblicksmäßig und »unhierarchisch« zu zeigen.

8 Aus: Samuel Beckett, *Watt.* Roman, erschienen 1953

9 *Der gekrümmte Horizont – Kunst in Berlin 1945-1967* war eine 1980 von Johannes Gachnang in der Akademie der Künste (Berlin-West) organisierte Ausstellung.

10 Franz Wests Bruder Otto Kobalek

11 *Otium,* die gemeinsame Ausstellung mit Michelangelo Pistoletto, fand 1990 in der Sala Boccioni in Mailand statt.

12 Aus: Samuel Beckett, *Das Ende, Erzählungen und Texte um Nichts*, 1962

13 Der Komponist und Bratschist Paul Hindemith (1895-1963) war zunächst als Konzertmeister in Frankfurt tätig und hatte dann zahlreiche Professuren inne, u. a. 1927-1937 an der Musikhochschule in Berlin, 1940-1953 an der Yale University und in den 50er Jahren auch in Zürich. Hindemiths Ziel war es , auf den »natürlichen Grundlagen« einen allgemein verbindlichen musikalischen Stil zu schaffen. Er komponierte vor allem Opern, Ballette, Chorwerke, Orchesterwerke und Kammermusik.

14 Bei der Donauinsel handelt es sich um ein großes Bade- und Freizeitareal in Wien, das »Flex« ist ein Rockkonzertveranstaltungsort.

HOET

BURDEN

CHRIS BURDEN:

Before I was a crazy violent person...

A conversation with Jan Hoet

Jan Hoet: Chris Burden – welcome! After this philosophical and a little bit deca-
dent conversation [between Franz West and Johannes Gachnang], I must ad-
mit that I don't know how to start. I had the intention to do my part very serious-
ly, mainly because of the fact that I finally met you, for the first time, here in
Vienna. I saw some works you did, I've read a lot about what you did, and also
some texts you wrote, and I saw some performances on video recordings, but I
never met you in person. [Seriousness is also required because] I feel that you
occupy a particular position compared to other artists of today. Your position is
different in the sense that most of the artistic production I know can still be
considered as a "product as product"[1] and most of this [art product] can still
be labeled "icon", art as an icon.

I think that [your special position derives from the ways] you are trying to artic-
ulate art in space, and the way you provoke the audience and the observer to
move into your work, into the formulation of your ideas. Your space is no longer
the passive observation space, but the space in which the observer is invited
to participate and to be active. When did it all start?

Chris Burden: In terms of making art that is not an object? ... probably when I
was studying at the university. Before I got interested in performances I made
sculptures whose objective was that you were supposed to use them. It was
the use of them, at least in my mind, that constituted the art and not the making
[of the object]. The closest thing I can think of similar to these pieces is exer-
cise equipment. The biggest problem was that people would come and see
this equipment, and still understand them as objects to be looked at.

When I was graduating from the university, my university exhibition was a per-
formance in which I was in a locker for books for five days[2]. I thought about it a
lot and came to the conclusion that instead of fabricating a box, I could use
one already made. After this I did a whole series of performances, where the
fact that I had once used something already made solved for me the problem

CHRIS BURDEN:

Ganz am Anfang war ich ein irrer, gewalttätiger Mensch...

Ein Gespräch mit Jan Hoet

Jan Hoet: Schön, Sie zu sehen, Chris Burden! ... Ich muß zugeben, daß ich nach diesem philosophischen und doch wohl etwas dekadenten Gespräch [zwischen Franz West und Johannes Gachnang] nicht mehr genau weiß, wie ich anfangen soll. Ich hatte mir ursprünglich vorgenommen, meine Rolle hier als Gesprächspartner ganz ernst zu nehmen, was auch damit zu tun hat, daß ich Sie hier in Wien nun doch schließlich kennengelernt habe. Ich habe einige Ihrer Arbeiten gesehen, ich habe viel über Ihre Arbeiten gelesen, ich kenne auch einige Ihrer eigenen Texte und habe die eine oder andere Performance auf Video gesehen. Ernsthaftigkeit scheint mir auch deswegen angebracht, weil ich meine, daß Sie, im Vergleich zu anderen Künstlern, eine besondere Stellung einnehmen. Diese Stellung steht im Gegensatz zu dem [verbreiteten] Verständnis von künstlerischer Arbeit als Produkt, das ich einmal mit der Gleichung Kunst als »Produkt als Produkt« zusammenfassen will[1]. Und dieses Kunstprodukt begreife ich nach wie vor als Ikone – Kunst als Ikone also.

Ich meine nun, daß [sich Ihre Stellung daraus erklärt, daß] Sie versuchen, Kunst im Raum zu artikulieren, und zwar so, daß Sie das Publikum, den Betrachter dazu bringen, in Ihr Werk, in Ihre Formulierung von Ideen einzutreten – was nichts anderes heißt, als daß es nicht mehr um einen wahrzunehmenden Raum geht, sondern um einen Raum, an dem der Betrachter teilhat, einen Raum, in dem er aktiv ist. Ein aktiver Raum also.

Wann hat denn alles angefangen?

Chris Burden: Mit Arbeiten, die keine Objekte sind ... das war wahrscheinlich, als ich noch an der Universität studierte. Bevor ich mit Performances begann, habe ich Skulpturen gemacht, die der Betrachter verwenden sollte. Für mich zumindest war nicht der Schaffensprozeß das künstlerische Moment, sondern die Verwendung. Diese frühen Arbeiten lassen sich wohl am ehesten mit Sportgeräten vergleichen. Das entscheidende Problem lag darin, daß die Leute kamen, die Geräte sahen, sie aber als nicht als zur Verwendung bestimmte Gegenstände er-

Ausstellung/Exhibition: Body Movements,
La Jolla Museum of Contemporary Art, California, 1971

of making an object that made me do something. That was the beginning, the early sixties.

Jan Hoet: In those objects, was there already an element of violence?

Chris Burden: You could get hurt if you didn't use [my objects] properly. I actually did an exhibition in California, La Jolla, with Bruce Nauman and Mowry Baden[3] with these objects of mine that you had to use. The guards in the exhibition were helping people, and so you would see old ladies trying to get into these contraptions – pretty dangerous! This show wouldn't happen today, because of legal aspects. At that time people were not suing as much, but still, it was amazing that the exhibition was organized. My pieces were supposed to be dangerous, but even to get on a pair of skies can be pretty dangerous!

Jan Hoet: When I look at your work, I always have the impression that it is more than just a reflection on art "as art", that it also contains a reflection on society, even a kind of judgement on the experiences in society, daily life, struggles, shooting, fighting, discrimination. Is that true?

Chris Burden: Yes, some of my works are. My sources are sometimes from the news, from reading, from what goes on in the world. The performance I did a

Ausstellung/Exhibition: Body Movements,
La Jolla Museum of Contemporary Art, California, 1971

kannten… Als Abschlußarbeit an der Universität habe ich eine Performance ge-
macht, bei der ich fünf Tage lang in einem Schließfach verbrachte.[2] Ich habe mir
die Sache gründlich überlegt und mich dann entschlossen, nicht selber ein Fach
zu konstruieren, sondern eines zu verwenden, das es bereits gab. Anschließend
habe ich eine ganze Reihe von Performances gemacht, und da ich einmal etwas
Vorgefundenes verwendet habe, stand ich nicht mehr vor dem Problem, etwas
konstruieren zu müssen, das mich zu einer Handlung zwang. Das war der An-
fang, in den frühen sechziger Jahren.

Jan Hoet: Gab es in diesen Objekten bereits ein Moment der Gewalt?

Chris Burden: Natürlich konnte man sich verletzen, wenn man mit den Sachen
nicht entsprechend umging … Ich habe tatsächlich damals an einer Ausstellung
in Kalifornien teilgenommen, in La Jolla, mit Bruce Nauman und Mowry
Baden[3], das war recht interessant – da gab es also diese Objekte von mir, die es
zu benutzen galt … solche Dinge wären heute nicht mehr realisierbar, einfach
schon aus rechtlichen Gründen. Damals sind die Leute nicht dauernd vor Gericht
gegangen… Die Aufseher haben den Leuten geholfen – z. B. älteren Damen, die
versuchten, in diese Vorrichtungen zu steigen – eine ziemlich gefährliche Ange-

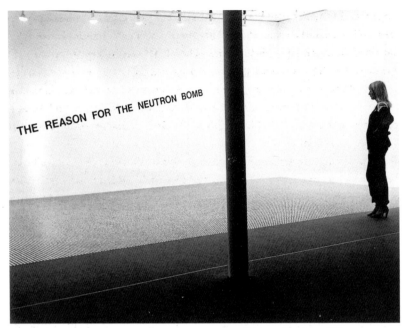

Chris Burden, The Reason for the Neutron Bomb, Ronald Feldman Fine Arts, 1979

long time ago – when I was shot – *Shoot*[4], worked so well because it deals with issues that everybody thinks about [like violence, shooting, and crime]. You can see these things on television, you see it in real life and you read about it all the time – it has become an American tradition, like apple pie. Since I was an artist and I did this piece [about these everyday violent experiences] in an extremely clinical, scientific way it made people ask themselves: Why does he do this? What does it mean?

The piece finally becomes the vehicle for an empirical, scientific inquiry because it ultimately raises the question: What does it feel like? Well, in order to find out, you have to do it! [Getting shot] is a fear everybody has, especially in America, for it's there all the time. When you read that an artist did this, then it does suddenly spark.

Some of the installations, like the one I did with all the Russian tanks, *The Reason for the Neutron Bomb*[5], had the same impact. I was reading a story in the newspaper about the abstraction of an army of fifty thousand tanks. Numbers are extremely abstract, they don't give you a true sense of reality. A couple of

legenheit. Erstaunlich, daß die Ausstellung überhaupt zustande kam! Meine Objekte sollten gefährlich sein, aber Schilaufen ist ja schließlich auch nicht ohne!

Jan Hoet: Wenn ich Ihre Arbeiten sehe, habe ich das Gefühl, daß Sie Kunst nicht nur unter dem Aspekt »Kunst als Kunst« betrachten, sondern daß es auch um gesellschaftliche Zusammenhänge geht, ja daß Ihre Arbeiten vielleicht eine Einschätzung oder sogar ein Urteil über gesellschaftliche Erfahrungen und Alltagserlebnisse enthalten, über Kämpfe, Schießereien, Zusammenstöße, Diskriminierungen ... Stimmt das?

Chris Burden: Auf manche Arbeiten trifft das sicher zu. Oft beziehe ich Informationen aus den Nachrichten, aus Zeitungen. Eine frühe Performance von mir, bei der ich angeschossen wurde, *Shoot*[4], hat, denke ich, deshalb so gut funktioniert, weil jeder über [Gewalt, Schießereien und Verbrechen] nachdenkt. Jeder kennt das aus dem Fernsehen, die ganze Zeit sieht man das, dauernd liest man darüber — das hat Tradition in Amerika, wie apple pie. Da ich als Künstler auftrat und [mit diesen Alltagserfahrungen] auf extrem klinische, wissenschaftliche Art umging, mußten sich die Leute fragen: Warum tut er das bloß? Was bedeutet das? Die Aktion wird dann auch wirklich zu einer empirischen Untersuchung, weil sich zudem die Frage stellt: Was empfindet man dabei? Nun, um das herauszufinden, muß man es selber versuchen! Vor allem in Amerika hat jeder vor diesen Dingen Angst, weil man dauernd damit konfrontiert ist. Und wenn man dann liest, daß ein Künstler damit arbeitet, dann fangen die Leute an, darüber nachzudenken.

Aber das war auch bei manchen meiner Installationen so, wie zum Beispiel bei der mit den russischen Panzern, *The Reason for the Neutron Bomb*[5]. Ich hatte die Geschichte aus der Zeitung, und was ich nicht vergessen konnte, war diese Abstraktion von 50.000 Panzern. Zahlen sind etwas ziemlich Abstraktes, vermitteln einem kein Gefühl, was wirklich los ist. Ein paar Nullen dazu, und schon schaut die Sache ganz anders aus, und irren kann sich schließlich jeder einmal.

Ich bin bei meiner Arbeit von derselben Information ausgegangen. Ich habe die gesamte russische Panzerstreitkraft mit [50.000 Fünf-Cent-]Münzen und Streichhölzern dargestellt. Das hat eine Fläche in Anspruch genommen, die doppelt so groß war wie dieses Podium hier [im MAK, das etwa 5 x 9 m mißt]. Dies[e ungeheure russische Panzerstreitkraft] war der Grund dafür, daß die Vereinigten Staaten die Neutronenbombe immer weiter entwickelt haben, die Menschen, aber keine Maschinen vernichten sollte ...

Jan Hoet: Nicht die Kultur ...

extra zeroes change things dramatically, and someone can always make a mistake.

I made my work based on the [publicly available] information trying to get a grip on this abstraction. I made a model of the whole Russian tank-force by using these [fifty thousand nickel] coins and little matches. The [model] had twice the size of this stage [in the MAK, about 5 x 9 meters]. This [huge Russian tank force] was the reason why the United States continued to further develop the neutron bomb, which was supposed to kill people but not machines.

Jan Hoet: And the culture.

Chris Burden: Maybe [this work] was a good idea – maybe the coins were Russian tanks to me – maybe it was a bad idea. There was perhaps even a moral question in it. I only wanted to look at the available information in a different way. I think that if you take information and change its form, you learn something new. I wasn't [initially] taking a moral position.

Jan Hoet: But still, I think it wasn't the first time that you were confronted with moral judgement [with respect to your work]. Do you raise moral questions at all in your artistic reflections, in your installations and your performances?

Chris Burden: Sometimes, not always. I think – if you were to isolate one [attribute of my work, such as morality] and wanted to take it onto a general level, you would have to realize that I have tried to push it to the extreme. A glass of water would, in such a process, become a swimming-pool or a microscopic drop. You would need to go to the extremes and find out where the boundaries, the limits are, where the edge is.

Jan Hoet: In America, I was confronted with many artists who have a moralistic attitude regarding art and the position of art in society – as if they had to appeal to the society in a moral sense. The way you operate – does it have to do with your American "position" as opposed to an European "position" of the artist in society?

Chris Burden: I think I am an American artist, yes ... I lived a long time in Europe, as a child, but I think that makes me more American!

Jan Hoet: In what way?

Chris Burden: It's like a convert! When you convert to a religion, you are usually more zealous about it then people who were born into it – you have to believe more because you were not always there. My living long in Europe has made me more American than if I had grown up in America.

Jan Hoet: I am asking this question in relation to the subject of this symposium:

Chris Burden: Es kann sein, daß [diese Installation] eine gute Idee war, vielleicht waren die Münzen für mich russische Tanker – vielleicht war die Idee aber auch gar nicht so gut. Vielleicht habe ich sogar ein moralisches Problem aufgeworfen. – Mir jedenfalls ging es einzig und allein darum, die verfügbare Information auf eine andere Art zu sehen: Ich meine nämlich, daß man etwas dazulernt, wenn man eine gegebene Information aufgreift und ihre Form ändert. Ursprünglich lag mir [sicherlich] nicht daran, moralisch Stellung zu beziehen.

Jan Hoet: Ich meine aber, daß das nicht das erste Mal war, daß Sie sich [im Hinblick auf Ihre Arbeit] einer moralischen Beurteilung ausgesetzt sahen. Werfen Sie in Ihren künstlerischen Überlegungen, Ihren Installationen und Performances überhaupt moralische Fragen auf?

Chris Burden: Manchmal, nicht immer. Ich glaube, wenn man [ein Merkmal meiner Arbeit wie etwa den moralischen Inhalt] herausgreifen will und allgemeine Schlüsse zu ziehen versucht, muß man schon verstehen, daß die Sachen bis zum Äußersten getrieben sind. Da wird dann ein Glas Wasser zum Swimmingpool oder zum mikroskopischen Tropfen. Man müßte bis zum Äußersten gehen und feststellen, wo die Grenzen liegen.

Jan Hoet: In Amerika bin ich vielen Künstlern begegnet, die der Kunst und ihrer Stellung in der Gesellschaft gegenüber eine moralistische Haltung einnehmen – als ob sie sich moralisierend an die Gesellschaft wenden müßten. Sehen Sie sich in Ihrem Vorgehen einer amerikanischen – im Unterschied zu einer europäischen – Position des Künstlers in der Gesellschaft verbunden?

Chris Burden: Ich glaube, daß ich ein amerikanischer Künstler bin, ja ... Als Kind habe ich zwar lange in Europa gelebt, aber das macht mich noch amerikanischer, finde ich!

Jan Hoet: Warum?

Chris Burden: Das ist wie bei einer Bekehrung. Wenn man erst später einer Religionsgemeinschaft beitritt, ist man viel eifriger, als wenn man in diese Gemeinschaft hineingeboren wird – man muß intensiver daran glauben, weil man ihr nicht immer angehört hat. Daß ich lange in Europa gelebt habe, hat mich amerikanischer werden lassen, als ich wäre, wenn ich in Amerika aufgewachsen wäre.

Jan Hoet: Ich frage Sie das im Hinblick auf das Thema dieses Symposiums: »Positionen zur Kunst«, im Hinblick auf die Stellung des Künstlers also. Könnte es nicht sein, daß die Antwort auf diese Frage von den demographischen, nationalen und kulturellen Bedingungen so verschiedener Orte wie Amerika, Österreich oder Deutschland abhängt? Ich bin der Auffassung, daß das Individuum in Ame-

"Positions in Art", the position of the artist. Could it be that the answer to that question varies in relation to demography, nationality, culture of places as different as America, Austria, Germany? I think that, generally speaking, the American as an individual is much more [trapped] in a container, is much more feeling like a person in a container as part of a collective society. That, for example, may be one of the reasons why your work is trying to break out?

Chris Burden: I think that being American is a little bit schizophrenic. There is all this lip service paid to being an individual, to individuality, but in its essence the immigrant experience is to conform, to become assimilated. If you come from Italy, you don't go on keep looking Italian. You want to look American, shed your immigration, and become anonymous. For instance, if you look at the architecture in America – I am talking about housing – what the people really like is the same [prototypical] house, the identical house!

On the other hand, I think that in some ways there is more freedom in America, because America is not bound to tradition. To be an European artist is very difficult, at least in my mind, for there are traditions and values to fight and confront all the time. To be [an artist] in California is also easier than to be an artist in New York. Tradition can be very oppressive. In California nobody cares about art, in New York they do. L. A. is about the motion picture industry. But New York is not American. America seems to be outside of it.

Jan Hoet: Did you make art before you went to America?

Chris Burden: No. I was in Europe only until I was thirteen. When I came to America and entered college, I studied architecture. I even worked for an architectural firm, but it seemed to me that [in architecture] you might have to become very old before you got to make some decisions. I was also taking art classes and discovered that in the arts one can make something and immediately get results. The architectural firm [I worked for] was in Cambridge, Massachusetts, and these Harvard University graduates were coming out from the best school and drawing bathrooms! The men at the top were fifty-five, sixty, and I said to myself: I can't wait that long!

Jan Hoet: So what about American morality?

Chris Burden: I am not sure it's about morality. America is always changing, I think that's what is interesting about it. I live in Los Angeles, and I think that more than half of the population is of Hispanic origin, about 25% is black, 7 % Asian, 15 % white. New York is the same thing.

There are all these people now that are trying to look back and turn Christo-

rika im allgemeinen viel isolierter lebt, sich eher wie in einem Behälter [gefangen] fühlt, und nicht als Teil einer Gemeinschaft. Das könnte einer der Gründe dafür sein, daß Ihr Werk auszubrechen versucht ...

Chris Burden: Ich glaube, daß Amerikaner zu sein, irgendwie schizophren ist. Da gibt es diesen ganzen amerikanischen Traum über das Individuum, die Individualität, in Wirklichkeit aber bedeutet Einwanderersein, sich anzupassen, sich zu integrieren. Wenn jemand zum Beispiel aus Italien kommt, will er nicht weiter aussehen wie ein Italiener ... er will amerikanisch aussehen, um die Einwanderung zu verstecken, um anonym zu werden. Oder wenn man sich die Architektur in Amerika anschaut, und ich rede jetzt über das Einfamilienhaus, merkt man, was die Leute wollen: in völlig gleichen Häusern leben!

Andererseits glaube ich, daß es in Amerika in gewisser Weise wieder mehr Freiheit gibt, weil es keine Tradition gibt. Mir zumindest kommt vor, daß es ein europäischer Künstler sehr schwer hat, weil es ununterbrochen darum geht, bestimmten Traditionen und Werten entgegenzutreten und diese zu bekämpfen. Auch in Kalifornien hat man es da insofern einfacher als in New York. Tradition kann einen sehr belasten. In Kalifornien kümmert sich niemand um Kunst, in New York schon. In Los Angeles dreht sich alles um die Filmindustrie. Aber New York ist keine amerikanische Stadt. Amerika scheint erst jenseits der Stadtgrenzen von New York zu beginnen.

Jan Hoet: Waren Sie künstlerisch tätig, bevor Sie nach Amerika gingen?

Chris Burden: Nein. Ich bin aus Europa weg, da war ich dreizehn. Als ich nach Amerika kam und dort aufs College ging, habe ich Architektur studiert. Ich habe sogar einmal für ein Architektenbüro gearbeitet, aber mir kam vor, daß man in dieser Branche sehr alt werden muß, ehe man da eine Entscheidung treffen darf. Ich war dann in einer Kunstklasse und habe dort entdeckt, daß es auch möglich ist, etwas zu machen und sofortige Ergebnisse zu erzielen. Dieses Architektenbüro war übrigens in Cambridge, Massachusetts – und da kamen dann die Harvard-Absolventen und durften Badezimmer zeichnen. Die, die was zu sagen hatten, waren fünfundfünfzig, sechzig, und da wußte ich, so lange kann ich nicht warten!

Jan Hoet: Was halten Sie also von amerikanischer Moral?

Chris Burden: Ich weiß nicht , ob es wirklich um Moral geht ... Amerika verändert sich ja ständig, und das finde ich auch so interessant an diesem Land. Ich lebe in Los Angeles, wo, glaube ich, mehr als die Hälfte aller Einwohner hispanischer Herkunft sind, 25 Prozent sind Schwarze, 7 Prozent Asiaten, 15 Prozent

pher Columbus into a villain. It is a revisionist time 500 years after the fact. In terms of art, the situation is especially sad, because I don't think this [cultural morality] is about quality. I'll give you an example. I teach at the University of California, at UCLA, and we were looking for a new professor for a major painting position. People are being introduced by their race, their sex, and only then by what they do. "He is a black man who paints". "She is a Latina who does ceramics". It's a little bit like propaganda. The art is not really the important issue, but rather, your cultural background becomes the important [criterion].

Jan Hoet: Isn't there a problem? Art is involved, after all, with problems of humankind. Why make art that is totally isolated from the problems of society?

Chris Burden: On the other hand, it is unfair to ask artists to be social doctors. I was asked to be in the show in Potsdam, Germany and all the letters had this: "You must come to Berlin, and we must go to East Germany because you must see the problems we have, and you must make a sculpture that addresses those problems."

Jan Hoet: Really? Why?

Chris Burden: I was also asked by people in Graz[6] to design a poster related to problems in Yugoslavia. The underlying assumption is that if enough artists made these posters, then... It is an unfair assumption. Nobody in the world can solve these largely political problems and now artists are supposed to have some magic, and make a piece that would do it. I think it is very naive and unfair, too. To be an artist should be without a real reason or purpose, at least in my mind. Art is an inquiry, a search, like what physicists do in a laboratory. It's looking. To expect solutions all the time subverts what art is.

Nobody really knows why [our ancestors] started to paint on the caves, but I don't think that it was because they wanted to make "pictures" of those animals. Surely, they knew what these animals looked like! It was an attempt to solve something that they didn't understand. It was about gaining power over things that are mysterious and frightening. It was about the feeling that they could have some control over the unknown [by capturing its image]. When art becomes very specific, I think it becomes propaganda. That is problematic and not very interesting for me.

Jan Hoet: But, it seems to be more and more so, in fact. One of the most recent examples was the *Whitney Biennial* [in 1993].

Chris Burden: That show certainly wasn't about morality!

I had a room at the Whitney made out of metal, called *The Fist of Light*. The

Weiße … In New York ist das nicht anders. Diese Kulturgemeinschaften, die sich nun alle der Vergangenheit zuwenden und Christoph Kolumbus zu einem Verbrecher machen wollen! Eine revisionistische Zeit: fünfhundert Jahre nach dem tatsächlichen Ereignis soll jetzt alles anders werden. Vom Standpunkt der Kunst aus finde ich das besonders traurig, weil diese Kultur-Moral mit Qualität nichts zu tun hat. Ein Beispiel: Ich unterrichte an der UCLA, und wir haben für einen wichtigen Posten in der Malereiklasse eine neue Lehrkraft gesucht. Und wie wurden die Leute vorgestellt? Zuerst kam die Abstammung, dann kam das Geschlecht, und dann erst, was sie tun – »Ein Afroamerikaner, der malt«, »Eine Lateinamerikanerin, die Keramik macht«. Das hat etwas von Propaganda. Es geht in erster Linie nicht wirklich um Kunst, sondern um den kulturellen Hintergrund, der wird dann wichtiger.

Jan Hoet: Liegt da nicht ein Problem? Die Kunst setzt sich doch trotz allem mit Problemen der Menschheit auseinander. Warum sollte jemand eine von der Gesellschaft vollkommen abgehobene Kunst machen?

Chris Burden: Andererseits ist es wieder unfair, von Künstlern zu verlangen, Ärzte der Gesellschaft zu sein. Man hat mich einmal zu einer Ausstellung nach Potsdam eingeladen, und in jedem Brief stand irgendwo: »Sie müssen nach Berlin kommen und Ostdeutschland besuchen, um zu sehen, welche Probleme wir hier haben, und Sie müssen eine Skulptur machen, die sich thematisch mit diesen Problemen auseinandersetzt.«

Jan Hoet: Wirklich? Was steckt da Ihrer Meinung nach dahinter?

Chris Burden: Ein paar Leute aus Graz[6] haben mich einmal gebeten, ein Poster zu entwerfen, das sich auf die Probleme in Jugoslawien bezieht. Sie haben wohl gemeint, daß, wenn sich genügend Künstler finden, die solche Poster machen, dann … Davon kann man nicht ausgehen. Niemand auf der Welt kann diese politischen Probleme lösen, und jetzt sollen Künstler zaubern können und das mit irgendeiner Arbeit zustande bringen. Ich halte das für ebenso naiv wie unfair. Ich bin ein Künstler — und verfolge, zumindest sehe ich das so, weder einen spezifischen Grund noch Zweck in meiner Arbeit… Meine Arbeit ist eine Untersuchung, eine Suche, nicht unähnlich der Tätigkeit eines Physikers in einem Labor. Es geht darum, zu schauen. Dauernd Lösungen zu erwarten, untergräbt die Essenz der Kunst.

Niemand weiß wirklich, warum [unsere Vorfahren] begannen, Höhlen zu bemalen, aber ich glaube nicht, daß sie es taten, weil sie »Bilder« von den Tieren machen wollten. Sie haben ja bereits gewußt, wie die Tiere aussahen! Vielmehr war

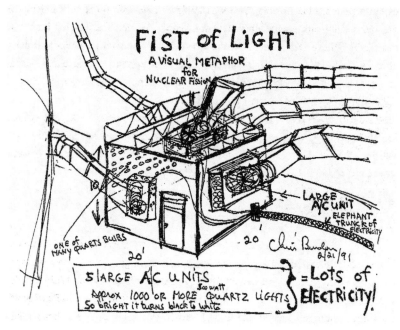

FiST of LiGHT

A ViSUAL METAPHOR
foR
NUCLEAR FiSSioN

ONE of
MANY QUARTS BULBS

LARGE
A/C UNIT

ELEPHANT
TRUNK of
ELECTRICITY

20'

20

Chris Burden
8/21/91

5 LARGE A/C UNITS
Approx 1000 oR MORE QUARTZ LiGHTS
So bRIGHT iT turns black to white

500 watt

} = Lots of
ELECTRicity!

Chris Burden, Studie für /Study for The Fist of Light, 1991

concept was to make a room that was completely covered with light bulbs on the inside, and [to create] so much light that black would turn white, if you went inside. It's a little bit like what some of the California people – Jim Turrell – do, but raising the additional question: What happens if you had as much light as possible, maximum light? You can't go in this room, because it would harm you. The viewer, in fact, does not see anything [from the outside]. He sees this huge aluminum box with a lot of air-conditioning around it to cool [the heat generated by the light tubes]. It's a little bit like going to a nuclear power plant where you don't get to see atoms. In the case of an atomic explosion you would see a lot of water, a lot of concrete, that's all. Only later they would tell the public that it was very, very dangerous, very powerful. When you come to my installation you see a huge aluminium box, a lot of big tubes blowing and cooling the air around it. And, there is just a wall label that says: "In this room it is so bright that black turns white" – but there is no way to confirm this information visually, you have to believe it.

es ein Versuch, eine Lösung für etwas zu finden, was sie nicht verstanden. Ich glaube, es ging um Macht über geheimnisvolle und erschreckende Dinge, um das Gefühl, diese Dinge irgendwie in den Griff bekommen zu können, [indem man sie in einem Bild einfängt]. Wenn Kunst sehr bestimmt wird, gerät sie zur Propaganda, finde ich. Ich halte das für ziemlich problematisch, und es interessiert mich auch nicht.

Chris Burden, The Fist of Light, 1992–1993

Jan Hoet: Aber wenn man sich umsieht, scheint sich Kunst immer mehr so zu entwickeln. Die *Whitney Biennial* [1993] ist so ein Beispiel aus der letzten Zeit …

Chris Burden: Da ging es aber sicher nicht um das Problem der Moral …
Ich war bei der *Biennial* mit einer Rauminstallation aus Metall mit dem Titel *The Fist of Light*[7] vertreten. Das Konzept war, einen Raum zu schaffen, der innen ganz mit Glühbirnen ausgekleidet war, [die] so viel Licht [erzeugten], daß Schwarz zu Weiß wurde, wenn man den Raum betreten hätte. Es ging von den Sachen von James Turrell und einigen anderen Leuten, die in Kalifornien arbeiten, aus, warf aber zusätzlich die Frage auf: Was geschieht bei einem Maximum an Lichtintensität? – Man kann den Raum nicht betreten, weil das Licht dem Betrachter Schaden zufügt. Für den Betrachter gab es [von außen] nichts zu sehen, sichtbar war nur dieser riesige Aluminiumkasten mit den Kühlvorrichtungen [wegen des Lichts im Inneren]. Ein wenig wie bei einem Atomkraftwerk, wo man ja keine Atome sieht. Explodiert eine Atombombe, sieht man eine Menge Wasser, eine Menge Beton, aber das ist es auch schon. Nur nachher dann erzählen sie einem, daß es sehr, sehr gefährlich war, eine ungeheuer starke Explosion … In der Ausstellung hatte man also nur diesen riesigen Aluminiumkasten und jede Menge großer Rohre vor sich, die die Luft kühlten. Und ein Schild an der Wand mit der Aufschrift: »In diesem Raum ist es so hell, daß Schwarz zu Weiß wird« – aber es gab keine Möglichkeit, diese Aussage visuell nachzuvollziehen, man mußte es einfach glauben.

Jan Hoet: Das erinnert mich an das Wasserglas, das zum Swimmingpool wird. In diesem Fall wird Licht zu Dunkelheit. Der Grad der Lichtsättigung ist so stark, daß man das Licht nicht mehr wahrnehmen kann. So gesehen, hat Ihre Arbeit einen konzeptuellen Ansatz, oder wie sehen Sie das?

Chris Burden: Ja, sie ist konzeptuell, ohne die Möglichkeit der Verifikation.

Jan Hoet: It relates to what you said about the glass of water that becomes a swimmingpool. In the work you've just mentioned light becomes so saturated that you can no longer experience it. At this point, does your work become conceptual, or what?

Chris Burden: Yes, it becomes conceptual, without a possible verification. The machine is just there to embody the concept, so that you believe the concept, that you understand the wall label. In the context of the *Whitney Biennial,* which this year was very political...

Jan Hoet: Politically correct!

Chris Burden: Right. Because of that some artists from different cultural backgrounds were chosen to be in the exhibition – and they had a lot of messages about it. I thought that there was some humor in my sculpture, but apparently nobody understood it. I was a white man, making a machine that turns white into black – I thought somebody will say something about that, especially in this context. Well, nobody did.

But [to come back to our discussion] I am not sure that the show was about morality, as much as I am not sure that it was about art either! It was about a social agenda.

Jan Hoet: And sociology.

But art can also be a canary taken by mine-workers into the mines to check the gas level – somebody said that. In your work I sometimes see this affinity to the canary taken into the mines in order to confront us with violence, fear, aggression, with ugly things in society. When you said: "I do my work in a scientific way", you meant in an abstract way, meaning that you are producing abstraction, but nevertheless, [these abstractions] hurt and frighten people.

Chris Burden: When I started to do those performances, I was seen as a maniac and people were frightened of me. That was twenty years ago. Now, in America, I am seen as a moralist. It's a total switch. Before I was a crazy violent person, and now I am...

Jan Hoet: ... a good moralist ...

Chris Burden: Almost! It's a funny change and I don't know what to make out of it exactly.

Jan Hoet: When you lecture at the University, is it always about your work?

Chris Burden: It's hard to say. I meet with students and we talk, about their work too.

Jan Hoet: What are they making in your class?

Die Maschine ist nur dazu da, daß man das Konzept glaubt, daß man es begreift, den Hinweis auf der Wandtafel versteht.

Was nun die *Whitney Biennial* betrifft, die heuer eine sehr politische Angelegenheit war ...

Jan Hoet: Eine politisch korrekte Angelegenheit ...

Chris Burden: Stimmt. Die Besonderheit des kulturellen Hintergrunds war in vielen Fällen ausschlaggebend dafür, daß jemand zur Teilnahme an der Ausstellung eingeladen wurde, und genau das wurde dann auch sehr stark thematisiert.

Ich fand, daß mein Objekt in diesem Kontext Witz hatte, aber den hat anscheinend niemand verstanden: ein Weißer, der eine Maschine konstruiert, die Schwarz in Weiß verwandelt. Ich habe erwartet, daß da jemand etwas dazu sagt, vor allem in diesem Zusammenhang. Aber es kam nichts.

[Um auf unsere Anfangsfrage zurückzukommen:] Ich bin mir nicht sicher, ob es in der Ausstellung um das Problem der Moral ging, und ich weiß auch nicht, ob es um Kunst ging! Es ging auf jeden Fall um ein soziales Programm.

Jan Hoet: Und um Soziologie.

Aber Kunst kann doch auch ein Kanarienvogel sein, den man in eine Mine mitnimmt, um draufzukommen, ob Gas austritt ... Sie kennen den Vergleich? Bei Ihren Arbeiten habe ich manchmal das Gefühl, daß da ein Kanarienvogel in eine Mine mitgenommen wird, daß Sie uns mit Gewalt, Angst und Aggression, mit den häßlichen Dingen unserer Gesellschaft konfrontieren wollen. Wenn Sie sagen, daß Sie in Ihren Arbeiten wissenschaftlich vorgehen, meinen Sie abstrakt, meinen Sie, daß Sie Abstraktionen schaffen, aber dennoch erschrecken und verletzen diese Abstraktionen die Leute.

Chris Burden: Als ich meine ersten Performances machte, hielten mich die Leute für verrückt und hatten Angst vor mir. Das war vor zwanzig Jahren. Nun sieht man mich in Amerika als Moralisten. Die totale Umkehrung. Zuerst war ich ein irrer, gewalttätiger Mensch und jetzt bin ich ...

Jan Hoet: ... ein braver Moralist ...

Chris Burden: Fast! Eine komische Wandlung, mit der ich nicht wirklich etwas anzufangen weiß.

Jan Hoet: Sprechen Sie in Ihren Vorlesungen an der Universität ausschließlich über Ihre Arbeit?

Chris Burden: Das ist schwer zu sagen. Ich treffe Studenten und wir sprechen eben, auch über ihre Arbeiten.

Jan Hoet: Was machen die Studenten in Ihrer Klasse?

Chris Burden: I am not teaching a specific technique. In fact, my area is called *New Genre* – nice French word – and it was supposed to be an area in between, the new media.

Jan Hoet: Did you ever consider explicitly the position of the artist in society? In times of recession, for example? My experience is that many people are bored with art, with exhibitions, with art as objects for sale, it all is boring. There was a show in Belgium, a retrospective of the *Jeune Peinture Belge* after the second World War, very beautiful work, an excellent show – everybody came – but it was pure 19th century salon.

In the 20th century, we have so many products of art, enormous quantities to be kept and archived, and to be shown again and again and again! Art becomes outdated very fast. My feeling is that time is over for art to be an object. Information is so dense that it makes history move faster than before. What are, for example, your thoughts about your own works from twenty years ago? Although I think your situation is different, since you don't make art as objects – and this seems to me a very crucial distinction – time is over for art to be a painting, a sculpture, an object as an object.

Chris Burden: Even though I've done a lot of art that is non-object, I do not have any problems with art which is an object.

Jan Hoet: I spoke to the painter Gerhard Richter and he told me: "We can do everything today! We can mix all kinds of colors, we will always do it right. It is no longer possible to do a bad painting." I am mentioning this only for us to focus on the logic of "everybody can be anything – everybody can do anything". I am wondering, are installations, for example, less boring than paintings? Isn't the observer more involved in the piece?

Chris Burden: If your question is whether art-making becomes more conservative in a recession, and its reception also, I think this happens only to bad artists. There are artists whose motives are solely production and reproduction. They make a product, and make it over and over. If that's what they want to do, and if there is a demand for that – fine! There are, after all, all kinds of artists. I get this newspaper and it's unbelievable to see all about the West Coast art, the Cowboy art. It is a huge, huge business and huge prices, half a million, a million dollars! And you look at these Indian girls and you wonder... It looks as a kitsch from here, but in America there is a parallel art world that we know nothing about. There are always artists like that. Maybe recession is bad for them, maybe not.

Chris Burden: Ich unterrichte keine bestimmte Technik. Mein Gebiet heißt eigentlich *New Genre* – ein hübsches französisches Wort – und sollte die Zwischenbereiche der neuen Medien abdecken.

Jan Hoet: Haben Sie sich je ganz konkret mit der Stellung des Künstlers in der Gesellschaft auseinandergesetzt? Mit der Stellung des Künstlers in Zeiten der Wirtschaftskrise etwa? Ich habe den Eindruck, daß heute viele Menschen Kunst langweilig finden, Ausstellungen, Kunst als Ware langweilig finden, das alles satt haben. In Belgien gab es eine Ausstellung, eine Retrospektive junger belgischer Malerei nach 1945, sehr schöne Sachen, und gut gemacht, sehr gut besucht – aber es herrschte genau dieselbe Atmosphäre wie in einem Salon des 19. Jahrhunderts.

Wir verfügen heute über so viele Kunstprodukte, haben so ungeheure Mengen von Kunst zu bewahren und zu archivieren, und natürlich auszustellen und immer wieder auszustellen! Kunst ist heute sehr schnell überholt. Ich habe den Eindruck, daß die Zeit für Kunst in Form von Gegenständen vorbei ist. Die heutige Informationsdichte treibt die Geschichte schneller voran. Wie denken Sie zum Beispiel über Ihre Arbeiten von vor zwanzig Jahren? Wobei ich gleich einräumen will, daß Ihre Situation eine andere ist, weil Sie ja keine Gegenstände produzieren. Ja, das scheint mir ein ganz wichtiger Punkt zu sein, daß die Zeit vorbei ist für Gemälde und Skulpturen, für Kunst als Gegenstand.

Chris Burden: Wenn ich auch eine ganze Reihe von Arbeiten gemacht habe, die keine Gegenstände sind, ich habe mit den Kunstgegenständen kein Problem ...

Jan Hoet: Der Maler Gerhard Richter hat mir einmal gesagt: »Man kann heute alles machen! Man kann alle Farben mischen und es wird einem nie ein Fehler unterlaufen. Es ist heute nicht mehr möglich, ein schlechtes Bild zu malen.« Ich erwähne das hier nur, um auf die Logik zu verweisen, daß jeder alles sein kann, alles machen kann. Ich frage mich z. B., ob Installationen weniger langweilig sind als Malerei? Sind Betrachter bei Installationen nicht mehr an der Arbeit beteiligt, mehr in der Arbeit drinnen?

Chris Burden: Wenn Sie mit Ihrer Frage darauf abzielen, ob künstlerisches Arbeiten in wirtschaftlichen Krisenzeiten konservativer wird, ob die Rezeption von Kunst konservativer wird, so denke ich, daß das nur für schlechte Künstler gilt. Es gibt Künstler, deren einzige Beweggründe Produktion und Reproduktion sind. Sie stellen immer wieder ein und dasselbe Produkt her. Aber bitte, wenn sie das wollen und es eine Nachfrage dafür gibt – wunderbar! Es gibt ja schließlich die unterschiedlichsten Künstler. Unglaublich, was ich da unlängst in der

But I don't have problems with making art as an object, because I believe that if an artwork is really great, then it transcends the form which it takes – no matter whether it is an installation or a sculpture.

Jan Hoet: Nevertheless, those are not the possibilities that satisfy you.

Chris Burden: No. I've never made a painting in my life, but I do recognize that there are differences in quality, that there is bad and good painting. I can even talk to students about their paintings. I don't know why people would want to paint, but I recognize that it is a whole special language that some people are involved in. And, even as a non-painter, you can sense something that is great when you are confronted with it.

Jan Hoet: I am considering this question also in the context of art-historical experiences with works which don't exist any more, like the *Merzbau* by [Kurt] Schwitters. It doesn't exist, while the small objects which he could sell still exist. Or, the music room of [Wassily] Kandinsky – it doesn't exist anymore. His paintings still exist. Rooms of El Lissitzky, with some exceptions, mostly disappeared. [All these works are] stored in our minds. The memory is there, but the actuality disappeared. We are stuck with those works which were intended for sale.

Chris Burden: Yes, but I think these are all just facts of the world. The world is just about commerce, that is the way it is structured, and I think you just have to accept that.

I understand what you are saying, and I understand your anger, but take [Vito] Acconci's installation[8] here: in a few months it is gone.

Jan Hoet: Is it true? It will disappear? This is sad.

Chris Burden: Yes, it is sad, but on the other hand, it is not as sad as if it would have never happened. As an artist, I wish that room would stay here, and I could come and see it again in five years.

Jan Hoet: Let's go back to your work. The violence that you've been dealing with in past years, and as you said, you have been trying to articulate "in a scientific way" – does it have some psychological reasons? Does it originate in your personal experience and life? Or is [your preoccupation with violence] actually independent from your personality?

Chris Burden: I'll try to be very careful now. I guess you are referring to the performances I did or to the Eiffel Tower piece[9], which is supposed to hit you on the head. You could name a few pieces but I don't think that [violence] was the motivating factor in their conception. Although, when we were making it, I

Zeitung alles gesehen habe, über diese Kunst an der Westküste, diese Cowboy-Kunst. Das ist ein irres Geschäft, ein riesiges Business, Wahnsinnspreise, eine halbe Million, eine Million für ein Bild! … Und man schaut sich diese Indianer-mädchen an und fragt sich … Von hier aus gesehen, schauen die Sachen wie Kitsch aus, aber in Amerika gibt es eben eine zweite Welt der Kunst, von der wir keine Ahnung haben. Solche Künstler wird es immer geben. Vielleicht trifft sie die Rezession besonders hart, vielleicht aber auch nicht.

Aber, wie gesagt, mit Kunst in Form von Objektes habe ich kein Problem. Ich glaube nämlich, daß Kunst ihre Form transzendiert, wenn es wirklich große Kunst ist, und da spielt es keine Rolle, ob es sich um eine Installation handelt oder um eine Skulptur …

Jan Hoet: Gut, aber das sind ja nicht die Möglichkeiten, die Sie zufriedenstellen.

Chris Burden: Das stimmt. Ich habe in meinem ganzen Leben kein einziges Bild gemalt, aber ich erkenne, daß es Unterschiede in der Qualität gibt, daß es gute und schlechte Malerei gibt. Ich spreche auch mit den Studenten über ihre Bilder. Ich habe keine Ahnung, warum Menschen malen wollen, aber ich nehme zur Kenntnis, daß es da eine ganz eigene Sprache gibt, mit der sich manche Leute beschäftigen. Und auch jemand, der nicht selbst malt, spürt, wenn er vor einem großen Bild steht.

Jan Hoet: Ich habe die Frage auch in einem kunsthistorischen Erfahrungszusammenhang gestellt, im Hinblick auf Werke, die es nicht mehr gibt, wie etwa den Merzbau von [Kurt] Schwitters. Den gibt es im Unterschied zu den kleinen Sachen, die er verkaufen konnte, nicht mehr. Oder das Musikzimmer von [Vassily] Kandinsky, das es auch nicht mehr gibt. Seine Bilder allerdings schon. Oder die Räume El Lissitzkys, die mit wenigen Ausnahmen verschwunden sind. [Diese Werke sind alle] in unserem Kopf gespeichert. Das Gedächtnis gibt es, die Wirklichkeit ist verschwunden. Und uns sind lediglich die Werke geblieben, die zum Verkauf bestimmt waren.

Chris Burden: Aber das sind doch alles nur Tatsachen, die Tatsachen des Lebens. Oder? In der Welt geht es um Kommerz und Handel, so ist sie beschaffen, und das muß man eben akzeptieren, finde ich. Was Sie sagen, verstehe ich schon, und ich verstehe auch Ihren Zorn, aber was wird mit z. B. mit der Installation [Vito] Acconcis[8] hier geschehen? In ein paar Monaten wird sie verschwunden sein …

Jan Hoet: Wirklich? Verschwinden wird sie? Das ist aber traurig.

83 **Chris Burden:** Stimmt, das ist traurig, aber andererseits nicht so traurig, wie wenn

wanted those cables as long as possible, I wanted it right at the edge of not being possible to work.

However, if you are referring to the performances, I believe that generally speaking the anticipation of what could happen during such a piece is always much greater than the actual event. So, for instance *Shoot* and *The Bed Piece*[10] are about having a fantasy that most people would be afraid of and thus would reject. So you must create a situation where you can test your fantasy and your fear against the actuality – rather then turn from it, face it head on and find out what it is.

Jan Hoet: Does it mean, that the performances are more like investigations and less like psychological [experiments].

Chris Burden, Shoot, Nov. 19th, 1971

Chris Burden: Let's take *The Fist of Light*. The question here is what if you made [a light-producing machine] like that and see what happens? What would happen if you had too much light? Or not enough? What is the opposite of darkness? Is it like having a conservative who is so right-wing, that he becomes left wing? Is it just a big circle? I think a lot of violence is a mental construct. Violence stems both from the observer and from the doer. What is violence in one culture is perfectly normal in another: for the Mayans, were human sacrifices violent or simply a way of communication with the Gods? For us their behavior seems very violent – but what does that mean?

Jan Hoet: I am asking these questions about violence, destruction – also of the destruction of codes – as they relate to psychology, to some theories of Freud. As I said before, I don't think that psychology is what defines your work. I have the impression that that's one of the most common misunderstandings that people make in relation to your work, and why people are fearing to show your work. They don't consider it an abstraction, as an articulated body that stays autonomous, independent of sociology, psychology, and of all those marginal 'isms' around arts. That is the same reason why the *Wiener Aktionists* were long time underestimated.

Chris Burden: I think, in my case, the confusion becomes only true when people don't know the body of my work – only know the performances. This is part of the problem: they became well known, famous, notorious. Once you get fa-

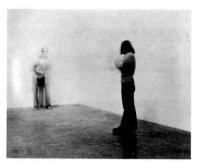

Chris Burden, Shoot, Nov. 19th, 1971

es sie nie gegeben hätte. Als Künstler würde ich mir wünschen, daß der Raum permanent erhalten bleibt und ich in fünf Jahren wiederkommen könnte, um ihn mir anzusehen.

Jan Hoet: Ich möchte wieder auf Ihre Arbeit zurückkommen. Hat die Gewalt, mit der Sie sich in den letzten Jahren beschäftigt haben und die Sie, wie Sie gesagt haben, in wissenschaftlicher Form zu artikulieren versuchten, psychologische Ursprünge? Gründet diese Gewalt in Ihren persönlichen Erfahrungen, in Ihrem Leben? Oder hat diese Gewalt überhaupt nichts mit Ihrer Person zu tun?

Chris Burden: Ich versuche, sehr vorsichtig zu sein. Ich vermute, daß Sie meine Performances im Auge haben. Der Eiffelturm[9], der einem auf den Kopf fallen soll, wäre so eine Arbeit, denke ich. Aber Gewalt war nicht mein Beweggrund. Auch wenn ich diese Kabel so lang wie nur irgend möglich haben wollte, als wir die Arbeit gemacht haben, und ich bis an die Grenzen des Handhabbaren gehen wollte. Aber wenn Sie die Performances im Auge haben, da ist für mich die Vorstellung und die Erwartung immer wesentlich stärker als das tatsächliche Ereignis. Nehmen wir einmal die Performances *Shoot* und *The Bed Piece:*[10] da geht es um Phantasien, die die meisten als schrecklich ablehnen würden. Man steht vor einer Situation, in der es die Phantasie zu erkunden gilt, die Angst vor der Wirklichkeit, und statt sich abzuwenden, muß man der Sache ins Auge blicken, um herauszufinden, worum es sich handelt.

Jan Hoet: Eher eine Suche also und nichts Psychologisches.

Chris Burden: Es ist ähnlich wie bei *The Fist of Light* ... Was passiert, wenn man sich auf so eine Idee einläßt, und sieht, was dabei geschieht? Was geschieht, wenn man zu viel Licht erwischt? Oder zu wenig Licht? Was ist das Gegenteil von Dunkelheit? Ist das wie bei einem Konservativen, der politisch so rechts ist, daß er schon wieder links ist? Oder ist alles nur ein großer Kreis? Ich bin der Auffassung, daß Gewalt nicht zuletzt ein geistiges Konstrukt ist. Gewalt entspringt sowohl dem Betrachter als auch dem, der Gewalt übt. Was in einer Kultur als Gewalt angesehen wird, gilt in einer anderen Kultur als vollkommen normal. Waren die Opfer der Maya für die, die sie ausführten, ein Akt der Gewalt oder einfach eine Form der Verständigung mit den Göttern? Wir erkennen darin sehr viel Gewalt ... aber was heißt das schon?

mous for doing one thing, you are supposed to do it forever because it is much easier for your public, and for the critics, by the way. Work becomes digested and, once you change it, [the public] has to change too! Getting known early for a certain body of work presents one with many difficulties. For me, there is a relationship between everything I did, but for others it may be hard to see. I stopped doing performances in 1975! I wish people would get more familiar with the newer work.

1 Jan Hoet here refers to the twofold character of art as a product, to the three-dimensional materiality of art on the one hand and to art as a commercial product within the capitalist cycle of goods on the other.

2 Burden spent five days (*Five Day Locker Piece*, 26 April–30 April 1971) in a closed locker he could not leave; the locker only measured 60 x 60 x 90 centimeters. While the locker above contained a vessel with 19 litres of water, there was a urine receptacle in the one below.

3 The exhibition *Body Movements* at the Museum of Contemporary Art, La Jolla, California, 1971, together with Mowry Baden and Bruce Nauman.

4 *Shoot* (1971), one of Burden's first performances, consisted of a single shot fired from a distance of about five meters into the artist's upper arm.

5 *All the Russian Tanks* was actually titled *The Reason for the Neutron Bomb* (1979); the expression Burden uses here hints at its affinity to the later work *All the Submarines of the United States* (1987), an installation consisting of 625 miniature submarines. *The Reason for the Neutron Bomb* was realized for the Ronald Feldman Gallery in New York and questions the absurd legitimation for the arms race during the cold war years: The Soviet superiority in the number of tanks over the US-Army was compensated strategically by the neutron bomb. Each of the 50,000 Soviet tanks was rendered in this installation by a nickel and a match establishing a twofold configuration of military economic power and fire power.

6 Burden was invited to participate in the first Austrian »Triennale zur Fotografie« at the Neue Galerie of the Landesmuseum Joanneum in Graz (September 17 – October 31, 1993). Its subject being "WAR", the artists were asked to formulate their positions regarding the "situation of war" in former Jugoslavia. Due to the mentioned reasons Burden did not participate in this exhibition.

7 The installation *The Fist of Light* (1992–93) was realized for the *Biennial Exhibition* at the Whitney Museum which was shown from March 4 to June 20, 1993.

8 This remark refers to Vito Acconci's installation conceived for the exhibition *The City Inside Us* (March 17 – August 29, 1993) that was on show at the MAK during the symposium. The exhibition hall of the museum, measuring 600 square meters and 15 meters in height, and its glass roof were rebuilt as a tilted and shifted room within a room to create a „temporary reconstruction" partly covered with lawn and emphasizing both the museum's reflection on its own nature and the visitors' spatial experience.

Jan Hoet: Wenn ich Ihnen diese Fragen über Gewalt und Zerstörung – auch über die Zerstörung von Codes – stelle, tue ich das in der traditionellen, psychologischen, an gewisse Theorien von Freud anknüpfenden Art. Ich glaube allerdings, daß dieser Ansatz Ihren Arbeiten nicht entspricht. Und ich habe den Eindruck, daß es manchmal genau zu diesem Mißverständnis kommt, wenn sich Leute mit Ihren Arbeiten auseinandersetzen, wenn Leute Angst haben, Ihre Arbeiten zu zeigen – sie sehen Ihr Werk nicht als Abstraktion, als autonom artikulierten Komplex, der unabhängig von den gesellschaftlichen und psychologischen Aspekten der zahlreichen ihn umgebenden nebensächlichen ›Ismen‹ Bestand hat. Das ist auch der Grund dafür, daß man den Wiener Aktionismus so lange unterschätzt hat.

Chris Burden: Das ist bei mir ja nur dann der Fall, wenn die Leute nicht mein gesamtes Werk kennen und nur von den Performances wissen. Die Performances sind wirklich bekannt geworden. Das ist der Grund für das Problem. Wenn man einmal wegen etwas berühmt wird, dann soll man immer wieder dasselbe tun, weil das für das Publikum und – nebenbei bemerkt auch für die Kritiker – bequemer ist. Da hat jemand ein Werk bereits verdaut, und auf einmal ändert sich der Künstler. Also muß auch er sich ändern. Daß man in jungen Jahren für eine bestimmte Art von Arbeiten bekannt wird, ist sicher ein Problem. Für mich gibt es einen Zusammenhang zwischen allen meinen bisherigen Arbeiten, aber der ist vielleicht für jemanden anderen nicht so leicht zu erkennen. 1975 habe ich bereits aufgehört, Performances zu machen! Ich würde mir wünschen, daß man meine jüngeren Arbeiten mehr wahrnehmen würde.

1 Jan Hoet bezieht sich hier auf die doppelte Produktnatur des Kunstwerks: einerseits als künstlerisches Produkt, als dreidimensionale Dinglichkeit, andererseits als kommerzielles Produkt im Rahmen des kapitalistischen Warenzyklus.

2 Die Performance *Five Day Locker Piece* war Burdens Abschlußarbeit seines Kunststudiums an der University of California, Irvine. Die fünf Tage von 26. bis 30. April 1971 verbrachte Burden eingesperrt in einem Schließfach von 60 x 60 x 90 cm. Im Schließfach darüber befand sich ein 19-Liter-Wasserbehälter, im Schließfach darunter ein Behälter zur Urinaufnahme.

3 Die Ausstellung *Body Movements* im Museum of Contemporary Art, La Jolla, 1971, gemeinsam mit Mowry Baden und Bruce Nauman.

4 *Shoot* (1971), eine von Burdens frühesten Performances, bestand aus einem einzigen Schuß, den Burden sich von einem Freund aus etwa 5 Metern Entfernung in den Oberarm schießen ließ.

5 Der eigentliche Titel der Installation *All the Russian Tanks* war *The Reason for the Neutron-Bomb* (1979); der Ausdruck, den Burden im Gespräch verwendet, verweist allerdings auf deren Parallelität zu einer späteren Arbeit: *All the Submarines of the United States of America* von 1987, eine aus 625 Miniatur-U-Booten bestehende Installation. *The Reason for the Neutron-Bomb* wurde für die Ronald Feldman Gallery, New York, geschaffen und thematisiert die Absur-

9 This refers to the installation *Another World* (1992). Burden used an engine to rotate ship-models of the Titanic fixed to a model of the Eiffel Tower at great speed. The work was shown as part of the group exhibition of Californian artists LAX at the Krinzinger Gallery in Vienna from November 4 to December 22, 1992.

10 *The Bed Piece* (1972) is one of the few performances not dealing with forms of violence. It may be said to belong to the border area between body art and surrealistic humour. Exposing himself as a living sculpture so to speak, Burden stayed in bed for the full extent of his 22-day one-man show in Venice, California.

dität der dem Wettrüsten während des Kalten Kriegs zugrundeliegenden Legitimation, derzufolge die sowjetische Übermacht an Panzern in den USA durch die Neutronenbombe wettgemacht werden müsse. In der Installation wurde jeder der 50 000 sowjetischen Panzer durch einen Nickel (5 Cent) und ein Streichholz dargestellt - eine doppelte Konfiguration der militärischen Wirtschaftskraft und Feuerkraft.

6 Burden wurde eingeladen, an der ersten »Österreichischen Triennale zur Fotografie 1993« teilzunehmen, die von 17. 9. bis 31. 10. 1993 in der Neuen Galerie am Landesmuseum Joanneum in Graz stattfand. Das Thema der Triennale war »KRIEG« und die Aufgabenstellung war es, in Hinblick auf Ex-Jugoslawien zur »Situation Krieg« Stellung zu beziehen. Chris Burden hat aus den geschilderten Gründen nicht an der Ausstellung teilgenommen.

7 Die Installation *The Fist of Light* (1992-93) wurde für die *Biennial Exhibition* im Whitney Museum (4. März - 20. Juni 1993) realisiert.

8 Der Verweis bezieht sich auf die Rauminstallation Vito Acconcis im Rahmen der Ausstellung *The City Inside Us*, die zur Zeit des Gesprächs (von 17. März bis 29. August 1993) im MAK-Österreichisches Museum für angewandte Kunst zu sehen war. Die 600 m² große und 15 m hohe Ausstellungshalle des Museums mit ihrem Glasdach wurde verkippt als Raum im Raum nachgebildet, so daß eine begehbare, teilweise begrünte Konstruktion entstand, die in der Verschiebung und Verdopplung des Ausstellungsraums sowohl die Selbstreflexion des Museums als auch das räumliche Erleben des Besuchers thematisierte.

9 Gemeint ist die Installation *Another World* (1992), bei der ein Motor an ein Eiffelturmmodell gehängte Titanic-Schiffmodelle in rasende Rotation versetzte, gezeigt im Rahmen der Gruppenausstellung kalifornischer Künstler LAX in der Galerie Krinzinger, Wien, von 4. 11.– 22. 12. 1992.

10 *The Bed Piece* ist eine der wenigen Performances Burdens, die sich nicht mit den Erscheinungsformen der Gewalt auseinandersetzen, sondern im Grenzbereich zwischen Body-art und surrealem Humor angesiedelt sind. Die 22 Tage von 18. Februar bis 10. März 1972 verbrachte Burden im Bett (in einer Galerie in Venice, Kalifornien) und stellte sich derart als lebende Skulptur selbst aus.

RIEDL

WOODS

LEBBEUS WOODS:
The space could also become a weapon ...
A conversation with Joachim Riedl

Joachim Riedl: There are many questions one could start with. The one that interests me most is: How [could we today] develop new, different urban and social spaces? For example, how do we generally define city centers? Mostly as political monuments or as monuments to strong economic powers. And who is actually defining these things? Everybody seems to agree on these concepts and no one challenges them, no one seems to believe that there are other options, that there could be alternatives. You are one of those architects who think about alternative definitions, about alternative questions – of those who challenge the status quo by the very nature of their projects.

Lebbeus Woods: I would like to refer to the Architecture Conference at the MAK, just for few moments. The title that Peter Noever established for this meeting was "The End of Architecture?"[1]. This title had certain inherent ambiguities. I would interpret it now

Lebbeus Woods, War and Architecture Series n°1, 1992

as an end of architecture as professional activity. It is not the end of ideas, not the end of architecture as a physical fact, but as a professional pursuit.

I think the end of architecture is upon us in terms of the idea of a professional person who is trained in a variety of fields, who understands history, some aspects of culture, who reads books and is supposed to manifest [this global culture] in form of a building that occupies its place in the civic realm. The situation has changed now, because architects are no longer independent spirits. They are no longer 'artists' but have been absorbed into corporate structures, bit by bit. Therefore, they are expected to follow the ideology and the

LEBBEUS WOODS:
Der Raum könnte auch zur Waffe werden ...
Ein Gespräch mit Joachim Riedl

Joachim Riedl: Man könnte ja mit vielen Fragen beginnen. Mich interessiert aber vor allem, wie man heute andere urbane, andere gesellschaftliche Räume schaffen kann. Wie werden zum Beispiel Stadtzentren definiert? – Zur Zeit doch wohl meist als politisches Denkmal oder als Denkmal für starke wirtschaftliche Mächte. Wer bestimmt eigentlich diese Definitionen? Jeder scheint die herrschenden Vorstellungen zu akzeptieren, ohne sie in Frage zu stellen, niemand scheint zu glauben, daß es da andere Möglichkeiten gibt, Alternativen zum Bestehenden. Sie sind einer jener Architekten, die über andere Definitionen und Fragestellungen nachdenken, die bereits durch die Art ihrer Projekte den Status quo in Zweifel ziehen ...

Lebbeus Woods: Ich möchte zuerst einmal kurz auf die Architekturkonferenz im MAK[1] eingehen. Peter Noever hat sich damals für den Titel »Architektur am Ende?« entschieden – ein in verschiedener Hinsicht mehrdeutiger Titel. Für mich bedeutet er heute das Ende der Architektur als berufliche Tätigkeit. Nicht das Ende der Architektur als Idee, als materielle Gegebenheit, sondern das Ende der Architektur als berufliche Aufgabe steht im Vordergrund.

Es ist, so meine ich, eine bestimmte Vorstellung obsolet geworden: die Vorstellung des Architekten als „Professional", der in verschiedensten Fachgebieten ausgebildet ist, etwas von Geschichte versteht, sich mit kulturellen Fragen beschäftigt hat, Bücher liest und der die Fähigkeit besitzt [diese globale Kultur] in einem Gebäude zu vergegenständlichen, das im gesellschaftlichen Gefüge seinen Platz hat. Die Situation hat sich sehr verändert, weil Architekten heute kaum mehr unabhängig denken. Sie sind heute keine freien »Künstler« mehr, da sie Stück für Stück von Betriebsstrukturen vereinnahmt wurden. Man erwartet von ihnen, daß sie sich jener Wirtschaftsideologie und deren Voraussetzungen fügen, die den Strategien und Vorgangsweisen der Konzerne nützen. Und die wenigen Architekten, die das nicht tun, die gelten dann als alternativ, nicht wahr? Die paar, die sich weigern, dem vorgeschriebenen Programm zu folgen, die bilden

assumptions that underline corporate maneuvers, corporate action. Those few architects who don't do that, represent the alternative, right?! The ones who won't follow the proscribed program are so-called alternatives! In a curious way that is a mistake. The few architects who refuse to conform to, and follow the corporate definition of the architectural practice are the ones, in fact, who are acting as agents for society in general and for the changes society is undergoing.

The idea of "making space" or "making forms that define space" brings up certain [shared] assumptions. They exist in the very room we sit in, built into the idea of space. It's a kind of Cartesian world of predictable measurements. We can measure space very exactly according to the language and the systems that permeate society. And yet, these systems are being overrun by everyday events – political events, societal events – by those things that are happening not in art galleries but down at the core of society, there where values are being transformed. Architects who are going outside of the former idea of professional architectural practice are really acting at the core, at the center, not at the edge! They are trying to take on the tough issues of the changes in everyday life that are happening to people all over the world; to [people] who have become destabilized – politically, economically – who don't have jobs any more, whose country is dissolving, who don't even belong anymore to the same country, or who live in the city that is attacked by social unrest. I react against this "alternative" idea because I think that these few architects are acting in the mainstream of where architecture belongs, and that is in society itself, in its needs and turbulences.

Joachim Riedl: So you are talking about the social responsibilities [of the architect]. Architecture as you define it, architecture established in the mainstream, cannot be associated with some kind of detached virtues, a glossary of aesthetic ideas. You said that [mainstream architects] react to events, but shouldn't it be, ideally, that you would be ahead of the event?

Lebbeus Woods: The minimum quest is the one for participation. If you are not some kind of leader of the event, you should be able to participate as it is happening. Another attitude is to try to imagine what might occur from twenty-five possibilities of a given moment – and guess two or three of the most favorable outcomes. But at least one should be engaged in the changes of the present time and not be following, which for an architect means to provide the physical manifestation of that present.

dann die sogenannte Alternative! Es mag vielleicht sonderbar klingen, aber ich halte das für einen Irrtum. Die wenigen Architekten, die sich weigern, sich der wirtschaftlichen Definition der Architekturpraxis anzupassen und zu unterwerfen, sind in Wirklichkeit diejenigen, die die Anliegen der ganzen Gesellschaft und der in ihr stattfindenden Veränderungen vertreten.

Was nun das »Schaffen von Räumen« angeht, beziehungsweise das Schaffen von »Formen, die Räume definieren«, gibt es bestimmte [gemeinsame] Voraussetzungen. Diese sind genau auch in diesem Saal, in dem wir uns befinden, in die Idee des Raums eingeschrieben. Wir haben es mit einer Art kartesianischer Welt absehbarer Größen zu tun. Mit der Sprache und den Systemen, die eine Gesellschaft durchdringen, können wir Raum sehr genau messen. Aber diese Systeme werden heute von verschiedenen Ereignissen politischer und gesellschaftlicher Art überwältigt – von jenen Dingen, die nicht in den Kunstgalerien stattfinden, sondern tief im Herzen der Gesellschaft, dort, wo sich Werte verändern. Architekten, die sich außerhalb der traditionellen Vorstellung von professioneller Architektur bewegen, agieren in Wirklichkeit im Zentrum und nicht am Rand der Gesellschaft! Wir versuchen uns den komplizierten Fragen zu stellen, die die Veränderungen im Alltag der Menschen aufwerfen, überall auf der Welt – Menschen, die politisch oder wirtschaftlich aus der Bahn geworfen wurden, ihre Arbeit verloren haben, deren Land zerfällt oder geteilt wird, sodaß sie ihre Heimat verlieren, die in Städten leben, die von sozialen Unruhen heimgesucht werden. Ich wehre mich gegen diese Vorstellung von *alternativ,* weil ich meine, daß gerade diese wenigen Architekten im Mainstream dessen arbeiten, wo Architektur eigentlich hingehört – und das ist die Gesellschaft selbst, ihre Nöte und Umbrüche.

Joachim Riedl: Sie verweisen also auf eine gewisse gesellschaftliche Verantwortung [des Architekten]. Architektur in Ihrem Sinn, Architektur im Mainstream, hat nichts mit irgendwelchen abgehobenen Tugenden zu tun, stellt kein Verzeichnis ästhetischer Vorstellungen dar. Sie reagieren auf Ereignisse – aber sollte es nicht idealerweise so sein, daß Sie den Ereignissen voraus sind?

Lebbeus Woods: Zumindest sollte man sich um Mitwirkung bemühen. Das ist die minimale Forderung. Wenn man ein Ereignis schon nicht selbst bestimmt, sollte man wenigstens versuchen, am Geschehen beteiligt zu sein. Eine andere Möglichkeit ist, sich vorzustellen, was aus fünfundzwanzig verschiedenen Möglichkeiten eines bestimmten Augenblicks werden könnte, und dabei versuchen, die zwei oder drei wahrscheinlichsten zu erahnen und zu verfolgen. Zumindest soll-

Lebbeus Woods, Model/Modell Double Landscape Vienna, 1991

Joachim Riedl: But is the work then a consequence of what happened at the same time?

Lebbeus Woods: Not really, and certainly not more than anyone else's in society. I don't know how the people sitting in this room feel about it – are they only the consequence of their society, or participants? I hope we are all spontaneously interacting and not just replying to the 'offer': "This is a pattern. Let's follow it!" My point about [professional architects] was that the majority at the moment is only following.

Joachim Riedl: Can you elaborate on how participation would look like? What would it require?

Lebbeus Woods: Today participation requires some speed of action. It is no longer possible to participate and wait for five years for a project to get realized, or to see some manifestation of your thinking. I think that there needs to be some kind of spontaneity in architecture today, which is exactly one thing historically denied to it. Architecture was always supposed to be that thing which codified in a physical form the great truths carried from generation to generation. I think that's over now. I think architecture needs to have an element of invention that rises out of the experience of the moment. This has never existed in architecture.

Again, the small group of architects I was referring to is developing this idea of an architecture of spontaneity, of direct engagement – a word used by the ex-

te man sich in den Veränderungen der Gegenwart engagieren und ihnen nicht nur folgen, und das heißt im Fall des Architekten: die physische Ausdrucksform für diese Realität zu schaffen.

Joachim Riedl: Aber ist dann nicht das Werk zugleich ein Resultat dessen, was geschieht?

Lebbeus Woods: Nicht wirklich, und sicher nicht mehr als alles andere, was jemand in der Gesellschaft tut. Ich weiß nicht, wie die hier in diesem Raum Anwesenden zu dieser Frage stehen – halten sie sich für ein bloßes Ergebnis ihrer Gesellschaft oder nehmen sie an ihr teil? Ich jedenfalls hoffe, daß wir alle spontan interagieren und nicht nur das »Angebot« mit den Worten begrüßen: »Das ist das Muster. Folgen wir ihm!« [Meine Beurteilung der professionellen Architekten] bezog sich eben darauf, daß die meisten nur mehr den vorgegebenen Mustern folgen.

Joachim Riedl: Können Sie näher darauf eingehen, was Sie unter Mitwirkung verstehen? Was gehört da dazu?

Lebbeus Woods: Man muß vor allem rasch handeln können. Es ist heute nicht mehr möglich, sich am Geschehen beteiligen zu wollen und zugleich fünf Jahre darauf zu warten, daß ein Projekt verwirklicht wird oder daß die eigenen Gedanken irgend etwas bewirken könnten. Ich meine, daß es heute in der Architektur einer gewissen Spontaneität bedarf, einer Eigenschaft also, die der Architektur historisch gesehen abgesprochen wurde. Man hat Architektur immer für die kodifizierte Materialisierung der von Generation zu Generation weitergegebenen großen Wahrheiten gehalten. Damit scheint es heute vorbei zu sein. Ich glaube, daß Architektur ein erfinderisches Element haben muß, das über die Erfahrungen des Augenblicks hinauswächst. Das hat es bisher in der Architektur nicht gegeben.

Die kleine Gruppe von Architekten, auf die ich mich vorher bezogen habe, verfolgt diese Idee einer Architektur der Spontaneität, des direkten Engagements, wie die Existentialisten sagten, des Engagements in der Gegenwart. Mag sein, daß man sich damit dem Vorwurf aussetzt, altmodisch zu sein, den sechziger, siebziger, achtziger, neunziger Jahren anzugehören, aber dieses Risiko muß man sowieso eingehen.

Joachim Riedl: Akzeptieren sie solche Zuordnungen wirklich?

Lebbeus Woods: Daß ich keine Kunst der sechziger Jahre mache, weiß ich. Wenn Sie aber auf Etikettierungen bestehen, dann würde ich sagen, daß ich jetzt im Augenblick Neunziger-Jahre-Sachen mache, und zwar *Mainstream-Nineties!*

istentialists – engagement in the present. O.K., maybe one runs the risk of being dated, of being 60es, or 70es, or 80es, or 90es, but one will have that risk anyway, so why not go all the way with it!

Joachim Riedl: Do you really accept these labels?

Lebbeus Woods: I am not 60es, that I know for sure – if you want me to follow the labels, right now I am Nineties..., mainstream Nineties!

There is another aspect of architecture that I think is changing: This is the role of the few institutions of culture where inventiveness still can occur. Architecture is not necessarily about constructing buildings anymore, and I am aware that some of my colleagues don't agree with this. I enjoyed the talk between Ziva Freiman and James Turrell, especially the question dealing with learning about things through publications, newspapers, television, all these mediated experiences of space. James Turrell has a strong position in this regard, a position which I respect. Mine is very different. I feel that to experience space through the media is part of our

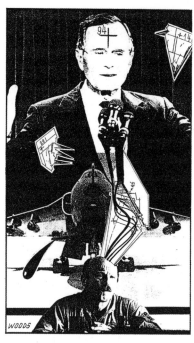

Lebbeus Woods, Axis of Symmetry, Collage *zu/collage for Zagreb Free Zone, 1991*

culture, so why not involve ourselves with that experience. Let's use [the media] as a strength and not as a weakness. Being an American and growing up without the ability to travel and visit all the great monuments of architecture around the world, I learned about them through books. I don't feel deprived because of that. Maybe one learns about the great Angkor Wat through books only, but that doesn't mean that one doesn't learn about it. It is just a different level of experience, perhaps more conceptual. Along the same line of logic, perhaps it is possible as an architect practicing today not to always execute a design in order to make a space. We can make space through mediated forms. It is, however, a difficult idea to accustom oneself to, if one is used to the idea that architecture is only constructed buildings.

Joachim Riedl: If I further develop your argument, I ultimately reach a point where it becomes necessary to enlarge the concept of space from something purely physical into something more 'ideal' – where, for example, information per se should be treated as a space-design.

Ich denke, daß auch ein anderer Aspekt der Architektur im Wandel begriffen ist, und zwar die Rolle der wenigen Kulturinstitutionen, in denen es noch Raum für Einfallsreichtum gibt. Auch wenn ich weiß, daß mir da einige Kollegen widersprechen werden, meine ich, daß es heute in der Architektur nicht mehr unbedingt um das eigentliche Bauen geht. Mir hat das Gespräch zwischen Ziva Freiman und James Turrell sehr gefallen, insbesondere der Teil, in dem davon die Rede war, daß man seine Informationen durch Publikationen, Zeitungen und Fernsehen erhält, vor allem in Bezug auf vermittelte Raumerfahrungen. James Turrell vertritt da einen ganz klaren Standpunkt, den ich anerkenne, auch wenn ich ganz anders darüber denke. Mir kommt vor, daß die mediale Erfahrung von Raum Teil unserer Kultur ist, und wir uns daher auf diese Erfahrung einlassen sollten. Ich meine, daß man sich der Stärken und nicht der Schwächen [der Medien] bedienen sollte. Als Amerikaner, der ohne die Möglichkeit aufgewachsen ist, die großen Baudenkmäler dieser Welt zu besuchen, war ich auf Bücher angewiesen. Ich fühle mich deshalb nicht benachteiligt. Wenn man vom großen Angkor Wat nur aus Büchern erfährt, heißt das doch nicht, daß man garnicht davon erfährt. Das ist eben eine andere, vielleicht etwas konzeptuellere Ebene der Erfahrung.

Überträgt man diesen Gedanken auf die Architektur von heute, könnte das heißen, daß wir einen Entwurf nicht immer ausführen müssen, um einen Raum zu schaffen. Wir schaffen heute rein mediale Räume. Es ist freilich nicht ganz einfach, diese Vorstellung zu akzeptieren, wenn man gewöhnt ist, Architektur immer als gebaute Form zu verstehen.

Joachim Riedl: Wenn ich diesen Gedanken fortführe, gelange ich schließlich an einen Punkt, an dem es notwendig wird, den rein materiellen Begriff des Raums zu erweitern und in einen »ideelleren«, abstrakteren Kontext zu stellen – wo zum Beispiel Information an sich als Raumentwurf Gültigkeit hat.

Lebbeus Woods: Ja, sicher. Es geht doch darum, daß unsere Vorstellung von Raum heute viel komplexer ist als früher, weil die verschiedenen Ebenen der medialen Vermittlung dazugekommen sind und wir alle in diesem Bereich agieren. Mir kommt es nicht darauf an, ob wir Architekten Gebäude bauen oder nicht. Wenn Richard Rogers[2] – und das ist ein Architekt, der baut – irgendwo ein Gebäude errichtet, erfährt das der Rest der Welt durch die Medien. Letzten Endes ist dieser mediale Raum sein Raum. Warum sollte man sich zum Beispiel nicht all der wunderbaren Hollywood-Techniken bedienen, um ein Gebäude einfach zu simulieren, das auf der ganzen Welt zu veröffentlichen und schließlich

Lebbeus Woods: Of course. The point is that our idea of space today is much more complex than it used to be. It now has these other layers in the mediated domain and we are all operating in it. I don't care if we are building buildings or not. If Richard Rogers[2] builds a building somewhere – and he is certainly a building architect – it reaches the rest of the world through the media. His space is ultimately the mediated space. Why couldn't you, for example, use all those wonderful techniques of Hollywood to simply simulate the building of a building and publish it around the world, and still be able to claim that you had made that space? This is an epistemological argument.

Joachim Riedl: We are approaching the notion of virtual-reality-architecture.

Lebbeus Woods: Sure we are. But we come to it through a variety of directions, not only through its NASA-high-tech version. We can talk about some things in this museum right now, about [Vito] Acconci's installation[3] – as belonging to virtual and real [space]. The virtual doesn't have to be just the high-tech helmet and gloves phenomenon. But we are straying a bit from what we really wanted to talk about.

Joachim Riedl: About war! About conflicts between power-structures which make architects obedient and about those [architects] who are disobedient. About your *Free-Zone* project for Berlin[4].

Lebbeus Woods: I am not trying to be disobedient, and [my attitude] is certainly not just about being a bad boy – although I probably have some of that in me too.

As far as the Berlin project, it seems to me that a city which has become a museum, a cultural theme park, where tourism is the strongest industry, leaves out important human opportunities. Everything is labeled in advance, all meanings are pre-set, and these preconceptions determine the whole structure of the center of the city – in terms of "this important sight" and "that historic place". Something meaningful in human terms gets lost. What I did in the Berlin project in reaction to these tendencies was to insert into the existing city structure a series of spaces that were invisible, buried within actual buildings. There I introduced the concept of "useless and meaningless" space as the real potential of architecture in our time. I called it Free-Space[5] because [space of this kind] is free of predetermined meaning, free of typologies, available for all people, race, gender, and free of predetermined programs of use – be it a museum, a hotel, a hospital, or apartments. All these [functional units] need to be re-examined in terms of those very same "type-ing" procedures. For me, Free-Space is

den Anspruch erheben, diesen Raum geschaffen zu haben? Aber das ist eine epistemologische Frage ...

Joachim Riedl: Damit nähern wir uns der Vorstellung von Architektur als virtueller Realität.

Lebbeus Woods: Das stimmt. Allerdings auf verschiedene Weise, nicht nur in der High-Tech-Variante der NASA. Man kann einige Dinge, die es zur Zeit in diesem Museum hier zu sehen gibt, wie die Installation Vito Acconcis[3] zum Beispiel, als virtuell[en] und real[en Raum] bezeichnen. Virtuelle Wirklichkeit muß nicht immer Helm, Handschuhe und High-Tech heißen. Aber ich glaube, wir sind ein wenig von unserem Thema abgekommen.

Joachim Riedl: Wir wollten über Krieg sprechen, über Konflikte zwischen Machtstrukturen, die Architekten gehorsam machen, und über Architekten, die unfolgsam sind – wie Sie zum Beispiel, mit Ihrem *Berlin-Free-Zone* Projekt[4] ...

Lebbeus Woods: Mir liegt nicht daran, unfolgsam zu sein. Mir geht es nicht darum, das schlimme Kind zu spielen – auch wenn ich das natürlich irgendwo bin. Was das Projekt in Berlin betrifft, so meine ich, daß die Vorstellung einer Stadt als Museum, als kultureller Erlebnispark, in dem der Tourismus zur wichtigsten Industrie geworden ist, entscheidende menschliche Möglichkeiten ausschließt. Alles hat im vorhinein sein Etikett, jede Bedeutung ist festgelegt, und die vorgefaßten Meinungen bestimmen – mit Begriffen wie »diese wichtige Sehenswürdigkeit« oder »dieser historische Platz« – die Gesamtstruktur des Stadtzentrums. Da geht etwas in menschlicher Hinsicht Sinnvolles verloren. Ich habe bei meinem Berliner Projekt auf diese Tendenzen reagiert und in die bestehende Stadtstruktur eine Reihe unsichtbarer, in den vorhandenen Gebäuden verborgener Räume eingefügt. Für diese Räume habe ich die Idee des »nutzlosen und bedeutungslosen« Raums als Potential für die Architektur von heute formuliert. Ich habe das *Free Space*[5] – Freiraum – genannt, weil räumliche Strukturen dieser Art von im voraus festgelegten Bedeutungen frei sind. Sie sind frei von typologischen Vorstellungen, für Menschen jeder Rasse und jeden Geschlechts zugänglich, frei von vorprogrammierten Verwendungszwecken – sei es als Museum, als Hotel, als Spital oder für Wohnungen. Alle diese [funktionalen Einheiten] müssen in Hinblick auf eben diese Typisierungen überdacht werden. Ich wollte, daß man den Freiraum als in der Stadt steckendes Potential versteht. Ich kann natürlich nicht garantieren, daß daraus ein kreativer Ort entsteht oder daß die Menschen diesen Ort auf kreative Weise nutzen werden. Vielleicht wird der Raum auch immer leer bleiben.

to be understood as a potential within the city. I cannot guarantee that it would become a creative place, or that the people would occupy it in a creative way. Maybe it will always remain empty.

Joachim Riedl: In other words, that means that this space is free to become whatever its inhabitants propose it to be, that it can be conquered by whatever meaning or use?

Lebbeus Woods: Exactly. Some of it can be very questionable, some of it can be quite exciting. I have been very much criticized for this [freedom of choice] because some see in it fascistic possibilities, others see in it total anarchy.

Joachim Riedl: In what way fascistic?

Lebbeus Woods: Well, what if skinheads get hold of it? If it's free, how can they be stopped, and should they be?

The Free-Spaces I proposed for the center of Berlin are something like interior landscapes, and not the standard architectural spaces that can be understood and occupied in familiar ways. These landscapes are [equipped] with all the elements of electronic communication technology, from television, radio, fax to computers linked world-wide to all the major data bases that are presently controlled by corporations and governments. If one had that kind of power [the space] could become a weapon. But this is always the danger when you give people power! And that's where the state, where law comes in: to control the use of power.

Increasingly, power means the power over data, the access to information. What if we really had freedom, meaning the freedom to get to and use information? What would we try to do? Would we try to rule the world, or would some compassion that we might have for each other or ourselves be the manifestation we would make of that power? What I proposed in Berlin is risky, but it is a risk that has to be taken if we are going to have a society in which the notion of justice has any significance.

Joachim Riedl: Every democratic process is risky in itself. You cannot create a society or an urban space, or any kind of architecture without taking risks.

Lebbeus Woods: Let's go back to the question: Who commissions buildings? Who has the money to do so? In the MAK, this wonderful manifestation of culture, art, ideas – who is providing the money for it? Can these people be "tricked" to provide money for things that are undercutting their power?

Joachim Riedl: In other words, it is very hard to get [commissions for the realization of] things which question those who give you the commission.

Joachim Riedl: Das heißt, daß aus dem Raum werden kann, was seine Bewohner wollen, daß er durch jede Bedeutung und jeden Zweck erobert werden kann?

Lebbeus Woods: Genau. Manches daran kann sehr fragwürdig, aber manches auch sehr aufregend sein. Ich wurde [wegen dieser Offenheit] ziemlich angegriffen: manche haben gemeint, daß man dadurch dem Faschismus eine Möglichkeit bietet, andere haben von totaler Anarchie gesprochen.

Lebbeus Woods, Dreadnought, Collage zu/collage for Zagreb Free Zone, 1991

Joachim Riedl: Inwiefern Faschismus?

Lebbeus Woods: Na, was ist, wenn Skinheads von dem Raum Besitz ergreifen? Wenn es sich um einen freien Raum handelt, was kann man dann dagegen tun? Und soll man überhaupt etwas dagegen tun?

Die Freiräume, die ich für das Stadtzentrum von Berlin vorgeschlagen habe, sind so etwas wie innere Landschaften, ganz anders als die Standardräume unserer herkömmmlichen Architekturvorstellung, die man in vertrauter Weise verstehen und bewohnen kann. In diesen Landschaften gibt es alle Elemente der elektronischen Kommunikationstechnologie – Fernsehen, Radio, Fax und Computer, die an die größten und heute von Konzernen und Regierungen kontrollierten Datenbanken der Welt angeschlossen sind. Wenn einer diese Macht besäße, könnte [der Raum] auch zur Waffe werden. Aber es ist eben immer gefährlich, wenn man Menschen Macht gibt! Wie benützen wir die Macht, die wir haben? Wenn es darum geht, den Gebrauch der Macht zu kontrollieren, setzt die eigentliche Rolle des Staates, des Gesetzes ein. Macht heißt immer mehr: Macht über Daten, Zugang zu Information. Was würde geschehen, wenn wir wirklich frei wären, wenn wir frei auf Information zugreifen und diese frei verwenden könnten? Würden wir versuchen, die Welt zu beherrschen, oder würden wir die Macht, über die wir verfügen, in einer Form des Mitgefühls zum Ausdruck bringen, die wir vielleicht füreinander oder für uns selbst empfinden? Was ich in Berlin vorgeschlagen habe, ist gefährlich, aber wenn wir eine Gesellschaft wollen, in der Gerechtigkeit etwas bedeutet, muß man diese Gefahr auf sich nehmen.

Joachim Riedl: Jeder demokratische Prozeß birgt Gefahren in sich. Man kann weder eine Gesellschaft noch einen urbanen Raum oder Architektur überhaupt schaffen, ohne gewisse Risiken einzugehen.

Lebbeus Woods: Kommen wir auf die Frage zurück, wer Gebäude in Auftrag gibt. Wer hat das Geld dazu? Von wem kommt zum Beispiel das Geld für das

Lebbeus Woods: Yes. Basically you have to lie. Another [possibility] is to make the ultimately difficult, idealistic argument: Even though this doesn't sound like it is good for the state or for society because it could be anarchistic or nihilistic, nevertheless it is really good and necessary.

Joachim Riedl: Have you tried [this argumentation]?

Lebbeus Woods: Yes. I've been a complete failure at this game. But some of the architects I have spoken about earlier have managed to have a few lucky breaks and to achieve something. But it is all so small, and that is the real problem. A whole world is being created out there, day to day, with vast human resources being poured into it, with incredible amounts of money, energy, skill, technology. And yet, [real] architecture is being reduced to a pinhead. Remember that medieval problem about how many angels can dance on the head of a pin? That's what architecture now has become. It's been forced to the size of a microchip, but without the power to be plugged in. The power of architecture today – and I don't mean building per se – is very small.

Joachim Riedl: But what is the answer to that question?

Lebbeus Woods: The answer to that question [that I would suggest] was given by Alfred North Whitehead, who wrote in the twenties *Science and the Modern World*[6]. In this Harvard lecture, he talks about the development of science into world-transforming technologies, and [comes to the conclusion] that ideas are still the most powerful forces in the word.

Architects have the stewardship over the ideas with regard to the conception and the making of space – if they choose to be conscious of them and to push them forward. Our ideas shouldn't become watered-down or filtered-through corporate processes that reduce them to powerlessness. Our ideas can directly link architecture and human beings without the filter of corporate enterprise. Ideas can be transmitted from architects to the people and back. That's the relationship to be sought. .

Joachim Riedl: Let me summarize what you just said: Architects shouldn't care about construction, because whatever is built is bound to fall apart and crumble anyhow. They should concentrate on the vision, on the projection of their ideas as visionary alternatives – I am sorry to come back to this word. Since we live in ruins, let's not waste our time with strengthening the ruins, or replacing them with new ones.

Berlin, it seems to me from what we've said, is a perfect example of a city with possibilities and opportunities but lacking ideas. The easiest and most conven-

MAK, für diese wunderbaren Zeugnisse von Kultur, Kunst und Ideen? Kann man diese Leute reinlegen und dazu bringen, daß sie Geld für Dinge hergeben, die möglicherweise gegen sie arbeiten?

Joachim Riedl: Anders gesagt: Es ist sehr schwierig, [Aufträge für die Verwirklichung von] Dingen zu bekommen, die diejenigen in Frage stellen, die den Auftrag vergeben.

Lebbeus Woods: Ja. Eigentlich müßte man immer lügen. Man könnte natürlich auch die allerschwierigste, alleridealistischste Argumentation aufbauen: Dieses Projekt klingt zwar so, als sei es für den Staat oder die Gesellschaft nicht gut, weil es anarchistisch oder nihilistisch zu sein scheint, ist aber in Wahrheit gut und notwendig.

Joachim Riedl: Und das haben Sie einmal versucht?

Lebbeus Woods: Ja, habe ich. Ich bin aber ein völliger Versager, was diese Spielchen angeht. Einige der vorher erwähnten Architekten hatten manchmal Glück und es ist ihnen gelungen, mit dieser Methode etwas zu realisieren. Aber der Bereich ist so winzig, und das ist das eigentliche Problem. Da wird eine Welt geschaffen, Tag für Tag, da werden gewaltige menschliche Ressourcen hineingesteckt, unglaubliche Mengen an Geld, Energie, Geschick, technischem Können. Und »wirkliche Architektur« wird auf die Größe eines Stecknadelkopfs reduziert. Sie kennen das mittelalterliche Rätsel mit den Engeln? Wie viele Engel können auf dem Kopf einer Stecknadel tanzen? So ist das mit der Architektur heute. Man hat die Architektur auf die Größe eines Mikrochips eingeschrumpft – allerdings ohne ihr das Potential eines Chips zu verleihen. Die Architektur – und damit meine ich nicht das Bauen an sich – hat heute eine nur ganz geringe Macht.

Joachim Riedl: Aber was heißt das?

Lebbeus Woods: [Meiner Meinung nach] hat Alfred North Whitehead in seinem in den zwanziger Jahren erschienenen Buch *Science and the Modern World*[6] diese Frage beantwortet. In dieser Harvard-Vorlesung spricht er von der Entwicklung der Wissenschaften zu weltverändernden Technologien, und [kommt zu dem Schluß, daß] Ideen noch immer das Mächtigste auf der Welt sind. Im Hinblick auf Konzeption und Gestaltung von Raum sind es die Architekten, die Ideen entwickeln und verwalten, wenn sie sich dieser Rolle nur bewußt sein und sie vorantreiben wollten. Wir sollten es nicht zulassen, daß unsere Ideen durch ökonomische Vorgänge so lange verwässert oder gefiltert werden, bis sie ihre Kraft verlieren. Ideen könnten das direkte Bindeglied zwischen der Architektur und den Menschen sein, wenn sie nicht durch Firmeninteressen gefiltert würden.

ient strategy is to fall back on old solutions. The entire "rebuilding" of Berlin was planned without vision, under immense time constraints, dominated by very traditional decision-makers. The literal reconstruction of the Royal Prussian Castle was just a logical consequence of the [politicians'] conservative understanding of Berlin's traditional role. The history of Twentieth Century Berlin, World War II, the Cold War have been simply obliterated for the sake of an earlier history.

Lebbeus Woods: [What they have done in Berlin is to apply] the traditional technique of masking reality, of concealing the reality which should be forgotten. This is the role architects always get cast into. The really sad thing is that there is so much pressure on the younger generations to adopt this behavior. Many of them go along with it, because it seems the respectable definition of the architectural profession. That's why I am very much against architecture as a profession. I hope that this [statement] doesn't get back to the United States, because I would immediately be fired from my teaching job at the University, since there all degrees are professional degrees!

I now would like to talk, more specifically, a little bit

Lebbeus Woods, Free-Space structure in transit, Collage zu/collage for Zagreb Free Zone, 1991

about the nature of experimentation, the nature of a more spontaneous interaction with society. I believe that anyone who chooses to be an architect chooses so not in order to be celebrated in the manner of fashion, but rather in order to participate in society on a very common level. Building in the city is a part of common life, and cannot be separated from it. The instinct to be an architect is an instinct to be on that level of life. Experimentation is along the lines of that part of architecture which has to do with the making of everyday space.

But what is the shape of this space, how is it shaped? The shape of the space is related to who is in it, who asks for it. People who only want to reaffirm existing values will ask for a known type of space. The question is: What happens if the architect, acting as an agent for culture and for people generally, might

Wir sollten uns darum bemühen, daß es zu einem Austausch von Ideen zwischen den Architekten und den anderen Menschen kommen kann.

Joachim Riedl: Ich will versuchen, Ihren Standpunkt zusammenzufassen: Architekten sollten sich nicht ums Bauen kümmern, weil alles Gebaute ja doch dazu verurteilt ist, einmal einzustürzen und zu zerbröckeln. Sie sollten sich ihren Visionen widmen, ihre Ideen als visionäre – ich muß leider wieder auf dieses Wort zurückgreifen – Alternativen zu entwickeln versuchen, und da wir nun schon einmal in Ruinen leben, sollten sie keine Zeit damit verschwenden, die Ruinen abzustützen oder durch neue Ruinen zu ersetzen. Berlin scheint mir unserem Gespräch zufolge das beste Beispiel für eine Stadt zu sein, in der es viele Möglichkeiten und Herausforderungen gäbe, es aber völlig an Ideen mangelt, und sich daher eine Situation ergeben hat, in der es sehr einfach und bequem geworden ist, auf alte Lösungen zurückzugreifen. Der gesamte »Wiederaufbau« von Berlin wurde ohne jede Vision und unter ungeheurem Zeitdruck geplant und von sehr traditionellen, konservativen Entscheidungsträgern bestimmt. Die detailgenaue Rekonstruktion des Königlichen Preußischen Schlosses war nur die logische Folge dieses sehr konservativen Verständnisses der geschichtlichen Rolle Berlins. Da hat man zugunsten einer älteren Geschichte auf das Berlin des zwanzigsten Jahrhunderts, auf den Zweiten Weltkrieg und den Kalten Krieg einfach verzichtet.

Lebbeus Woods: So kaschiert man nun einmal die Realität, versteckt jene Wirklichkeit, die vergessen werden soll. Diese Rolle wurde seit jeher den Architekten zugewiesen. Wirklich besorgniserregend ist aber, daß soviel Druck auf die jüngere Generation ausgeübt wird, dieses Verhalten zu übernehmen. Viele fügen sich, weil ihnen scheint, daß dies einer ehrenhaften Definition des Berufs des Architekten entspricht. Deshalb bin ich auch so sehr gegen die Vorstellung von Architektur als Beruf. Ich kann nur hoffen, daß das [, was ich hier sage,] in den Vereinigten Staaten niemandem zu Ohren kommt, sonst bin ich sofort meinen Job los – ich unterrichte ja Leute, die den Beruf des Architekten ergreifen wollen!

Ich möchte nun noch etwas näher auf das Wesen des Experimentierens, auf die spontane gesellschaftliche Interaktion mit dem Architekten eingehen. Ich meine, daß jeder, der sich entschließt, Architekt zu werden, das nicht tut, weil er wie die Mode gefeiert werden will, sondern weil er auf einer ganz normalen Ebene die Gesellschaft mitgestalten will. Städtisches Bauen ist Teil des normalen Lebens und untrennbar mit diesem verbunden. Der Wunsch, Architekt zu werden, entsteht aus dem Drang, auf genau dieser Ebene des Lebens zu handeln und

make space that does not conform to the familiar types of space and its established values? This occurs only on the level of experimentation, down in the trenches. It's in the dirty parts of architecture where materials are used for or coerced into shaping space, [resulting in] something that people can occupy, or inhabit in some new way, according to the architect's understanding of new conditions appearing just now in society. It is amazing how few architects are willing to take on that task. Ten – if I am not being too optimistic?! Even less than that. We are speaking here of a minority position attempting to speak to a majority.

Joachim Riedl: But do you really believe that there are all these people out there waiting for places ready for them to occupy, accessible to them? Or is it necessary to make people want to conquer spaces?

Lebbeus Woods: No. I don't think anyone should make people want to conquer anything. But people who have money to make space, to build buildings, are not making the kinds of space that many people

Lebbeus Woods, Free-Space structure in place (suspended), Zeichnung zu/drawing for Zagreb Free Zone, 1991

might be ready to occupy, if it were available. It simply is not available, so people, all of us, only have a choice within a very limited spectrum. If there were more experimental spaces enabling the spontaneity, the flux and dynamics of modern society, you might be surprised to find many people eager to occupy them. But they aren't being built! And this fact accounts for the growing public interest in virtual space, the importance of new kinds of spaces at present experienced only through the media..

Joachim Riedl: At the same time, nobody is demanding experimental space.

Lebbeus Woods: How should they demand? Make a demonstration in front of the MAK and say *We want Lebbeus Woods' kind of space in Vienna!?* They don't do that. If they would – I'd be very flattered. But I don't expect it.

Joachim Riedl: I think every democratic change takes place because people are demanding it.

Lebbeus Woods: This leads us to the issue of war, and to the element of human crisis. Human crisis brings out certain extreme conditions. In normal good

nicht darüber. Das Experimentieren entsteht aus denselben Gründen wie die Architektur, der es um das Schaffen von Alltagsraum geht. Aber wie ist dieser Raum gestaltet, wie schaut so ein Raum aus?

Joachim Riedl: Wem gehört denn dieser Raum überhaupt?

Lebbeus Woods: Die Gestalt des Raums hängt von der Person ab, die sich in ihm befindet und nach ihm verlangt. Menschen, die nur die etablierten Werte bestätigt sehen wollen, verlangen bereits bekannte Raumtypen. Die Frage ist also folgende: Was geschieht, wenn der Architekt, der ja die Kultur und die Menschen überhaupt vertritt, einen Raum schafft, der den vertrauten Raumtypen und den damit verbundenen etablierten Werten nicht entspricht? So etwas geschieht nur auf der Ebene des Experimentierens, im Schützengraben sozusagen. Das gehört zum schmutzigen Bereich der Architektur, wo Materialien dafür verwendet oder dazu gezwungen werden, Räume zu formen, die die Leute benützen können, auf eine neue Art besetzen können, die dem Verständnis des Architekten von den neuen, sich gerade in der Gesellschaft abzeichnenden Bedingungen entspricht. Man wundert sich, wie wenige Architekten sich dieser Aufgabe zu stellen bereit sind. Zehn vielleicht – oder bin ich da zu optimistisch? Wahrscheinlich sind es sogar weniger. Es geht hier eben um eine Minderheit, die sich an eine Mehrheit zu wenden versucht.

Joachim Riedl: Glauben Sie wirklich, daß es so viele Menschen gibt, die auf Orte warten, die sie besetzen können, Orte, die ihnen offen stehen? Oder muß man die Leute dazu bringen, diese Räume erobern zu wollen?

Lebbeus Woods: Nein, ich glaube, daß niemand Menschen dazu bringen sollte, irgend etwas erobern zu wollen. Es geht vielmehr darum, daß die Leute, die das Geld haben, Raum zu schaffen und Gebäude zu errichten, nicht jene Räume schaffen, die viele Menschen gern in Besitz nehmen würden, sofern sie ihnen überhaupt zur Verfügung stünden. Sie stehen ihnen aber gar nicht zur Verfügung, und deshalb haben wir, wir alle, nur sehr beschränkte Wahlmöglichkeiten. Gäbe es mehr experimentelle Räume, die Spontaneität, Fluß und Dynamik der modernen Gesellschaft zulassen, wären Sie wahrscheinlich überrascht, wie viele Leute diese gerne besetzen würden. Daß solche Räume eben zur Zeit nicht gebaut werden, ist sicher auch Grund für das wachsende allgemeine Interesse an virtuellem Raum, für die Bedeutung neuer Raumformen, die im Augenblick nur über die Medien erlebt werden können.

Joachim Riedl: Aber es verlangt doch eigentlich niemand nach experimentellen Räumen …

109

times, people are relaxed, enjoying nice wine, the sun is shining, they are dreaming of their childhood or of their retirement. But crisis brings out something else. It brings to [the surface] questions like: Where am I, how am I going to structure the rest of my life, why am I here in the first place?

That's why my work has turned to the issues of war and architecture. The war can be in Yugoslavia, it can be in Los Angeles, New York – there are differ-

Lebbeus Woods, Monument, Collage zu/collage for Zagreb Free Zone, 1991

ent kinds and stages of war and the crisis can have many different manifestations. Crisis opens up a vast terrain of questioning that can lead us, I think, to a hopeful doorway into a new set of conditions. In times of crisis people have to reach for uncomfortable understandings in order to get on to another place, another level.

Joachim Riedl: You were mentioning Los Angeles and the kind of civil war that is going on there – which is essentially about the question: Whose space is this? Who runs the ghettos? These crucial questions were accompanied by immense destruction and violence. So far, there has hardly been any reconstruction of the damages caused by the L. A. riots in 1992. The city just cleaned the dirt and the impression that remains is one of a wasteland.

How does the architecture you are proposing enter that specific scene?

Lebbeus Woods: I am reaching the point in my life, having come through the so-called normal route of architectural development, where I believe that architecture has to come from below and grow upwards. It can no longer be proposed from above, because the institutions that are above, the ones with the money and the power, are never going to institute architecture that really participates in critical political and social transformations. They have every reason not to, for their own self-interest and self-preservation. I think that in Los Angeles, as in other places, it is going to require the effort of architects who will [bypass] the corporate or institutional structures and will propose and organize construction as the Greek architect used to do. Let's not forget that then the architect was the *leader of building*. This is what architects need to become again – not to wait for orders to come from above, but to initiate projects in Los Angeles, in Sarajevo, in any city that has suffered crisis. Architects must lead the reconstruction in a way that mends the society but also provides a different future.

Lebbeus Woods: Wie sollte denn das aussehen? Sollten wir eine Demonstration vor dem MAK veranstalten mit der Parole: *Woods-Räume für Wien!?* Das tut doch niemand – und wenn, wäre ich sehr geschmeichelt. Aber so etwas erwarte ich nicht.

Kommen wir aber jetzt zur Frage des Krieges und zum Stellenwert menschlicher Krisen. Menschliche Krisensituationen fördern immer bestimmte Extreme zutage. In normalen, guten Zeiten sind die Menschen entspannt, trinken guten Wein, genießen den Sonnenschein, und träumen von ihrer Kindheit oder von ihrer Pension. Krisen fördern nun etwas anderes zutage. Es tauchen Fragen auf wie: Wo bin ich? Wie werde ich den Rest meines Lebens gestalten? Warum bin ich überhaupt hier?

Deshalb habe ich mich in meiner Arbeit dem Thema Krieg und Architektur zugewendet. Jugoslawien, Los Angeles, New York – der Krieg hat viele Gesichter, und Krisen können auf die verschiedenste Art zum Ausdruck kommen. Krisen eröffnen ein weites Feld von Fragen, die uns, denke ich, auf einem Weg der Hoffnung zu einer Ordnung mit neuen Lebensbedingungen führen können. In Zeiten der Krise gelangen Menschen zu vielleicht unbequemen Einsichten, um von da aus eine neue Ebene zu erreichen.

Joachim Riedl: Sie haben Los Angeles und den „Bürgerkrieg" dort erwähnt, in dem es doch vor allem um die Frage ging, wer über einen Ort bestimmt und wer in den Gettos das Sagen hat. Das Aufbrechen dieser Probleme hatte ungeheure Zerstörungen und Gewalttaten zur Folge. Bisher wurden nur wenige der bei den Unruhen von L. A. im Jahr 1992 angerichteten Schäden wieder repariert, die Stadtverwaltung hat nur den Schutt beseitigt – und was bleibt, ist eine Einöde. Welche Rolle könnte Ihr Architekturbegriff in diesem spezifischen Zusammenhang übernehmen?

Lebbeus Woods: Nachdem ich den sogenannten normalen Werdegang des Architekten nun hinter mir habe, bin ich an einem Punkt angelangt, an dem ich glaube, daß Architektur von unten kommen und nach oben wachsen muß. Architektur kann heute nicht mehr von oben bestimmt werden, weil die Institutionen, die es da oben gibt, die das Geld und die Macht haben, niemals eine Architektur vertreten werden, die wirklich teilhat an kritischen politischen und gesellschaftlichen Veränderungen. Diese Institutionen haben aus Eigeninteresse und Selbsterhaltungstrieb auch allen Grund dazu, das nicht zu tun. Ich glaube, daß es in Los Angeles wie anderswo des Einsatzes von Architekten bedarf, die bereit sind, wirtschaftliche und institutionelle Strukturen [zu umgehen], und denen es ge-

1 "The End of Architecture?" was the title of a closed conference that took place on June 15, 1992 at the MAK – Austrian Museum of Applied Arts. At this conference, based on an idea by Peter Noever, Coop Himmelblau, Zaha Hadid, Steven Holl, Thom Mayne, Eric O. Moss, Carme Pinós, and Lebbeus Woods presented their positions regarding the state of contemporary architecture. The following round table discussion focussed on the architect's role in the shadow of today's significant political and social chamges and called for the realization of architectural programs, visions, and urban concepts suitable for the complex character of contemporary society.

2 Richard Rogers, born in 1933, together with his wife Su and with Norman and Wendy Foster, member of the London *Team 4* founded in 1963; he became Renzo Piano's partner in 1970. The use of a high-tech vocabulary and his definition of architecture in close connection with sociopolitical issues may be seen as crucial aspects of Rogers' work. Building the *Centre Pompidou* (*Beaubourg*) in Paris (1977–1981) together with Renzo Piano and Sir Ove Arup and Partners brought about his international breakthrough. The *Institut de Recherche et de Coordination Acoustique* (1977, with Renzo Piano) and *Lloyd's of London Headquarters* (1977–1984) are two of his most important commissions.

3 See Chris Burden / Jan Hoet , note 8.

4 Woods' first experimental Berlin project from 1988 suggested the creation of a united *Underground Berlin* below the then still divided city: according to Woods' design a subterranean urban network would connect the inhabitants of East and West Berlin and create a united city from below. After Berlin had actually been unified, Woods extended his project into *Berlin-Free-Zone* (1991): electronically connected networks, invisible, inward *Free-Spaces* (see note 5) without any immediate purpose projected into the existing structure of the city figure as germ cells for future forms of less restricted social contexts and ways of communication.

5 *Free-Space* and *Free-Zone* are two concepts Woods developed in connection with his experimental architectural projects for Berlin and Zagreb. *Free-Zones* have neither a predetermined purpose nor meaning, both are to be established individually by the users when occupying them. Representing autonomous hidden spaces within a hierarchically structured city, these *Free-Zones* represent the subversion inherent to the concept of "heterarchy", the rule of numberless isolated units.

6 The British mathematician and philosopher Alfred North Whitehead (1861-1947) taught at Harvard University in Cambridge, Massachusetts. His principal work "Process and Reality" develops a metaphysical cosmology that is based on subjectivity, relativity and ontology as its supreme principles. His work "Science and the Modern World" mentioned by Woods was published in 1925, its German translation ("Wissenschaft und moderne Welt") in 1949.

lingt, im Sinn des griechischen Architekten Konstruktionen zu entwerfen und zu organisieren. Man darf ja nicht vergessen, daß der Architekt damals *Bauführer* war. Architekten müssen wieder Bauführer werden, nicht auf Anordnungen von oben warten, sondern Projekte initieren, in Los Angeles, in Sarajewo, in allen Städten, die von einer Krise zerrüttet wurden. Architekten müssen den Wiederaufbau so leiten, daß er die Genesung der Gesellschaft fördert, aber auch eine andere Zukunft eröffnet.

1 Unter dem Titel »Architektur am Ende?« fand am 15. Juni 1992 im MAK-Österreichisches Museum für angewandte Kunst nach einem Konzept von Peter Noever eine geschlossene Architekturkonferenz statt, in der Coop Himmelblau, Zaha Hadid, Steven Holl, Thom Mayne, Eric O. Moss, Carme Pinós und Lebbeus Woods ihre Positionen zum aktuellen Stand der Architektur präsentierten. Im Mittelpunkt des anschließenden Round-table-Gesprächs stand die Frage nach der Rolle des Architekten in einer komplexen Gesellschaftsstruktur sowie die Forderung nach einer Umsetzung von Architekturprogrammen, Visionen und urbanen Konzepten, die dieser Komplexität gerecht werden können.

2 Richard Rogers (geboren 1933), ab 1963 gemeinsam seiner Frau Su und mit Norman und Wendy Foster im *Team 4* in London tätig und ab 1970 Partner von Renzo Piano, zeichnet sich durch seine »High-Tech«-Formensprache aus sowie durch eine Gesinnung, die Architektur immer in engem Zusammenhang mit soziopolitischen Problemstellungen definiert. Der internationale Durchbruch gelingt ihm mit dem Bau des *Centre Pompidou (Beaubourg)* in Paris (1977-1981), gemeinsam mit Renzo Piano und Sir Ove Arup and Partners.Weitere wichtige Bauten sind das *Institut de Recherche et de Coordination Acoustique* (1977, mit Renzo Piano) sowie das *Lloyd's of London Headquarters* (1979-1984).

3 vgl. FN 8, Chris Burden/Jan Hoet

4 Woods erstes experimentelles Berlin-Projekt aus dem Jahre 1988 bestand aus Plänen, ein vereintes *Underground Berlin* unter der damals noch geteilten Stadt zu schaffen: Woods' Entwurf zufolge sollten in einem unterirdischen urbanen Netzwerk Bewohner von Ost und West zueinander finden und von unten eine vereinigte Stadt schaffen. Nach der Vereinigung Berlins erweitert Woods sein Projekt zu *Berlin-Free-Zone* (1991); *Free-Zones* sind in die bestehende Stadtstruktur hinein projektierte, unsichtbare, zweckfreie, innere *Free-Spaces* (Freiräume, vgl. FN 5), die sich zu einem elektronisch verbundenen Netzwerk zusammenschließen und als Keimzellen für künftige Formen eines freieren Zusammenlebens und einer offeneren Kommunikation konzipiert sind.

5 Die Begriffe des *Free-Space* (Freiraum) und der *Free-Zone* (Freizone) prägt Woods in Zusammenhang mit seinen Projekten experimenteller Architektur für Berlin und Zagreb. Den »Freiräumen« wird kein Zweck und kein Inhalt vorgegeben, diese konstituieren sich vielmehr erst in der Eroberung durch ihre späteren Benützer. Als autonome verborgene Räume innerhalb einer hierarchisch strukturierten Stadt verkörpern sie zugleich die Subversion der »Heterarchie«, der Herrschaft unendlich vieler isolierter Einheiten.

6 Der britische Mathematiker und Philosoph Alfred North Whitehead (1861-1947) war ab 1924 Professor an der Harvard University in Cambridge, Massachusetts und entwickelte in seinem Hauptwerk »Process and Reality« eine metaphysische Kosmologie, deren oberste Prinzipien Subjektivität, Relativität und die Ontologie sind. Das von Woods erwähnte »Science and the Modern World« erschien 1925 und wurde 1949 unter dem Titel »Wissenschaft und moderne Welt« ins Deutsche übersetzt.

PARK

SMITH

KIKI SMITH:

Nothing is more serious than how you are peeing...

A conversation with Kyong Park

Kyong Park: While preparing this interview I've spent a bit of time going back to some of your catalogues and reading interviews you gave. In doing so I realized how your work has changed over the years, how the materials that you use became increasingly important and how they relate to subjects that keep coming up in many different forms. One striking example for this seems to be for instance the nearly ontologic relationship [you have created] between body/skin and paper.

Kiki Smith: Paper and body have, in my view, very strong connotations and a definite cultural determination. Asia for example has an enormously developed history of paper making, of the use of paper, and its symbols. People have developed all different histories [about paper] depending on where you are and have established rituals around it. I don't know about Europe, but in the US we don't have a history of paper – so we also have a lot less baggage to carry with us – and paper is certainly not associated with power, economical or historical power.

For me, paper is a very nice material to talk about a body with. It has the two foremost qualities that life has: it is very strong and very vulnerable at the same time. In Korea, for example, paper is used for floor coverings. It can be that vital a material. Or you can penetrate it, burn it, and destroy it very easily. Paper hangs in this nice dichotomy.

Kyong Park: I also like the idea that you use paper as body-skin, since paper is porous, possibly transparent, translucent just as the skin. This concept coincides with your longstanding preoccupation with the body and your idea of entering into the body. The skin then is the first [barrier] to the body itself – it is revealing the body to the outside...

Kiki Smith: Before I got into [the use of] paper I was making sculptures of organs, of digestive systems, livers, and hearts for about eight years. At the time, I did not want to do work outside of the body, because I was not interested in

116

KIKI SMITH:
Nichts ist ernster, als wie man pißt...

Ein Gespräch mit Kyong Park

Kyong Park: Bei der Vorbereitung für dieses Gespräch habe ich mir einige Ihrer Kataloge wieder angesehen und das eine oder andere Interview gelesen: Da ist mir plötzlich klar geworden, wie die Materialien, die Sie in Ihren Arbeiten verwenden, an Bedeutung gewinnen und wiesehr sie mit wiederholt auftauchenden Themen in Zusammenhang stehen – es scheint zum Beispiel eine ontologische Beziehung zwischen Körper/Haut und Papier zu geben.

Kiki Smith: Meiner Ansicht nach lösen Papier und Körper starke Konnotationen aus, die sehr kulturabhängig sind. In Asien gibt es eine ungeheuer entwickelte Geschichte der Herstellung, Verwendung und Symbolik von Papier. Jede Region hat ihre eigene Geschichte und ihre um das Material entwickelten Rituale. Ich weiß nicht, wie das in Europa ist, aber in Amerika haben wir überhaupt keine Geschichte des Papiers und daher auch weit weniger kulturellen Reichtum mit uns herumzutragen. Papier wird hier weder mit wirtschaftlicher noch mit historischer Macht in Verbindung gebracht.

Für mich ist Papier ein sehr geeignetes Material, um über den Körper zu sprechen. Papier hat die beiden Eigenschaften des Lebens: es ist zugleich sehr stark und extrem verletzlich. In Korea verwendet man Papier zum Beispiel als Fußbodenbelag. So vital kann dieses Material sein. Man kann Papier auch durchdringen oder einfach verbrennen und letztlich sehr leicht zerstören. Papier befindet sich in dieser sehr schönen Widersprüchlichkeit und Zweideutigkeit.

Kyong Park: Mir hat auch der Gedanke gefallen, daß Sie Papier als Körper-Haut einsetzen, daß Papier durchlässig und unter Umständen sogar durchsichtig ist, lichtdurchlässig wie Haut. Das hat ja mit Ihrer Vorstellung zu tun, daß man in den Körper einzudringen vermag. Die Haut als erste [Körpergrenze] also, die den Körper der Außenwelt enthüllt ...

Kiki Smith: Bevor ich einen Zugang zu Papier fand, habe ich etwa acht Jahre lang Skulpturen von Organen gemacht, von Eingeweiden, Lebern, Herzen, und wollte mich dabei nie außerhalb des Körpers befinden, weil ich keine Portraits machen

portraiture. And I avoided to deal with sex and age, and race and all that stuff, mainly because I didn't know what to do with it. At one point I started to realize that the skin is also a system – like the digestive system – open to the outer space like a big porous net, sometimes catching things, and sometimes letting things go through it. As a next step I had to solve the problem of finding an [adequate representation] for a form – the form of the body – with no matter, no substance inside of it, just an empty envelope. When I saw Japanese paper balloons I knew that this was the way to do it.

But then, I also think that it is just very nice to use materials that nobody cares about, that are discarded. It is like being a woman in society, being marginalized, and what you are doing is discarded. So it seemed good to pay attention to all those other things that are being discarded. They seem to be useful tools.

Kyong Park: Your using materials that are marginalized relates directly to understanding the body in the way you do – as a mechanism, [a vehicle] to express subjects and issues that are marginalized. You have often described the body as a prison, the womb as an empty vessel or as a shell. I find [the double reference system of body-material-marginalization] a very complex way for describing this prison and also a possibility to escape this prison. As long as we are inseparably bound to our bodies, the issues of race, gender, politics, or age constitute an active part of your experience. The body is the thing that identifies and classifies these issues. I am curious about what would happen if the body itself was no longer present. Would the issues of race, gender, age disappear?

One way of looking at this question is through virtual communities of computer-networks. There is a story about a user who was hooked in the computer net for a number of years. This person, [known under a female computer identity] decided to commit suicide in the computer net. After she died – closed out of the net – other users tried to find her real identity. And they discovered that she was not she, but he. Without the body being present, all these attributes that the body codifies, not just in daily life but also historically, seem to have different meanings.

Kiki Smith: For me this whole issue has to do with things that are happening to you in the course of your life; one responds to that. It may sound like Christian stuff, but you are here in a physical form. It is the only way you get to be here – being in a body. It is through the body that you experience everything that is

Kiki Smith, Ohne Titel/Untitled, 1992

wollte. Und ich wollte mich auch nicht mit Geschlecht und Alter, mit Rasse und all dem Zeug auseinandersetzen, weil ich damit nichts anzufangen wußte. Und da begann ich schließlich zu begreifen, daß Haut auch ein System ist, wie das Verdauungssystem, ein System, das der Außenwelt gegenüber offen ist wie ein großes durchlässiges Netz, das manchmal Dinge auffängt und manchmal Dinge durchsickern läßt.

Und dann dachte ich: Wie [hält] man eine Situation [fest], in der es nur eine Form gibt, die Form eines Körpers, aber keinen Inhalt, keine Substanz innerhalb der Form, nur einen leeren Umschlag sozusagen? Als ich dann japanische Papierballons sah, wußte ich, das ist es. Außerdem ist es einfach schön, Materialien zu verwenden, die niemandem etwas bedeuten, die mißachtet werden. Das ist so wie eine Frau zu sein, vergleichbar mit ihrer marginalen gesellschaftlichen Stellung und damit, daß das, was Frauen machen, mißachtet und ausgegrenzt wird. Es scheint mir also wichtig, den Dingen Aufmerksamkeit zu schenken, die ebenfalls mißachtet und ausgegrenzt werden, weil es sich da um nützliche Werkzeuge handeln könnte.

Kyong Park: Wenn Sie Materialien verwenden, denen eine marginale Stellung zugewiesen wird, dann hat das doch unmittelbar damit zu tun, wie Sie den Körper einsetzen – als Mechanismus, [als Medium,] um Themen und Probleme zu behandeln, die ebenfalls marginalisiert werden. Sie haben ja den Körper oft als Gefängnis und den Mutterleib als leeres Gefäß, als bloße Hülse beschrieben ... Ich halte [dieses doppelte Bezugssystem] für einen sehr komplexen Versuch, dieses Gefängnis zu beschreiben, und zugleich für eine Möglichkeit, diesem Gefängnis zu entkommen.

Solange man an den Körper gebunden ist, bleiben Fragen der Rasse, des Geschlechts, der Politik und des Alters aktiver Bestandteil der Erfahrung. Der Körper identifiziert und klassifiziert diese Kriterien. Mich würde interessieren, was geschieht, wenn der Körper nicht mehr anwesend ist. Würden sich diese Fragen dann auflösen? Ich stelle mir das wie die virtuelle Gemeinschaft in einem Computernetzwerk vor. Da gab es einmal eine Geschichte über jemanden, der jahre-

Kiki Smith, Atelier

happening to you. [Physical consciousness and awareness of the body's vulnerability] are part of my daily life. In the last five years, parts of my family and of my community have died from AIDS. This is something you have to deal with, and of course you have to confront all these issues that these events bring about: governmental policies, health-care, your personal sense of mortality. In my work, the body is the place to make expression of all these things, and since they change all the time, are fluid...

Kyong Park: People tend to stereotype everything. One of the common stereotypes is the definition of what "American culture" is about, what "American art" is about. However, these issues are much more complex and for an artist it is specially dangerous to "represent" something, for instance a gender, especially the gender that has been so repressed...

Kiki Smith: I am not trying to "represent my gender". I am just here, and I am trying to say: What if we talked about this experience of [being here] in a larger context, under inverted preconditions? What if we made – however it may be practically impossible – female the generic body instead of male [being the standard]? This way we could turn human experience into female experience.

lang in so einem Netzwerk hing und eines Tages den Entschluß faßte, auszusteigen, in dem Netz Selbstmord zu begehen. Nachdem die Frau Schluß gemacht hatte, versuchte man, ihre wahre Identität herauszufinden. Und man stellte fest, daß die Frau ein Mann war. Wenn der Körper nicht sichtbar ist, scheinen die nicht nur im Alltag, sondern auch historisch durch ihn kodifizierten Eigenschaften einen anderen Lauf zu nehmen.

Kiki Smith: Für mich hat das alles mit den Dingen zu tun, die einem im Lauf des Lebens zustoßen; man reagiert darauf. Das klingt vielleicht irgendwie katholisch, aber man existiert schließlich in physischer Form. Das ist die einzige Möglichkeit, da zu sein: in einem Körper. Alles, was einem geschieht, erfährt man durch den Körper. [Sich der Physis und der Verletzbarkeit des Körpers bewußt zu sein] gehört für mich zum Alltag. In den letzten fünf Jahren sind Mitglieder meiner Familie und meines Freundeskreises an Aids gestorben. Mit diesen Dingen muß man sich befassen, und mit den Fragen, die sie aufwerfen, mit den Strategien der Regierung, dem Gesundheitswesen und seinem eigenen Gefühl der Sterblichkeit. Der Körper ist auch der Ort, an dem sich alle diese Dinge zum Ausdruck bringen lassen. Aber die Fragen ändern sich auch dauernd, sie sind beständig im Fließen...

Kyong Park: Es gibt in allen Bereichen eine Tendenz zu Stereotypen. Das trifft auch auf die Frage zu, worum es in der »amerikanischen Kultur«, in der »amerikanischen Kunst« geht. Ich kann nicht einmal davon ausgehen, daß es überhaupt eine amerikanische Kunst gibt ... die Dinge sind ja viel komplexer, und gerade für Künstler ist es besonders gefährlich, ein Geschlecht zu »vertreten«, vor allem jenes, das so unterdrückt wurde ...

Kiki Smith: Ich versuche nicht, »mein Geschlecht zu vertreten«. Ich bin einfach da und sage: Was wäre denn, wenn wir diese Erfahrung in einen größeren Zusammenhang stellten? Was wäre, wenn wir – so sehr das auch praktisch unmöglich sein mag – den männlichen Gattungsbegriff durch einen weiblichen ersetzten? So könnten wir menschliche Erfahrung in weibliche Erfahrung verwandeln. Da das der herrschenden Erfahrung ja nicht entspricht, wie würde denn das die herrschende Erfahrung untergraben?

Ich weiß eigentlich nichts über Computer, virtuelle Präsenz und so ... Mich interessiert, wie jemand mit dem Körper eins zu sein versucht, anwesend, physisch präsent. Ich verspüre nicht den Wunsch, meinen Körper zu verlassen.

Kyong Park: Sie nehmen aber auch – und das tut sonst niemand – Körper auseinander.

Since this would be different from the dominant experience, how would it subvert the dominant experience?

I don't really understand anything about computers, virtual presence and all that stuff... I am interested in knowing about how someone is "trying to get into the body", to occupy it, be here physically. I have no desire to leave my body.

Kyong Park: But one thing that you do and that no one else seems to do, is to take bodies apart.

Kiki Smith: People definitely like taking bodies apart. They make up different stories at different times about why they are doing it. The Egyptians kept brains in jars and made the beginnings of gynecology. [Taking bodies apart] is an activity that people are prone to, as well as the ritual of eating, of ingesting other people in order to lose the separation that their bodies provide.

When I was here in the MAK, having an exhibition, I showed sculptures of people peeing.[1] I was suggesting to think about what it means if women are peeing in public. Men are always peeing all over the place, but what does it mean when women do the same thing? In America they have created this romance about artists peeing: Pollock on the snow, like male-marking. Women have this blood coming out of them, they are staining everything – and a part of a woman's life is about making stains. What does that mean? It certainly means something on a personal level, but it also means something for society as a whole. It means something in terms of AIDS. People are in an state in which they are not used to losing control of their physical being.

Didn't we talk about big dicks earlier?

Kyong Park: Big dicks? Did we, really?

Kiki Smith: I've been watching all these porn-movies about men sucking their dicks because I was trying to make sculptures about self-contained feeding, being a self-contained feeding machine. Before that, I was making sculptures about all the body fluids leaving you, about being out of control, being a kind of Everyman, an innocent, and everything is just falling out of you and you are not responsible for it. That's certainly easier to bear than if you are fully responsible for your body activities! Then I've been trying to think: What if you are taking back in all the fluids that are leaving your body, being a mother and a child at the same time. You would be sucking your own dick, your own breast, feeding yourself. And this is where the story of the big dick comes in, the story about the man who is not allowed to have an erection because all his blood would converge in his dick and his brain would cease to function.

122

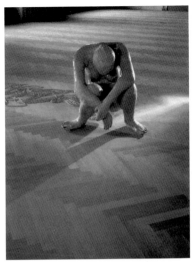

Kiki Smith, Lot's Wife/Peebody, 1991

Kiki Smith: Die Menschen tun das gern. Sie erfinden immer wieder andere Ausreden, um zu erklären, warum sie das tun. Die Ägypter haben Gehirne in Gefäßen aufbewahrt und die Gynäkologie begründet. Die Menschen haben einen Hang zu diesen Dingen ebenso wie zu der Vorstellung, andere Menschen zu essen, in sich aufzunehmen – die durch den Körper bestimmten Grenzen aufzuheben.

Als ich hier im MAK eine Ausstellung[1] hatte, habe ich die Skulptur eines pissenden Menschen gemacht. Was bedeutet das, wenn Frauen in der Öffentlichkeit pissen? Männer pissen immer und überall, aber was ist, wenn Frauen das auch tun? In Amerika gibt es da diesen Mythos vom pissenden Künstler. Pollock hat in den Schnee gepißt, sein Territorium markiert, sonst nichts. Frauen verlieren ja ihr Blut, sie beflecken alles – einen Teil ihres Lebens verbringen sie damit, etwas zu beflecken. Was bedeutet das? [Diese körperlichen Prozesse] haben eine persönliche und eine gesellschaftliche Bedeutung. Im Hinblick auf Aids bedeutet es, daß wir in einer Zeit leben, in der wir mit dem Verlust der Kontrolle über unsere physische Existenz nicht umgehen können.

Haben wir vorher nicht über große Schwänze gesprochen?

Kyong Park: Über große Schwänze? Ich kann mich nicht erinnern ...

Kiki Smith: Ich habe mir diese ganzen Pornos angesehen, in denen Männer an ihren Schwänzen lutschen, weil ich damals Skulpturen über Ernährung durch Selbstversorgung machen wollte, [über die Möglichkeit, durch Rückführung ausgeschiedener Substanzen in den Ernährungszyklus] eine selbstversorgende Ernährungsmaschine zu werden. Zuvor hatte ich mich in meiner Arbeit mit den [Körper-]Flüssigkeiten beschäftigt, die einfach aus einem austreten, und damit, daß man keine Kontrolle darüber hat ... Wir sind dabei absolut unschuldig, es rinnt einfach alles aus uns raus und wir können nichts dafür. Sicher ist diese Auffassung leichter zu ertragen, als wenn wir dafür die Verantwortung übernehmen müßten. In weiterer Folge habe ich mir überlegt, was denn wäre, wenn man alle diese Flüssigkeiten hernimmt und in einer Art Mutter-Säugling-Symbiose – an seinem eigenen Schwanz lutscht, an seiner eigenen Brust saugt, sich selbst stillt.

Kyong Park: Yeah, *Big Dick* seems like just another stereotype of male American culture...One time a girl that I knew participated in a competition about peeing higher than all the men could – but ... going back to a more serious subject...

Kiki Smith: Nothing is more serious than how you are peeing!

Kyong Park: I think this curiosity about "normal" things is the whole point of your work and maybe also the reason why you are taking bodies apart, or taking things out of the body. I know that you've been looking through a lot of science books, photographs, medical documents. But, science and medical traditions and their engagement with the body can be best described in terms of anatomical study. Your work is an experimental exploration, based on your own life, your own 'body as a living system', and its relationship with impersonal life, life in general.

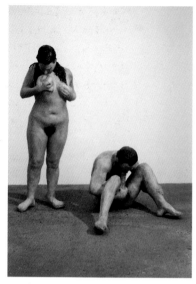

Kiki Smith, Mother and Child, 1993

Kiki Smith: Well, it seems to me that Western medicine is mostly involved with symptoms – looking into the appearances of illness and trying to make the symptoms disappear. Even if what we really need is a mending in the underground. It seems that our relationship with our bodies has something schizophrenic that makes us suffer in our daily lives, and this sufferance is used as justification for maintaining this mind-body dichotomy stuff. That, in a slightly altered hierarchical version, makes people cause pain to others because [the physical] becomes a justification for racism, for people getting paid less.

The speakers before us were talking about all this individualist bullshit, that America in fact tries to be more and more homogenized, and lessens the possibilities of choice rather than trying to expand them. Everyone eats processed food. It seems that you as a person have to try to negate these parameters and to create space for your things.

They also talked about the *Whitney Biennial*[2]. I believe that this show was just about people who are trying to occupy some space for themselves, because they are not given the necessary space and they have to take it. People are always in the process of taking, or of holding on to some space, only sometimes you don't notice that they are there.

Und da wird jetzt die Geschichte vom großen Schwanz wichtig, die Geschichte von dem Mann, der keine Erektion haben darf, weil es ihm dann das ganze Blut in den Schwanz treibt und das Gehirn zu funktionieren aufhört.

Kyong Park: Genau, der *Große Schwanz,* das ist auch ein Stereotyp der männerorientierten amerikanischen Kultur. Ich habe einmal ein Mädchen gekannt, das sich an einem Wettbewerb beteiligt hat, um unter Beweis zu stellen, daß sie höher pissen kann als alle Männer – aber, um auf eine ernstere Frage zurückzukommen …

Kiki Smith: Nichts ist ernster, als wie man pißt...

Kyong Park: Dieses Interesse an alltäglichen Dingen ist das Entscheidende an Ihrer Arbeit, und vielleicht auch für das Zerlegen und Ausnehmen von Körpern. Ich weiß, daß Sie viele wissenschaftliche Bücher, Fotografien und medizinische Dokumente durchgesehen haben. Allerdings lassen sich wissenschaftliche und medizinische Traditionen und ihre Auseinandersetzung mit dem Körper am besten durch anatomische Studien erfassen. Ihre Arbeiten sind experimentelle Untersuchungen, die einerseits auf Ihrem eigenen Leben, Ihrem »Körper als Lebensform« beruhen, andererseits jedoch ebensosehr mit der unpersönlichen Form des Lebens, dem Leben im allgemeinen zusammenhängen.

Kiki Smith: Also, es scheint mir, daß sich die westliche Medizin vor allem mit Symptomen beschäftigt, mit der äußeren Erscheinungsform von Krankheiten, und sich bemüht, diese Symptome zu beseitigen. Und das, obwohl wir nichts mehr bräuchten als eine Heilung in der Tiefe. Mir kommt vor, daß unsere Beziehung zu unserem Körper etwas schizophren ist und unseren Alltag mit Leiden erfüllt, und daß dieses Leiden als Rechtfertigung für diese unsinnige Spaltung von Geist und Körper benutzt wird. Das bringt auf einer etwas anderen Ebene, nämlich aus einer hierarchischen Betrachtungsweise, Menschen dazu, anderen Menschen Schmerz zuzufügen, weil [physische Unterschiede] als Rechtfertigung für Rassismus benützt werden und dafür, daß gewisse Leute weniger bezahlt bekommen als andere.

Die anderen Redner haben über den ganzen individualistischen Blödsinn gesprochen, darüber, daß Amerika auf dem Weg ist, immer einheitlicher zu werden und die Entscheidungsmöglichkeiten begrenzt statt sie zu erweitern. Jeder ißt Konserven. Mir kommt vor, daß man sich gegen diese Parameter zur Wehr setzen muß, um für seine eigenen Dinge Platz zu schaffen. Es wurde auch über die *Whitney Biennial* gesprochen[2] – und meine Meinung dazu ist, daß es in dieser Ausstellung genau darum ging, daß Leute für sich einen Platz in Anspruch zu

Being in the body is also about the experience of resisting the comfort of ones most private space, because the body is always under the siege of ideologies, the church, politics. To understand the body – and ultimately all the issues related to it – you have to go under the surface and look at the entire system. It is a hologram that contains all the information for the rest of everything. You must see for yourself whether and how you can make a more holistic version [of the body] that is more inclusive of your life.

Kyong Park: In terms of our relation to the body we can question Western culture, but we can question Eastern culture as well. The body has always been represented from the exterior. It's always been viewed from outside. If I use architecture as a metaphor or a reference it seems that almost everything about our history, our civilization in terms of the body has always been represented as exterior elevations. The inside spaces – in your case the kidney, intestines, stomach – are hardly represented at all. The body is almost like an archeological study, an excavation, something that has been repressed, buried. It is a service to mind, some kind of infrastructure-maintenance system for the mind. We were talking yesterday bit about a stereotypical hierarchy defined as: Mind equals the domain of the Man, and Body equals the domain of the Woman.

Kiki Smith: In one sense it is really good that people don't look too much into their insides – you only see your insides under adverse conditions. The only time when you have access to them is when you are been squeezed out. But it can be also very helpful to look at your insides and see what they mean to you – is it a relationship which is life-affirming, or is it detrimental to you? There are so many activities going on in the body – sex, consumption, digestion – you can look at these different points as if they were centers of a mandala. Diseases are ultimately linked both to questions of power as to personal experiences.

Kyong Park: In an earlier conversation Lebbeus Woods described his position in architecture in the context of crisis, crisis of and in the society. Having known him for years, I would imagine that his notion of crisis is quite "large-scale" – a political, social crisis that is geographically expansive and large in numbers. It comprises humanity as a whole. But we also face the crisis of the body today, and I think that your concern with the crisis of the individual, on the level of the individual body makes your work unique. AIDS, fitness freaks, Arnold Schwarzenegger's stomach and muscles, [the hypertrophy] of body consciousness..

Kiki Smith, Digestive System, 1988

nehmen versuchten, weil man ihnen den erforder-
lichen Platz nicht zugesteht und sie ihn sich daher
nehmen müssen. Menschen sind ständig damit be-
schäftigt, sich etwas anzueignen, man will sich im-
mer Platz schaffen, nur manchmal merken die ande-
ren nicht einmal, daß man überhaupt da ist. In einem
Körper zu sein, heißt auch, Widerstand gegen das ei-
gene Umfeld zu leisten, weil der Körper immer von
Ideologien, von der Kirche, von der Politik und so
weiter belagert wird. Um den Körper und letztlich
alle mit ihm verbundenen Fragen zu verstehen, muß
man unter die Oberfläche schauen und sich mit dem
gesamten System auseinandersetzen. Er ist wie bei
einem Hologramm, das die Informationen für alles
übrige enthält. Jeder muß für sich herausfinden, ob
und wie man eine ganzheitlichere Darstellung [des
Körpers] schaffen kann, eine Form, die mehr vom eigenen Leben beinhaltet.

Kyong Park: Was das Verhältnis zum Körper angeht, kann man sicherlich die
westliche Kultur in Frage stellen. Aber gilt das nicht auch für die östliche? Auch
dort ist der Körper immer nur von außen dargestellt worden. Wenn ich Architek-
tur als Metapher oder Bezugspunkt nehme, scheint mir, daß beinahe alles Kör-
perliche in unserer Geschichte, in unserer Zivilisation in Form von Außenan-
sichten dargestellt wurde. Die Innenräume – in Ihrem Fall also Nieren, Gedärme
und Magen – kommen fast überhaupt nicht vor. Der Körper gleicht einer archäo-
logischen Studie, einer archäologischen Ausgrabung, unterdrückt, dem Geist
dienend, [man hat aus ihm] eine seltsame Instandhaltungsinfrastruktur für den
Geist [gemacht]. – Wir sind gestern auf eine verbreitete stereotype Gleichung zu
sprechen gekommen: der Geist ist die Domäne des Manns, der Körper die der
Frau.

Kiki Smith: In gewisser Hinsicht ist es ja gut, daß die Menschen ihr Inneres nicht
allzuoft zu sehen bekommen – man sieht es ja nur unter widrigen Bedingungen.
Zu seinem Innersten hat man nur Zugang, wenn es aus einem herausgequetscht
wird. Es kann natürlich auch sehr hilfreich sein, sein Inneres zu betrachten und
draufzukommen, was es für einen bedeutet – hat man ein lebensbejahendes Ver-
hältnis oder ein negatives, [ist es etwas] Schädliches? Im Körper geht ja so vie-
les vor – Sex, Nahrungsaufnahme, Verdauung: man kann seinen Blick auf jeden

Kiki Smith: The changes in body awareness in fact have created a fluid situation. Just think about prosthetics, things implanted in you, all these soft boundaries, and people trying to stuff themselves back inside what used to be their container because they don't know where they are anymore. Part of this change relates to self-repression, parts to liberation, or to vanity, to transsexual stuff, to choosing one's identity and its presentation.

Kyong Park: The body becomes a catalyst for change, or an expression of your being, like fashion, or cars.

Kiki Smith: Yes. There is something like body-fashion. Orlan[3], an artist from France, stored in her computer all these images of women, historical images, which, put together, produced a kind of beauty-composite. Then she decided to have plastic surgery to turn herself into this idealized image version. A lot of popular artists in America had plastic surgery too, and are trying to radically alter the way they are perceived. There are all these ways now of how people can shape and improve their identities; Michael Jackson for example is one of them.

Kyong Park: Jackson is probably the most ideal – well, I shouldn't use the word 'ideal' – the most developed example [of someone who is in a fluid state], someone who is neither white, nor black. There is even a confusion about whether to read him as a male or a female.

Kiki Smith: People have lots of possibilities. A couple of years ago, they were really into piercing and tatoos. You can think about [these practices] in terms of self-mutilation, but also in a way that some people don't like the idea of being bound to their bodies. An artist living in Australia had himself made a prosthesis so that he could create writings with three arms and enlarge his body-features and possibilities. But then at the same time he exposed himself to electric shocks that made him unable to control his muscles and restricted his possibilities. Some things come out of drives and personal desires, but they are also attempts to adopt a more fluid form of identity.

Kyong Park: I don't know whether I understood you right from what I read, but you were speaking of a body as the ground or basis for 'authenticity'.

Kiki Smith: Yes. [The body] is the form, the vessel, the substance that everybody has, and everybody has his own authentic experience of it. For most of our lives we are involved with secondary experiences like reading or watching television and [in this condition of unawareness] the body is the thing that gives us a kind of integrity of ourselves, a trueness to ourselves. It embodies

dieser Punkte richten als wären sie Mittelpunkte eines Mandalas. Krankheiten stehen letztlich sowohl mit Fragen der Kraft als auch mit persönlichen Erfahrungen in Zusammenhang.

Kiki Smith mit/with Fat & Flesh Body, 1991

Kyong Park: Lebbeus Woods hat seine Stellung in der Architektur im Kontext einer Krise beschrieben, der Krise der Gesellschaft im allgemeinen und der Krise innnerhalb der Gesellschaft. Da ich ihn nun schon recht lange kenne, würde ich einmal davon ausgehen, daß er dabei ziemlich tiefgehende Probleme vor Augen hat – eine politische und gesellschaftliche Krise von geographisch und räumlich umfassenden Ausmaßen. Eine Krise der gesamten Menschheit. Aber es gibt heute auch eine Krise des Körpers, und das ist, glaube ich, das Besondere an Ihrer Arbeit: [daß sie] die Krise des einzelnen Körpers [thematisiert]. Aids, der Fitneßwahnsinn, der Magen und die Muskeln von Arnold Schwarzenegger, dieses unglaubliche Körperbewußtsein …

Kiki Smith: Die Situation ist eigentlich nicht wirklich eindeutig … Denken Sie an die ganzen Prothesen und Transplantationen, an all die fließenden Grenzen – Menschen, die sich wieder in sich reinstopfen lassen, weil sie nicht mehr wissen, wo sie eigentlich sind. Das hat teils mit Selbstunterdrückung zu tun, teils aber auch mit Befreiung, mit Eitelkeit, mit transsexuellen Neigungen, mit der freien Wahl der eigenen Identität und ihrer Darstellung.

Kyong Park: Der Körper wird zum Mechanismus des Wandels – oder zum Ausdruck des eigenen Seins, wie Mode oder Autos …

Kiki Smith: Ja. Es gibt so etwas wie Körpermode. Orlan[3], eine französische Künstlerin, hat in einem Computer Bilder von Frauen gespeichert, historische Bilder, und daraus dann eine Art Schönheitsmontage gemacht. Dann hat sie sich mithilfe der plastischen Chirurgie in dieses Idealbild verwandeln lassen.

In Amerika haben sich viele bekannte Künstler operieren lassen, um ihr Bild in der Öffentlichkeit radikal zu verändern. Heute gibt es ja so viele Möglichkeiten, seine Identität zu formen und zu verbessern … Michael Jackson etwa …

Kyong Park: Michael Jackson ist wahrscheinlich das idealste – in diesem Zusammenhang sollte man allerdings nicht von »ideal« sprechen –, das radikalste Bei-

no hierarchy, no one who knows more or less about the matters of the body; people can know different things about it, but the authenticity of that knowledge is not confined to some 'special' group. Each person can talk about its own body owner's manuals, or something like that. People don't own a lot more besides their [physical being]. Sometimes they are in economic bondage, or spiritual bondage, or in other different kinds of bondage which might increase their self-awareness, but all this ownership is arguable.

At least, when you get pinched – you know it, you feel it!

Kyong Park: How would you explain to us the notion of "trying to take control of our bodies"? And in your own case, do you understand your body in ways which – if not entirely new – are still radically different?

Kiki Smith: I think [this idea of controlling the body] is about trying to be conscious about what owns you, who owns you, and about attempting to figure out how much you want to serve those owners. It seems like something worth thinking about from time to time – since after all there isn't a stable reality.

Kyong Park: I remember reading somewhere that once as a child you saw a dead cat and felt that [death] was the most beautiful state in which a cat could be. You took some belongings special to you, placed them around the cat and you buried it. This seems to me like quite a ritual!

Kiki Smith: This is about mummies. We all have early, [fully developed] predilections for dead things, but when we grow up we suddenly are pressured to make up reasons for thinking about them. Especially, since it's very pleasurable to explore the borders [of our existence].

Once you start reflecting on the body, you have to locate yourself within it. You have to consider to what extent people are continuous in a physical sense. I had a sister who died a couple of years ago. While I was making her death mask, I realized how I was just as attached to the physical form of [her] being as I was to her as a person.

Kyong Park: We seem to always repress the [direct] experience of death. We've seen over and over John F. Kennedy's assassination and heard the [witnesses'] descriptions of how he was actually killed. The image of his assassination has become something like [a shot from] the family photo-album shown all over the world. But what we don't see is what John F. Kennedy actually looked like in the hospital. What strikes me is the democratic side of death – we are so common with regard to death and even someone who is that important, established and created by power, becomes just an ordinary man.

spiel, ein Mensch, der weder weiß noch schwarz ist. Man weiß ja nicht einmal, ob man ihn als Mann oder als Frau ansehen soll …

Kiki Smith: Es gibt ja so viele Möglichkeiten. Vor ein paar Jahren waren die Leute wild darauf, sich piercen und tätowieren zu lassen. Man kann das natürlich für Selbstverstümmelung halten, aber man könnte auch sagen, daß manche Menschen einfach nicht an ihren Körper gebunden sein wollen …

In Australien hat sich ein Künstler eine Prothese gemacht, um mit drei Armen schreiben zu können und dadurch das Spektrum seiner Körpermerkmale und -möglichkeiten zu erweitern. Andererseits hat er sich Elektroschocks unterzogen, die dazu führten, daß er seine Muskelbewegungen nicht mehr unter Kontrolle hatte und dadurch wieder seine Möglichkeiten eingeschränkt wurden. Manche Dinge haben sicher ihren Ursprung in Trieben und persönlichen Wünschen, zugleich sind es aber auch Versuche, eine offenere und fließendere Form der Identität zu finden.

Kyong Park: Ich weiß nicht, ob ich das richtig verstanden habe, aber ich habe gelesen, daß Sie den Körper für eine Grundlage oder Voraussetzung von »Authentizität« halten.

Kiki Smith: Ja, das stimmt. [Der Körper] ist die Form, das Gefäß und die Substanz, über die jeder Mensch verfügt, und jeder hat seine eigene authentische Körpererfahrung. Den Großteil unseres Lebens sind wir mit sekundären Erfahrungen beschäftigt, wir lesen, sehen fern und so weiter, es ist aber der Körper, der uns eine Art Integrität, eine Wahrhaftigkeit uns selbst gegenüber verleiht – da gibt es keine Hierarchie, niemanden, der mehr oder weniger weiß. Selbstverständlich wissen wir unterschiedliche Dinge über unsere Körper, aber die Authentizität des Wissens ist auf keine ausgewählte Gruppe beschränkt. Jeder hat seine eigenen Bedienungsanleitungen oder etwas ähnliches. Sonst besitzen die Menschen ja kaum etwas. Manchmal stehen sie in wirtschaftlichen, geistigen oder anderen Abhängigkeitsverhältnissen, die ihnen ein größeres Bewußtsein ihrer selbst gestatten, aber über diese Form des Eigentums kann man immer streiten.

Wenn einen jemand kneift, dann weiß man das wenigstens, dann spürt man das!

Kyong Park: Können Sie uns erläutern, was es heißt, »den Körper unter Kontrolle zu bekommen«, und ihn vielleicht auch, wie in Ihrem Fall, in einer wenn auch nicht ganz neuen, so doch radikal anderen Art zu verstehen?

Kiki Smith: Mir kommt es darauf an, daß man zumindest versucht, sich bewußt zu werden, was und wer einen besitzt, und versucht, dahinterzukommen, wie

Kiki Smith, Atelier

weit man diesen Eigentümern dienen will. Darüber sollte man manchmal nachdenken, denn schließlich gibt es keine stabile Wirklichkeit.

Kyong Park: Ich erinnere mich, irgendwo gelesen zu haben, daß Sie als Kind einmal eine tote Katze gesehen haben und dabei das Gefühl hatten, daß das für eine Katze der schönste Zustand sei. Sie haben damals ein paar Sachen von sich genommen, die Ihnen lieb waren, sie zu dem toten Tier gelegt und es dann begraben. Mir kam das wie ein wirkliches Ritual vor ...

Kiki Smith: Bei dieser Geschichte ging es mir um Mumien. Wir haben eine gewisse vorbestimmte Neigung, über tote Dinge nachzudenken, und erst wenn wir erwachsen werden, müssen wir uns Gründe ausdenken, um das zu rechtfertigen. Ich denke gern über diese Grenzen nach. Wenn man einmal beginnt, sich mit dem Körper zu beschäftigen, muß man sich zunächst in diesen Körper hineinversetzen. Man überlegt sich, wiesehr Menschen eigentlich in einem physischen Sinn fortbestehen. Meine Schwester ist vor ein paar Jahren gestorben: Als ich an ihrer Totenmaske arbeitete, habe ich begriffen, daß man an der physischen Form des Seins ebenso hängt wie an der Person selbst.

Kyong Park: Wir scheinen die Erfahrung des Todes immer zu unterdrücken. Wir haben unzählige Male die Ermordung John F. Kennedys gesehen und die Zeugenaussagen über das Attentat gehört. Das Bild von seiner Ermordung ist schon fast wie eine auf der ganzen Welt hergezeigte Aufnahme aus einem Familienalbum. Was wir nicht sehen, ist wie Kennedy im Spital wirklich ausgesehen hat. Mir fällt daran vor allem der demokratische Aspekt des Todes auf – ein so wichtiger, von der Macht eingesetzter und geschaffener Mann wird als Toter zu einem ganz gewöhnlichen Menschen.

Kiki Smith: Ich halte es für sehr hilfreich, Tote anzuschauen und sich mit der Vergänglichkeit des Fleisches auseinanderzusetzen, darüber nachzudenken, was das in physischer Hinsicht bedeutet. Wenn man Entscheidungen über Strategien und Gesetze treffen muß, die das Leben anderer Menschen [berühren], ist es nützlich, sich wirklich physisch vor Augen zu führen, was der Tod bedeutet, wenn Menschen und ihren Familien Eingeweide, Hirn und Unterleib ins Gesicht fliegen. Da beginnt man zu begreifen, daß es einen einmal selbst erwischen wird, daß es letztlich man selbst und die eigene Familie ist, der das alles einmal ins Gesicht fliegen wird. Es hilft einem, etwas physisch Begreifbares zu haben, und nicht nur eine Abstraktion, ein Stück Fernsehabenteuer. Die Menschen verschwinden, und wir müssen das zur Kenntnis nehmen.

Kiki Smith: It's helpful, I think, to look at people when they are dead, to experience the impermanence of the flesh, and to understand what [death] means physically. When you are making decisions about policies and rules [affecting] other people's lives, it is helpful to have a real physical example of what death means for your guts and brains, and [to know how it feels] to have abdomens exploding on your face and on your family's. That makes one understand that it will all come around, that it ultimately will be you exploding on your friends and your family. It is helpful to have something physically comprehensible, and not just an abstraction, a television romance. People are disappearing, and we have to acknowledge it.

1 Kiki Smith here refers to the sculpture *Lot's Wife,* also called *Pee Body,* a work she realized for her exhibition "Silent Work" at the MAK-Gallery of the Austrian Museum of Applied Arts (25 May–12 July 1992).
2 see: conversation between Chris Burden and Jan Hoet
3 Orlan, an artist living in Paris, had several times plastic surgery; on one occasion, the surgery was transmitted to viewers via satelite television. Photo-documentation of this process reveals that plastic surgery does not immediately produce the expected results, but deformations and mutilation of the face.

1 Kiki Smith bezieht sich auf die Skulptur *Lot's Wife*, auch *Pee Body* genannt, die für ihre Ausstellung »Silent Work« in der MAK-Galerie des Österreichischen Museums für angewandte Kunst (25. 5.–12. 7. 1992) entstand.

2 vgl. das Gespräch zwischen Chris Burden und Jan Hoet

3 Die in Paris lebende Künstlerin Orlan unterzog sich mehrfach kosmetischen Operationen, denen in einem Fall sogar Zuschauer über Satellitenfernsehen beiwohnen konnten. In der photographischen Dokumentation dieser Selbstversuche wird sichtbar, daß die plastische Chirurgie zunächst nicht das gewünschte Gesicht, sondern Verformungen und Verstümmelungen hervorbringt.

ROUND TABLE DISCUSSION: POSITIONS IN ART

with Chris Burden, Ziva Freiman, Jan Hoet, Kyong Park, Joachim Riedl, Kiki Smith, James Turrell, Lebbeus Woods, Daniela Zyman

Jan Hoet: We would like to start with the final round without making a resumé of the different talks we had this afternoon. Therefore, I would like to ask the public to stop us at any time when necessary and come in with questions.

As a general observation can I say that the prevalent attitude behind the talks we had today was substantially different from what we had some ten years ago? Minimal Art and Arte Povera were about working with the concrete materials unrelated to personal experiences. Today, we are emphasizing much more the emotional aspects of art and the work produced is much closer to direct experience. Is this evaluation something you would agree with?

Lebbeus Woods: I don't think that your evaluation applies to my position so well, but perhaps others might find it very sympathetic with what they were saying.

Kiki Smith: In my life it seems useful to talk about my own experience because – as a female – one is defined in the general scheme of things through other people's definitions of your experience. If you look at the history of representation of women, art-historical imagery of women, you will find naked women lounging about, basically that's all you have. Since that [activity] occupies a very small portion of my life, it seems to me more accurate to create an awareness for what women's lives are really about. [For women] it is useful to be self-defined and [for men] it decreases their imperialist position by not having to tell other people how they should be living. Self-definition opens up a range of possibilities.

Jan Hoet: James Turrell also spoke about emotions.

James Turrell: I mentioned emotions in a certain context. I implied direct perception in the sense that the work I am doing is about your seeing, and is responsive to your seeing. And so, though my work is a product of mine, its subject is the direct confrontation of the actual work with the perceiving of it. In fact, it doesn't exist without [your perception]. That makes possible the emotional content or the emotional context of my work.

138

ROUND-TABLE GESPRÄCH: POSITIONEN ZUR KUNST

mit Chris Burden, Ziva Freiman, Jan Hoet, Kyong Park, Joachim Riedl, Kiki Smith, James Turrell, Lebbeus Woods, Daniela Zyman

Jan Hoet

Jan Hoet: Wir haben uns gedacht, daß wir ohne eine Zusammenfassung der Gespräche von heute nachmittag in die letzte Runde gehen können. Ich bitte also das Publikum, sich direkt einzuschalten und Fragen zu stellen.

Ganz allgemein scheint mir, daß die Grundpositionen, die die heutigen Gespräche geprägt haben, sich wesentlich von jenen unterscheiden, die vor etwa einem Jahrzehnt die Diskussion bestimmt haben. Die Minimal art und die Arte povera beschäftigten sich hauptsächlich mit Materialien, die nichts mit persönlichen Erfahrungen zu tun hatten. Heute werden die emotionalen Aspekte der Kunst viel stärker betont, und die einzelnen Werke kommen mehr aus dem unmittelbaren Erleben. – Ist das eine Einschätzung, der Sie zustimmen würden?

Lebbeus Woods: Ich glaube, daß diese Beschreibung mit meiner Position nicht wirklich übereinstimmt, aber vielleicht erkennen sich die anderen darin wieder.

Kiki Smith: Was mein Leben angeht, erscheint es mir äußerst nützlich, über meine eigenen Erfahrungen zu sprechen, weil man – als Frau – im großen und ganzen durch die Definitionen der anderen bestimmt wird. Wenn man sich die Geschichte der Darstellung der Frau ansieht, die Bilderwelt der Weiblichkeit in der Kunstgeschichte, so findet man jede Menge nackter Frauen, die irgendwo herumliegen, und das ist im wesentlichen auch schon alles. Und weil das Herumliegen nur einen sehr kleinen Teil meines eigenen Lebens ausmacht, möchte ich ein Bewußtsein dafür schaffen, worum es im Leben der Frauen wirklich geht. Es ist wichtig [für Frauen], sich selbst zu definieren; und den Männern gibt es die Möglichkeit, ihre imperialistische Stellung abzubauen, weil sie den anderen nicht mehr sagen müssen, wie sie zu leben haben. Selbstbestimmung eröffnet also eine ganze Reihe von Möglichkeiten.

Lebbeus Woods: The work of an architect is fundamentally different from that of an artist. Just to clarify this point: artists work directly with the "finished result of their work", so they interact very directly [with their work, the viewer, the user] – although there are obviously artists who have made art that is not directly interactive. Architects are always making projects – projections usually in time and in space. Their work has to do with projecting things that could happen or that they would like to happen or that someone had commissioned to happen in the future. In a sense, the architect's work has a very indirect nature, and this provokes a more abstract thinking, if you will.

James Turrell: I think [architecture] is much more concrete [than art]. Architecture has a thingness that is very well defined, and often even has a function which is largely defined. In that respect, I think that looking at architectural projects [in the form of plans, elevation, technical drawings etc.] is a little bit like saying – "the piano is a fantastic invention that comes out of the period of time when the clavier..." Nobody does that, one simply starts to play without saying: "Oh, my God, what a machine!" And yet, you feel the instrument coming through the music. The same is true with architecture as well. There is a feeling that emanates from the actual confrontation of space and form. It happens both in architecture and in art.

James Turrell

I will take a little bit a similar position to yours [Lebbeus Woods'], because a lot of things that I do also happen sometimes out in the future – I would like them to happen now but it always takes sponsorship or something else greater than the moment. This resistance and the nature of what you do puts you in a very similar position with us.

Kyong Park: Shouldn't we really ask the question: What is direct experience? And then, the next question would be: What is indirect experience? I think [to find definitions which are valid for both the arts and architecture] is much more complicated then to be pursuing ideas that tend to lead to a certain kind of exclusiveness, projecting a conflict rather than the possibility of a dialogue. For example, it strikes me that Lebbeus has mentioned earlier that his work is not as direct as perhaps artists' would be. But I think this relates to the fact that our

Jan Hoet: Auch James Turrell hat über Gefühle gesprochen.

James Turrell: Ja, in einem bestimmten Zusammenhang. Ich habe von direkter Wahrnehmung gesprochen, da es in meinen Arbeiten um euer Sehen geht, da meine Arbeiten sich auf *euer* Sehen beziehen. Und obwohl sie meine Erzeugnisse sind, ist ihr Thema die unmittelbare Konfrontation des tatsächlichen Werks mit den Wahrnehmungsphänomenen, die es auslöst. Eigentlich gibt es meine Arbeiten ohne [eure Wahrnehmung] gar nicht. Die ermöglicht erst ihren emotionellen Gehalt oder emotionellen Kontext.

Lebbeus Woods: Die Arbeitsweise eines Architekten unterscheidet sich grundsätzlich von der eines Künstlers. Künstler arbeiten im wesentlichen unmittelbar mit dem »fertigen Ergebnis ihrer Arbeit«, interagieren also direkt [mit ihrer Arbeit, dem Betrachter, dem Benützer] – obwohl es selbstverständlich Künstler gibt, deren Kunst nicht unmittelbar interaktiv ist. Architekten hingegen planen immerzu Projekte, also zeitliche und räumliche Projektionen. Die Arbeit des Architekten besteht daraus, Dinge zu projektieren, die realisiert werden könnten oder von denen er möchte, daß sie geschehen, oder deren Realisierung jemand für die Zukunft in Auftrag gegeben hat. Die Arbeit eines Architekten ist daher in einem gewissen Sinn sehr indirekt, und das bewirkt, wenn man so will, ein abstrakteres Denken.

James Turrell: Ich bin überzeugt, daß [Architektur] viel konkreter ist [als Kunst]. Architektur besitzt eine Dinglichkeit, die sehr genau festgelegt ist, und meist auch eine im wesentlichen festgelegte Funktion. Wenn man Architekturprojekte [in Form von Plänen, Aufrissen, technischen Zeichnungen usw.] betrachtet, ist das irgendwie, als würde man sagen:»Das Klavier ist eine großartige Erfindung, die aus einer Zeit stammt, als das Klavichord…« Das tut doch niemand, man fängt einfach zu spielen an, ohne groß zu staunen, was für eine wunderbare Apparatur man da vor sich hat. Und doch spürt man das Instrument in der Musik. Ähnlich verhält es sich mit der Architektur. Die tatsächliche Konfrontation von Raum und Form erzeugt Emotionen, aber das geschieht auch in der Kunst.

Ich vertrete eine ähnliche Position [wie Lebbeus Woods], weil auch vieles von dem, was ich mache, irgendwann einmal in der Zukunft geschehen wird. Ich wünsche mir zwar, daß es sofort geschehen könnte, aber ich bin ja immer auf Subventionen angewiesen, auf etwas, das stärker ist als der Augenblick. Aufgrund dieser Widerstände und auch durch die Art deiner Arbeit bist du eigentlich in einer sehr ähnlichen Situation wie wir.

141 **Kyong Park:** Sollten wir uns nicht fragen, was unmittelbare Erfahrung eigentlich

experience now is generally becoming more indirect, well direct and also indirect at the same time: He mentioned the notion of architecture being experienced through the media, or in mediated form. The subject of virtual reality came up, the industry and culture of Hollywood was also brought on the table. Are these changes in the transmission and circulation of information affecting direct or indirect experiences? That becomes difficult to define because if architecture – which I strongly believe – should become mediated, presented in media form, then spaces don't have to be physically built. [Media experience] to me, as well as for Lebbeus, is the more direct kind of experience. But on the other hand, it is also an indirect experience: It is not of a real time, real space. And artists are understanding now – as James has mentioned – that many of their [art] projects work the same way as architectural projects. There are sites, proposals, there is time involved in execution which is independent of the artist's effort.

Lebbeus Woods: The question of direct and indirect [experience] is a kind of false dichotomy. The nature of architecture is such, that it very self-consciously takes on a set of issues that maybe artists don't have to pursue. I want to pursue this part a bit, because I am the only one here 'officially' in architecture although there are many people who know my work and would say that I am not an architect. I am defending the idea that there is something

Lebbeus Woods

called architecture, that has some special character or meaning. I would say that the nature of architecture is to try to bring material experience onto the level of communality, of a common everyday experience. It aims at the fabric of life, wants to dissolve in the fabric of existence, doesn't want to exist as a special project, as a special example. Of course, in the history of architecture, we can also find the concept of the great singular work, but by and large, architecture wants to be a part of the fabric.

Also, if one is "building the fabric of a community" or a city, than one should have a so-called direct confrontation [with this community], but in our present society this is no longer the case. Today, we experience things through different media that constitute the new fabric of our existence. Architecture is very self-consciously concerned with this societal change and – in response – I think that it wants to efface its role as the monumental and the special.

ist? Und weiters fragen, was vermittelte Erfahrung ist? Ich meine, daß es viel schwieriger ist [,Definitionen zu finden, die sowohl für die Kunst als auch für die Architektur Gültigkeit haben,] als Ideen nachzugehen, die letztlich zu sich ausschließenden Kategorisierungen führen und damit eher auf einen Konflikt als auf die Möglichkeit eines Dialogs hinauslaufen.

Mich überrascht zum Beispiel, daß Lebbeus meint, seine Arbeit sei wahrscheinlich weniger direkt als die eines Künstlers. Ich glaube, daß das mit der Tatsache zu tun hat, daß unsere Erfahrung generell vermittelter wird, besser gesagt: direkter und indirekter zugleich. Er hat davon gesprochen, daß Architektur über die Medien, in medialer Form erlebt wird. Es war dann auch von virtueller Realität die Rede, und von der Industrie und Kultur Hollywoods. Beeinflussen diese Veränderungen in der Übertragung und Verbreitung von Information unsere direkten oder indirekten Erfahrungen? Das ist nicht einfach zu beantworten, weil wenn Architektur – und davon bin ich überzeugt – in medialer Form vermittelt werden soll, muß man Räume nicht mehr tatsächlich bauen. Für Lebbeus und mich ist [mediale Erfahrung] die direktere Form der Erfahrung. Andererseits ist sie natürlich auch im gleichen Maße indirekt: sie gehört keiner realen Zeit, keinem realen Raum an. Künstler beginnen heute, wie James gesagt hat, zu verstehen, daß viele ihrer Projekte wie Architekturprojekte funktionieren. Es gibt sozusagen Baustellen, Entwürfe, Projekte, und die zur Ausführung erforderliche Zeit ist unabhängig von der Anstrengung des Künstlers.

Lebbeus Woods: Die Frage nach dem Unterschied von direkt[er] und indirekt[er Erfahrung] wirft eine Art falscher Dichotomie auf. Es liegt im Wesen der Architektur, daß sie sich höchst selbstbewußt einer Reihe von Aufgaben stellt, mit denen sich Künstler vielleicht nicht beschäftigen müssen. Ich möchte ein wenig bei diesem Punkt bleiben, weil ich hier im »offiziellen« Sinn der einzige Architekt bin, wenn auch viele Leute, die meine Arbeit kennen, mich nicht als Architekten bezeichnen würden.

Ich verteidige die Vorstellung, daß es etwas gibt, das Architektur heißt und eine bestimmte Eigenart, eine bestimmte Bedeutung hat: Ich würde sagen, daß das Wesen der Architektur darin liegt, daß sie materielle Erfahrungen einer Gemeinschaft, einem gemeinsamen Alltagserleben zugänglich zu machen versucht. Architektur zielt auf das Gefüge des Lebens ab, möchte im Gefüge der Existenz aufgehen, und will nicht ein außergewöhnliches Projekt oder gar beispielhaft sein. Natürlich stößt man in der Geschichte der Architektur auch auf die Vorstellung des einzigartigen Meisterwerkes, aber im wesentlichen möchte Architektur

I think that this is the difference between architecture and art, because art still has the ambition to represent the highest form of human presence, the exceptional, the epiphany, the peak. James, in your talk today you spoke of that almost unique moment when light becomes part of space. That represents, to me, a kind of peak experience, as opposed to the architectural ambition to be a part of the commonplace.

James Turrell: Well, I think that there are many architects who really believe to be doing pretty much the same thing that we are speaking of. Basically I think that we are involved in a structuring of reality.

Lebbeus Woods: Whose reality though?

James Turrell: Reality and the experience of it has two sides: There is the experience of the making of a work, and the experience of the viewers – of those for whom we intend the work. I believe that some of the focus has shifted. So, no longer is [the work] a journal of the maker's seeing, as it is the experience of someone else's seeing or perceiving. This is true for any structuring of reality whether it has to do with architecture, or with [conceptual work]. Thoughts are a structuring of reality as well. This shift has affected the more non-vicarious art forms – which is [compared to more traditional forms of art] like the difference between watching football on television and playing it. Now we are requesting that it be played, but we must be aware that [in order to participate] there is the price of admission that must be paid – the admission to the work. People have to deal with [the work], to confront it.

Ziva Freiman: I guess I disagree with Lebbeus that architecture is only seeking to somehow disappear in a noble and humble fabric of some kind.

Lebbeus Woods: I didn't say humble – it's your word.

Ziva Freiman: You didn't say noble either!

Lebbeus Woods: I only pointed to the one which I disliked most.

Ziva Freiman: This idea of somehow merging into anonymity, as part of an undefined fabric is a misrepresentation [of what architecture is about] as you well know. There are great 'peaks' of artistic emotion, great heights achieved by certain buildings, and not necessarily by the ones which are intended to be that way. Sometimes [greatness] just happens – independently of intention, as it happens in art.

Lebbeus Woods: But seriously, could you tell me what these peaks are? Are they the Gothic cathedrals, the Acropolis, what are these peaks?

Ziva Freiman: You want me to talk about the canon, and that's fine, I can do that

144

Teil des gemeinschaftlichen Gefüges sein. Wenn man »das Gefüge einer Gemeinschaft« oder einer Stadt baut, dann sollte man [mit dieser Gemeinschaft] in einer sogenannten unmittelbaren Auseinandersetzung stehen, aber das ist in der heutigen Gesellschaft nicht mehr der Fall. Heute erfahren wir von den Dingen aus den Medien, die das neue Gefüge unserer Existenz darstellen. Auf sehr selbstbewußte Weise setzt sich die Architektur mit diesem gesellschaftlichen Wandel auseinander und versucht, denke ich, auf ihn zu reagieren, indem sie ihre Rolle als das Besondere und Monumentale aufgibt. Hierin liegt meiner Auffassung nach der Unterschied zwischen Architektur und Kunst, verfolgt doch Kunst immer noch die Ambition, die höchste Form menschlicher Gegenwart zu sein: das Außergewöhnliche, die Offenbarung, der Höhepunkt. James hat heute beispielsweise in seinen Ausführungen von dem beinahe einzigartigen Augenblick gesprochen, in dem Licht Teil des Raums wird. Für mich ist das eine Art von Höhepunkt[erfahrung], die im Gegensatz steht zu dem Anliegen der Architektur, Teil des Alltäglichen zu sein.

James Turrell: Es gibt sicher jede Menge Architekten, die ernsthaft glauben, daß sie mehr oder weniger das tun, wovon wir hier sprechen. Grundsätzlich bin ich aber der Auffassung, daß wir uns mit dem Strukturieren von Wirklichkeit beschäftigen.

Lebbeus Woods: Aber wessen Wirklichkeit?

James Turrell: Die Wirklichkeit und das Erfahren der Wirklichkeit hat zwei Seiten: einerseits ist da die Erfahrung des Schaffens eines Werks, andererseits die Erfahrung des Betrachters, also derjenigen, für die wir arbeiten. Ich glaube, daß hier eine Verschiebung stattgefunden hat. [Das Werk] ist nicht mehr Tagebuch der Wahrnehmung des Schaffenden, es ist die Erfahrung des Sehens oder der Sinneswahrnehmungen der anderen. Das gilt für jedes Strukturieren von Wirklichkeit, ob es sich nun um Architektur oder um konzeptuelle Kunst handelt. Auch Gedanken sind ein Strukturieren von Wirklichkeit. Diese Verlagerung hat sich vor allem auf die nicht-vermittelte Kunst ausgewirkt, [deren Unterschied zu traditionellen Kunstformen] vergleichbar ist mit dem Unterschied zwischen »Fußball im Fernsehen und selbst Fußball spielen«. Heute wird verlangt, daß tatsächlich gespielt wird, aber wir müssen uns bewußt sein, daß [die Partizipation] ihren Preis hat, daß der direkte Zugang zum Werk etwas kostet: Die Leute müssen sich [mit dem Werk] auseinandersetzen, sich ihm aussetzen.

Ziva Freiman: Ich glaube, ich kann da Lebbeus nicht zustimmen, daß Architektur lediglich versucht, in irgendeinem edlen und bescheidnen Gefüge aufzugehen.

and list some so-called great names: Ronchamp[1] and all of those. But I also think in terms of mundane situations; for example the stairways in a house in Brentwood[2] can induce some kind of epiphany. [These exceptional architectural qualities] might result from the aspirations of an architect or not – it really does not matter – but still I think that architecture achieves these heights. I don't accept this idea that unites all [works in architecture] on some kind of semi-comatose level.

Jan Hoet: Is it not possible to say that architecture – which might be considered as integral part of the visual arts for it is not so easy to distinguish any more these two expressions – [regardless of the question whether] it creates peaks or not, is always very specific, perfectly articulated, and profiled? An artwork however is more about appearances, the articulation of global feelings, which is something that you don't have in architecture.

Ziva Freiman: I don't agree with that either, I am afraid. The most promising appeal of architecture, precisely where it succeeds the most, is where it manages to attain that kind of global appeal, beyond its specificity and functionality as a structure.

Ziva Freiman

Lebbeus Woods: I was talking about the fabric [of life, of existence, of a community], and you responded with the fact that there are many great works of architecture that represent a kind of epiphany, or a peak. I would like to identify what those peaks are. And, by the way, your example of the stairway in a Brentwood house is much more about the fabric then about monumental architecture.

I would say that those works in architecture that represent a peak [are really the product of] a kind of culture in which there is a pyramidal structure of authority. The political and social structures of a time designate certain monuments as peak monuments. The rest of architecture falls somewhere below that peak. All I am saying is that we are living in a time now – though we may wish to live in the time of patronage by aristocracy in which all the great monuments could be built – when that is fading. I am personally happy for that. All of the most daring experiments of architecture today are done by people who aim to be part of the fabric. In Coop Himmelblau's work, I don't see any aiming for monumentality. I see and hear it say: This is how the city could be, this could be the fabric of life today.

146

Lebbeus Woods: »Bescheiden« stammt nicht von mir, das ist von dir.

Ziva Freiman: »Edel« ist auch nicht von dir!

Lebbeus Woods: Ich habe das Wort herausgegriffen, das mich am meisten gestört hat.

Ziva Freiman: Diese Vorstellung, daß Architektur Teil eines unbestimmten Gefüges ist und sich irgendwie in der Anonymität auflöst, ist eine falsche Darstellung [dessen, worum es in der Architektur geht] – und das weißt du auch! Es gibt großartige »Höhepunkte« künstlerischen Empfindens, manche Bauwerke – und das sind nicht unbedingt die, die so geplant waren – haben ein ungeheures Niveau erreicht. [Qualität] stellt sich eben manchmal einfach ein, unabhängig von allen Absichten, wie in der Kunst.

Lebbeus Woods: Aber im Ernst: Kannst du mir sagen, an welche Höhepunkte du da denkst? Die gotischen Kathedralen? Die Akropolis? Woran denkst du, wenn du Höhepunkte sagst?

Ziva Freiman: Ich soll mich also zu einem Kanon bekennen. Ist mir recht. Wenn du willst, kann ich dir ein paar sogenannte große Namen nennen – Ronchamp[1] und all die anderen – aber auch ganz gewöhnliche Situationen. Ein Stiegenhaus in Brentwood zum Beispiel[2] kann auch eine Art Offenbarung auslösen. Ob nun [diese hervorragenden architektonischen Qualitäten] den Intentionen des Architekten entspringen oder nicht, spielt wirklich keine Rolle – auf jeden Fall bin ich überzeugt, daß Architektur diese Höhepunkte erreichen kann. Ich kann diese Vorstellung nicht akzeptieren, die alle architektonischen Arbeiten auf einer gleichsam halbkomatösen Ebene vereint sehen will.

Jan Hoet: Könnte man nicht sagen, daß Architektur, ob sie nun Höhepunkte hervorbringt oder nicht, als integraler Bestandteil der bildenden Künste – denn meiner Meinung nach lassen sich die beiden Begriffe nicht mehr so einfach auseinanderhalten – immer sehr konkret und völlig präzise ausformuliert und strukturiert ist? Ein Kunstwerk hingegen beschäftigt sich mit der Erscheinung, dem Ausdruck von umfassenden Gefühlen – das gibt es in der Architektur nicht.

Ziva Freiman: Ich fürchte, ich muß auch da widersprechen. Die stärkste Faszination hat Architektur – und dort verwirklicht sie auch ihre Möglichkeiten in höchstem Maße –, wo es ihr gelingt, jenseits ihrer spezifischen Funktionalität als Struktur eben diese Art umfassende Wirkung zu erzielen.

Lebbeus Woods: Ich habe vom Gefüge [der Existenz, einer Gemeinschaft] gesprochen, und du hast dagegen den Umstand angeführt, daß es eine Reihe von großen Werken der Architektur gibt, die eine Art Offenbarung, einen Höhepunkt

Ziva Freiman: We happen to be talking about whether architecture can achieve peaks of spirituality, of emotion, of experience – and that was the point on which I disagreed. We are not talking about monumentality.

Lebbeus Woods: Why do we need to identify certain things as peaks? Why isn't the fabric more important than peaks? It should be. Why can't the fabric of our so-called common life be the peak [of human achievement]? Why do we have to go to churches to have a peak experience, to a great temple in Greece – I am against this trivial peak-thinking, this peak-mentality in art or in architecture.

Ziva Freiman: Some architecture is better than other, that's all there is to it, it is not an advocacy of peaks. Sometimes you manage to attain an experience with a stairway, and sometimes you don't. It probably has to do with talent.

Kyong Park: Your controversy is a good example for what we are trying to differentiate here at the table. There are many undefined factors involved in your discussion which make it rather difficult to find a common ground. There seems to be a confusion between what the two of you believe is a peak, or is a fabric.

Kyong Park

Lebbeus Woods: You are confusing things, Kyong. We had it very clear.

Kiki Smith: But confusion is a much more accurate state of being.

Kyong Park: It is impossible for us – as architects – to make a clear and conclusive statement about virtually anything that we do. For my part, I agree that the notion of a peak overlaps with the notion of political authority, the authority of a profession. But, on the other hand, I also believe in the idea that we somehow [have the capacity to] excel in our work, and I think you, Lebbeus, do believe in that too. I think that with our search for a way to make our field and personal explorations a kind of common experience, we seek for reaching the peak. And then, mind you, peaks are also integral parts of larger bodies.

Lebbeus Woods: Now you are describing larger hierarchies: If there is a head, then there is a body, then there is an arm.

Kyong Park: I am not. All I am saying, is that the peak can be as much part of the fabric as the low points are, and that architects clearly have the desire both to reach peaks and to be part of the fabric of the society. We don't want to be the authority in distance, the measure that we enforce on others. We want to be part of it, and we want society to engage in what we do. Why not have both?

darstellen. Ich würde gerne näher auf diese Höhepunkte eingehen. Und übrigens ist dein Brentwood-Stiegenhaus viel eher ein Beispiel für Architektur als Gefüge denn als monumentale Struktur. Ich würde meinen, daß die Werke der Architektur, die einen Höhepunkt darstellen, [in Wahrheit] Kulturen [entstammen], in denen die Autoritätsstruktur streng hierarchisch pyramidenförmig aufgebaut ist. Die politischen und gesellschaftlichen Strukturen einer Zeit bestimmen, welche Bauwerke als Höhepunkte anzusehen sind, hinter die alles andere irgendwie zurückfällt. Wenn wir uns auch vielleicht wünschen, in jener Zeit zu leben, in der unter der Schirmherrschaft des Adels alle diese großen Bauten entstehen konnten, leben wir heute in einer Welt, in der diese Struktur im Verschwinden ist. Das wollte ich sagen. Und daß ich glücklich darüber bin. Die kühnsten Experimente in der Architektur von heute stammen alle von Leuten, die Teil des Gefüges sein wollen. In den Arbeiten von Coop Himmelblau kann ich kein Streben nach Monumentalität entdecken. Ich sehe und höre sie sagen: So könnte die Stadt aussehen, das könnte das Gefüge des heutigen Lebens sein.

Ziva Freiman: Wir sprachen darüber, ob Architektur Höhepunkte des Geistigen, des Gefühls, des Erlebens hervorbringen kann – und darauf bezog sich auch mein Einspruch. Um das Monumentale ist es nicht gegangen.

Lebbeus Woods: Warum müssen wir überhaupt bestimmte Dinge als Höhepunkte bezeichnen? Warum ist uns denn nicht das Gefüge wichtiger als einzelne Höhepunkte? Es sollte uns wichtiger sein. Warum gilt eigentlich nicht unser sogenanntes alltägliches Leben in seiner Gesamtheit als Höhepunkt [menschlichen Schaffens]? Warum müssen wir denn eine Kirche oder einen griechischen Tempel aufsuchen, um Höhepunkte zu erleben? – Ich habe etwas gegen dieses triviale Höhepunktdenken, diese Höhepunktmentalität in der Kunst und Architektur.

Ziva Freiman: Manche Architektur ist einfach besser als andere, darum geht es, und nicht um ein Plädoyer für Höhepunkte. Manchmal gelingt es, ein Stiegenhaus zum Erlebnis werden zu lassen, und manchmal nicht. Das hat wahrscheinlich etwas mit Begabung zu tun.

Kyong Park: Diese Debatte zeigt sehr gut, um welche Unterscheidungen wir uns hier bemühen sollten. Eurer Auseinandersetzung liegt eine Reihe von nicht definierten Begriffen zugrunde, und daher ist es so schwierig, einen gemeinsamen Nenner zu finden. Es scheint Verwirrung darüber zu herrschen, was ihr beide unter Höhepunkt bzw. Gefüge versteht.

Lebbeus Woods: Ich glaube, die Verwirrung liegt bei dir. Ziva und ich haben uns da nicht mißverstanden.

Kiki Smith, Kyong Park

Why do we insist on making definitions that create differences? This is the problem of our rational tradition.

Lebbeus Woods: The ability to make distinctions, so-called differences, is our critical faculty, the ability to see subtle differences even between very similar things. Don't dismiss the idea of differences – they are very important.

Kyong Park: When differences become so overloaded, then they only create conflict.

Lebbeus Woods: I would like to think that art and life are coming together, that they flow together into what I call the fabric. In that, yes, there is high and low, there are differences and I am not trying to eliminate them. We are sitting in a museum, in the institution that separates art from life and [every visitor] has to pay to be allowed to cross the barrier to enter the peak experience. I just rebel against that. And, by the way, media itself is the fabric.

From the public: But through the media, I am forming an opinion based on someone else's perception.

Lebbeus Woods: Do you think that with regard to Mr. Turrell's work you are not forming an opinion based on what he did? Of course you are. He did something very specific and very precise.

150

Kiki Smith: Aber Verwirrung ist ja ein sehr adäquater Bewußtseinszustand.

Kyong Park: Für uns als Architekten ist es meist unmöglich, über das, was wir tun, eine eindeutige und schlüssige Aussage zu treffen. Auch ich finde, daß die Vorstellung von Höhepunkten sich mit der Vorstellung von politischer Macht und professioneller Autorität überschneidet. Andererseits glaube ich aber auch, daß wir [die Möglichkeit haben,] uns in unserer Arbeit irgendwie auszuzeichnen, und ich bin überzeugt, daß du, Lebbeus, das auch glaubst. Indem wir nach einem Weg suchen, unser Fach und unsere persönlichen Forschungen zu einer Art allgemeinen Erfahrung zu machen, versuchen wir, denke ich, einen Höhepunkt zu erreichen. Und schließlich sind ja Höhepunkte nichts anderes als die Gipfel größeren Strukturen.

Lebbeus Woods: Du beziehst dich dabei nur auf größere Hierarchien: Wo es einen Kopf gibt, da gibt es auch einen Körper, und auch einen Arm.

Kyong Park: Ich wollte nicht von größeren Hierarchien sprechen. Ich wollte nur sagen, daß ein Höhepunkt ebenso Teil des Ganzen sein kann wie die Tiefpunkte, und daß es Architekten zweifellos darum geht, sowohl Höhepunkte zu erreichen als auch Teil des gesellschaftlichen Gefüges zu sein. Wir wollen keine abgehobenen, fernen Autoritäten darstellen, kein Maß sein, das wir anderen aufzwingen. Wir wollen dazugehören, und wir wollen, daß die Gesellschaft Anteil nimmt an dem, was wir tun. Warum können wir nicht beides haben? Warum beharren wir auf Definitionen, die Unterschiede schaffen? Das ist doch das Problem unserer von Rationalität bestimmten Tradition.

Lebbeus Woods: Die Fähigkeit, Unterscheidungen zu treffen, Unterschiede festzustellen, ist Teil unserer kritischen Vernunft, unserer Fähigkeit, selbst zwischen zwei sehr ähnlichen Dingen feine Unterschiede zu erkennen. Diese Differenzierungen sollte man nicht einfach abtun – sie sind doch etwas sehr Wichtiges.

Kyong Park: Wenn man Unterschiede aber derart überfrachtet, führen sie nur zu Konflikten.

Lebbeus Woods: Ich würde gerne daran glauben, daß Kunst und Leben zueinanderfinden, daß sie zusammenströmen in dem, was ich als Gefüge bezeichne. In diesem Gefüge gibt es Höhen und Tiefen, gibt es Unterschiede, die ich nicht beseitigen will. Wir sitzen hier in einem Museum, in einer Einrichtung, die die Kunst vom Leben trennt, und [jeder Besucher] muß bezahlen, wenn er die Schwelle überschreiten will, um am Erleben der Höhepunkte teilzuhaben. Dagegen wehre ich mich einfach. Und übrigens bilden ja die Medien selbst das Gefüge.

James Turrell: Yes, but this is very difficult to experience just from the drawing or a photo of it.

From the public: I am referring to what Mr. Turrell said that he doesn't want to see his work on photographs.

Lebbeus Woods: Yes, but we wouldn't even know who James Turrell was, or any of us for that matter, without the media.

Chris Burden: I am not sure about that.

Lebbeus Woods: Chris! You say that? How dare you? You were the innovator in using the media!

Chris Burden: But most of the people heard about my work through word of mouth.

Ziva Freiman: Be it as it may. I am a journalist and I would hardly be the one to suggest that we abolish the media. Leb, I think that your question is excellent. It is right on the button. Media mentality does tend to perpetuate peaks, it tends to make stars, only to show the remarkable. That is the opposite of what you are suggesting: A kind of fabric where we can experience things of all sorts of scales and dimensions. I agree with you also in that there are certain faculties that you employ [in the media], but there is a whole range of other faculties that are missing: smell, sound, movement, use of the body – these things that Kiki Smith and other artists were talking about.

Lebbeus Woods: But let's not deceive ourselves. How many James Turrell projects are there in Vienna? The point is that art today is transmitted through the media while the so-called authentic experiences are located on specific sites all over the world.

James Turrell: The myth is created through the media, and the actual experience is at the site. The myth can entice people to go and see things. That is a very good use of the media. But media itself is interesting only to a few artists, and there are few who do it very well. I am not one of them.

Chris Burden: I was thinking about what you said on the integration of architecture into the fabric. I think that what I am going to say applies to the arts too, but I am going to say it about architects. Maybe the way to do it is not to have architects. If you go through history, there are societies in which there are built structures, but no architects – as there are societies in which people are not designated as artists. They were rug-weavers, or pottery-makers.

Lebbeus Woods: I always thought that it was an insult to be called artist. I believe it is much better to designate the specific [craft] – the painter, the potter, the sculptor. There were places and times when the word artist was used for pretenders.

Aus dem Publikum: Durch die Medien bilde ich mir aber eine Meinung, die auf der Wahrnehmung anderer beruht.

Lebbeus Woods: Meinen Sie wirklich, daß Ihre Meinung über die Arbeiten von James Turrell nicht auf dem beruht, was er selbst getan hat? Natürlich tut sie das! Er hat ja etwas ganz Bestimmtes und Genaues gemacht.

James Turrell: Schon, schon. Aber das läßt sich auf einer Zeichnung oder einem Foto nur sehr schwer erkennen.

Aus dem Publikum: Ich beziehe mich darauf, daß Herr Turrell gesagt hat, daß er seine Arbeiten nicht auf Fotos sehen will.

Lebbeus Woods: Ja, aber ohne Medien wüßte niemand, wer James Turrell oder irgendeiner von uns überhaupt ist.

Chris Burden

Chris Burden: Da bin ich mir nicht so sicher.

Lebbeus Woods: Ausgerechnet du sagst das, Chris? Wie kannst du nur? Du warst doch bahnbrechend in deinem Einsatz der Medien!

Chris Burden: Die meisten haben aber durch Mundpropaganda von meiner Arbeit gehört.

Ziva Freiman: Lassen wir das. Ich bin Journalistin und wäre sicher die letzte, die für die Abschaffung der Medien eintritt. Leb, die Frage, die du gestellt hast, halte ich für ausgezeichnet. Du hast genau ins Schwarze getroffen. Die Natur der Medien tendiert dazu, Höhepunkte festzuschreiben, Stars zu machen und nur das Besondere zu zeigen. Und das ist genau das Gegenteil dessen, was du vorschlägst: eine Art Gefüge, in dem wir Dinge aller möglichen Größenordnungen und Dimensionen erfahren können. Ich bin auch damit einverstanden, daß [in den Medien] bestimmte Fähigkeiten eingesetzt und angesprochen werden, aber es gibt einen großen Bereich anderer Fähigkeiten, die hier wegfallen: Gerüche, Klänge, Bewegungen, der Einsatz des Körpers – all die Dinge, über die Kiki Smith und andere gesprochen haben.

Lebbeus Woods: Täuschen wir uns doch nicht! Wieviele James-Turrell-Projekte gibt es denn in Wien? Der Punkt ist doch, daß die Kunst heute über die Medien vermittelt wird, während das sogenannte authentische Erleben an bestimmte, über die Welt verstreute Standorte gebunden ist.

James Turrell: Der Mythos wird von den Medien geschaffen, und die tatsächliche Erfahrung findet vor Ort statt. Mythen können Menschen dazu bringen, Orte aufzusuchen und sich die Sachen anzusehen. Wenn Medien das bewirken, finde

James Turrell: In those periods, you certainly wouldn't want your daughter to marry one! Now you don't want to have your son marry one.

To me, the fabric that we were talking about is: Moving society from one place to another through the direct confrontation with works. Kiki's work, Chris' work does move the society from one place to another. This [potential for change inherent to artistic expression] is something aside from what the work itself is. [The individual work] has its own unique expression formulated by the individual artist. Thus, changes affecting the fabric are the result of the collective, of all art that is involved in the change of perception, in how we think about things, how we look at things.

Daniela Zyman: In his talk, Chris Burden spoke about art as a form of investigation. And this is what we should be looking at for a moment: the whole range of different themes, approaches, visions, and focuses of investigation that seem to me the constituting elements of both individual positions in art and [the collective fabric of] society. Kiki's investigations of the body, of death, female/male conflicts, disease; James is investigating light and space and perception, Leb: new spaces and forms of interaction as a model for society. The main thing that gets lost in media coverage, and that's my problem with it, is the process of investigation.

In this context I see the entire question from before, i. e. an individual work of art being a peak or not, as a static formulation of what to me is a process in evolution, a constant revision. Individual works, peak or not, can only be a kind of stage in an investigation.

Chris Burden: For me, the sculptures that are failures are sometimes much more interesting. When you are making something, you have a fantasy about how it is going to be, and you measure it with what the results are. When you are really wrong, then the process is the most interesting about that work. It may be a disaster for those who invited you because it might not fulfill their expectation, but the personal relevance of 'things that went wrong' is immeasurable.

Kiki Smith: All these things are related to one another, because you take something from the inside

Kiki Smith

ich das sehr gut. Aber eigentliche Arbeit mit den Medien ist ja nur für wenige Künstler interessant, und nur wenige können wirklich mit ihnen umgehen. Ich gehöre jedenfalls nicht dazu.

Chris Burden: Ich habe gerade über die Einbindung der Architektur in das Gefüge nachgedacht. Was ich jetzt sagen möchte, gilt meiner Meinung nach auch für die Kunst, bezieht sich hier aber auf Architekten. Vielleicht besteht die Lösung darin, daß wir ohne Architekten zurechtkommen sollten. Wenn man sich die Geschichte anschaut, gibt es Gesellschaften, in denen zwar gebaut wurde, aber ohne Architekten – wie es auch Gesellschaften gibt, in denen die Bezeichnung ›Künstler‹ nicht vorkommt. Die Leute waren eben z. B. Teppichknüpfer oder Weber.

Lebbeus Woods: Ich war immer der Auffassung, daß es eine Beleidigung ist, als Künstler bezeichnet zu werden. Ich glaube, daß es viel besser wäre, nach seinen bestimmten Fertigkeiten benannt zu werden: Maler, Töpfer, Bildhauer. Den Begriff Künstler hat man früher mancherorts für Scharlatane verwendet.

James Turrell: Damals hätte es wohl niemand gern gesehen, daß seine Tochter einen Künstler heiratet! Wie man sich heute nicht gerade darüber freuen würde, wenn sein Sohn einen heiratet …

Das Gefüge, über das wir gesprochen haben, bedeutet für mich: versuchen, die Gesellschaft durch die unmittelbare Konfrontation mit verschiedenen [Kunst]werken von einem Punkt zu einem anderen zu bewegen. Die Arbeiten von Kiki tun das, die Arbeiten von Chris tun das, es gelingt ihnen, die Gesellschaft weiterzubewegen … Dies[es dem künstlerischen Ausdruck immanente Veränderungspotential] ist unabhängig von dem, was das Werk tatsächlich darstellt. [Das einzelne Werk] hat seinen eigenen unverwechselbaren Ausdruck, den ihm der einzelne Künstler verleiht. Veränderungen des Gefüges sind das Ergebnis eines kollektiven Vorgangs, in den die gesamte Kunst involviert ist, die an einer Veränderung der Wahrnehmung arbeitet und sich mit unseren Sichtweisen und Denkmustern beschäftigt.

Daniela Zyman: In seinen Ausführungen hat Chris Burden Kunst als eine Form der Untersuchung bezeichnet. Sollten wir uns dem nicht für einen Augenblick zuwenden: dieses ganze Spektrum von Themen, Ansätzen, Visionen und Untersuchungen, die sowohl für die verschiedenen individuellen Positionen in der Kunst als auch [für das kollektive Gefüge] der Gesellschaft bestimmend sind? Kikis Untersuchungen gelten dem Körper, dem Tod, den Konflikten zwischen den Geschlechtern, der Krankheit; James erforscht Licht, Raum und Wahrneh-

of you. And the reality is always fucking you up, it is always slapping you around a little bit. Relationships with the outside world seem to be abusive by nature. But, I also think that I don't want to be a sculptor: I want to be an artist. It takes more space to be an artist and one wants to create more possibilities for one's life, not to narrow them.

Lebbeus Woods: Isn't the idea to make installations, or pieces which occupy the space in that way, a kind of desire to dissolve more into the fabric, into the landscape; to expand, spread, flow into something else, outside of bounds?

From the public: Would you say that we have reached today the age of the end of ideology in art? Or, how would you characterize the moment we are in? Has it become more subjective?

Lebbeus Woods: I certainly think so, and I think that was Jan's point at the beginning of this round table. I wouldn't use the word emotional as he did so much as I would describe some of what goes on right now as the end – the end of ... not the rules, but of beliefs. I think we are speaking here of actions based on experience and on real human conditions that one encounters.

Jan Hoet: There is an end of beliefs, but does this come simultaneously with the necessity for new beliefs?

Chris Burden: By beliefs, do you mean theories?

Lebbeus Woods: Not only theories, but Absolutes.

From the public: The question is how does one cope with it? Is it good or bad?

Lebbeus Woods: I think it is good, because it places us in the position of responsibility – for our own lives and actions, for example. We cannot any longer point to the figure of authority that represents the ideology and say: "Ah! You made me do this!" That is completely obsolete in our culture and this is a very good thing. But it also makes it very difficult for each of us – workers, artists, people – we really have to think about what we are doing, and why.

Jan Hoet: Everybody on his own has to search for his own voice which is credible, analytical, radical. This is the starting position for any further dialogue. Dialogues in which one can hear artists thinking, having confrontation are so rare – it seems that today there are more public discussions going on between museum and galleries directors than between artists.

Kyong Park: I think that the question about the end of ideology was a very powerful one, and the response was that ideology had ended. I can't say that. If we think in terms of logic rather than in terms of arts and architecture, then one

156

mung; Leb experimentiert mit neuen Räumen und Formen der Interaktion, die der Gesellschaft als Modell dienen sollen. In der Berichterstattung der Medien, und deshalb habe auch ich damit ein Problem, geht vor allem der künstlerische Untersuchungsprozeß verloren.

Vor diesem Hintergrund ist auch die Streitfrage von vorhin, ob nun ein bestimmtes Kunstwerk einen Höhepunkt darstellt oder nicht, nichts anderes als die statische Formulierung dessen, was für mich einen Prozeß darstellt, eine Entwicklung, eine ständige Neuorientierung. Einzelne Arbeiten, mögen sie nun Höhepunkte darstellen oder nicht, können nur eine Art Stadium in diesem Untersuchungsprozeß sein.

Chris Burden: Mich interessieren manchmal die mißratenen Skulpturen viel mehr als die gelungenen. Wenn man an etwas arbeitet, hat man eine Vorstellung davon, wie es werden soll, und das mißt man dann an den Resultaten. Wenn man wirklich daneben liegt, ist der Prozeß selbst das Interessanteste an der Arbeit. Für einen Auftraggeber mag das vielleicht eine Katastrophe sein, weil seine Erwartungen enttäuscht werden, aber für einen selbst ist die Bedeutung »schiefgelaufener Dinge« gar nicht hoch genug anzusetzen.

Kiki Smith: Das hängt alles damit zusammen, daß man etwas produziert: Man erschafft etwas aus seinem Inneren und die Wirklichkeit versaut einem immer alles, beutelt einen durch und durch. Verhältnisse zur Außenwelt scheinen von Natur aus beleidigend zu sein. Ich persönlich will keine »Bildhauerin« sein, ich möchte als Künstlerin definiert werden, denn als Künstlerin kann man mehr Platz beanspruchen, und man will doch schließlich mehr Möglichkeiten für sein Leben schaffen, nicht die Möglichkeiten einschränken.

Lebbeus Woods: Ist der Wunsch, Installationen oder Arbeiten zu machen, die den Raum in dieser Art besetzen, nicht eine Art von Verlangen, mehr im Gefüge, in der Landschaft aufzugehen – sich auszudehnen, auszubreiten, in etwas anderes einzufließen, jenseits aller Grenzen?

Aus dem Publikum: Meinen Sie, daß wir heute in einer Zeit des Endes der Ideologien in der Kunst leben? Oder wie würden Sie die gegenwärtige Situation charakterisieren? Ist heute alles subjektiver geworden?

Lebbeus Woods: Ganz sicher, und ich denke, darauf wollte Jan auch ganz am Anfang des Gesprächs hinaus. Ich würde nur nicht von Gefühl, von Emotion sprechen, wie er das mehrmals getan hat, sondern das, was jetzt geschieht, als das Ende – als das Ende der … nicht als Ende der Regeln, sondern als Ende des Glaubens beschreiben. Wir sprechen doch vom aktiven Handeln, das auf der Ba-

might say that ideology is not here at the moment, but that there are no guarantees that it won't 'strike back'.

Therefore the question of end/finality is rather premature. The more urgent issue would be to formulate a response to the question about the nature of the so-called end. Also: Why does it seem ideology, the absolute, has ended, for what reasons did it end? What was the force that put an end to it, if any? The political changes may be inspiring this kind of thinking, but if we look at architecture – a small community when compared with the art community – I think that we might conclude that with ideology or without it, we are speaking about the same game with more or less the same players. The "End of Ideology" is no more than a phrase, while even among the younger people there is very little attempt to structure thoughts differently.

It is politically, architecturally, artistically correct to say that the ideology is dead – that's all!

Ziva Freiman: I guess I support Kyong in that – what we are witnessing is the multiplicity of ideologies. I feel much more comfortable by saying that we are not living in such a doctrinaire age, and that the age of doctrine might be the only thing that is ending. We definitely have created a form of civilization, now, at least in the USA, that is privileging any number of ideologies. I certainly can't accept that there aren't any beliefs. How would you operate?

James Turrell: Well, I would say that amongst this crowd here art is a stronger form of belief than perhaps the church. I think that to get involved in art you have to have a belief just in order to go ahead – there is not a lot of support and positive feed – back for getting involved in art. I think that art is a better belief than a religion of the nineteenth century.

Lebbeus Woods: I don't know. I think we should renounce to beliefs. It is very possible to put old beliefs into new form, dress them in a new costume and present them as something new. That should be ended. We should face the complexity, multiplicity, confusion and confront these things in modern life and just forget the idea of beliefs.

James Turrell: I just think that there are more people in the world dressed entirely in black, wearing the art-frock, then we have ever had wearing the cloaks of religion.

Lebbeus Woods (wearing black): Come on James, you can do better than that.

Chris Burden: It's pretty good, it's pretty good!

Kyong Park: Well, it seems that Lebbeus is about to get everybody here. But

sis unserer Erfahrungen und der tatsächlich gegebenen Bedingungen menschlicher Existenz beruht?

Jan Hoet: Es gibt heute ein Ende des Glaubens, aber muß daraus zugleich die Notwendigkeit entstehen, einen neuen Glauben zu finden?

Chris Burden: Was verstehst du unter Glauben: Theorien?

Lebbeus Woods: Nicht nur Theorien, sondern absolute Kategorien.

Aus dem Publikum: Wie geht man aber damit um? Ist das gut oder schlecht?

Lebbeus Woods: Ich finde, es ist gut, weil es uns zur Verantwortung verpflichtet – Verantwortung für unser Leben und unsere Handlungen zum Beispiel. Wir können nicht mehr auf eine Autoritätsperson zeigen, die für eine bestimmte Ideologie steht, und sagen: »Du hast mich dazu gebracht, das zu tun!« Das gibt es in unserer Kultur nicht mehr, und das ist gut so. Aber das macht es auch für jeden von uns ziemlich schwer, für Arbeiter genauso wie für Künstler – für alle: jeder muß sich heute selbst überlegen, was er tut und warum er es tut.

Jan Hoet

Jan Hoet: Jeder muß heute auf sich allein gestellt seine Stimme suchen, eine glaubwürdige, analytische, radikale Stimme. Das ist der Ausgangspunkt jedes weiteren Dialogs. Man hat so selten Gelegenheit, an Gesprächen teilzunehmen, in denen Künstler denken, sich mit der Position anderer Künstler auseinandersetzen. Zwischen Museumsdirektoren und Galeriebesitzern scheinen heutzutage eher öffentliche Gespräche zustandezukommen als zwischen Künstlern.

Kyong Park: Ich finde, daß die Frage nach dem Ende der Ideologien wirklich Gewicht hatte. Die Antwort war, daß die Zeit der Ideologien vorbei ist. Ich kann mich dieser Einschätzung nicht anschließen. Ich denke jetzt eher in logischen Kategorien als in Kategorien der Kunst und Architektur, und da kann man vielleicht sagen, daß im Augenblick keine Ideologien vorhanden sind, aber es gibt doch keine Garantie dafür, daß sie nicht ›zurückschlagen‹ werden. Daher halte ich die Frage nach einem Ende/nach Endgültigkeit für ziemlich voreilig. Es wäre doch viel wichtiger, sich zu bemühen, eine Antwort auf die Frage nach dem Wesen dieses sogenannten Endes zu finden, also auf die Fragen: Warum sieht es denn so aus, als ob die Ideologien, als ob das Absolute ein Ende gefunden hätte? Welche Gründe gibt es denn da dafür? Gab es denn eine Kraft, die das Ende der Ideologien herbeigeführt hat, und wenn ja, welche? Die politischen Veränderungen geben sicher Anlaß zu solchen Überlegungen, aber wenn wir uns die Archi-

Johannes Gachnang

you who wants to annihilate all the beliefs – after all, what is your work about? Isn't it about certain beliefs that you project about society and the city and the future? It is in a mediated form, a mediated belief about the world in the future.

Lebbeus Woods: In the present!

Kyong Park: I think that with regard to the context in which you are working and the crisis you are responding to – your projects are about the present. But projecting, making projects, as you said – is working in the present, in the past, and for the future.

Daniela Zyman: For a more creative, complex, broader future ...

As a final remark, I would like to thank all of you for participating in this event. To me, this event today has manifested once more and very obviously that the prejudice according to which artists don't talk about their ideas has proven to be completely wrong. All of you have been very elaborate and precise and have allowed us to understand more deeply what your concerns and positions are with regard to a complex and confusing world. You have formulated your endeavor to continue to participate in the fabric of life, of society and I think this is a very strong position. Thank you very much.

tektur von heute ansehen – und das ist eine im Vergleich zur Kunst kleine Gemeinde –, muß man, denke ich, zu dem Schluß kommen, daß es mit oder ohne Ideologie immer noch um dasselbe Spiel mit mehr oder weniger denselben Spielern geht. Das sogenannte »Ende der Ideologie« ist doch nichts anderes als eine Phrase, solange nicht einmal die Jüngeren versuchen, ihr Denken wirklich anders zu strukturieren.

Es ist sowohl politisch als auch vom Standpunkt der Kunst und Architektur her eben korrekt, den Tod der Ideologie zu bestätigen – das ist alles!

Ziva Freiman: Da muß ich Kyong recht geben: Wir leben heute in einer Zeit der ideologischen Vielfalt. Ich fühle mich viel wohler, es so zu formulieren, daß wir heute in einer weniger doktrinären Zeit leben, daß es also vielleicht die Zeit des Doktrinären ist, die zu Ende geht. Wir haben, und das gilt zumindest für die Vereinigten Staaten, eine Form der Zivilisation geschaffen, die eine Vielfalt von Ideologien zuläßt. Auf keinen Fall kann ich aber der Einschätzung zustimmen, daß es heute keinen Glauben mehr gibt. Woran sollte man sich dann in seinem Vorgehen orientieren?

James Turrell: Was uns hier betrifft, würde ich einmal sagen, daß Kunst für uns wahrscheinlich ein stärkerer Glauben ist als die Kirche. Ich denke, daß man, wenn man sich entschließt, künstlerisch tätig zu werden, an etwas glauben muß, um überhaupt weiterzumachen – es gibt kaum Unterstützung oder positives Feedback, wenn sich jemand der Kunst zuwendet. Ich meine, daß Kunst ein besserer Glaube ist als irgendeine Religion des neunzehnten Jahrhunderts.

Lebbeus Woods: Da habe ich aber meine Zweifel. Ich denke, wir sollten überhaupt auf sämtliche Glaubensformen verzichten. Es ist ganz einfach, einem alten Glauben neue Form zu geben, ihn in ein neues Gewand zu stecken und als neuen Glauben zu präsentieren. Damit sollte Schluß sein. Wir sollten uns der Komplexität, der Vielfalt und Verwirrung des modernen Lebens stellen und das Thema des Glaubens endgültig vergessen.

James Turrell: Mir kommt allerdings vor, daß mehr Leute auf der Welt die Uniform der Kunst tragen und ganz in Schwarz gehen, als das je bei einer Religion der Fall war.

Lebbeus Woods [ganz in Schwarz]: Jetzt hör aber auf, James, dir fällt doch sicher was Besseres ein!

Chris Burden: Ich finde das gar nicht schlecht!

Kyong Park: Lebbeus, es sieht so aus, als ob du es dir hier mit jedem verscherzt. Aber wenn du jeden Glauben vernichten willst – worum geht es dann überhaupt

1 This remark refers to Le Corbusier's chapel Notre Dame du Haut built on a hill overlooking Ronchamp (Haute-Saône, France) from 1950 to 1955.

2 This remark refers to average American architecture which in its details may be of extraordinary quality.

in deiner Arbeit? Geht es da nicht um bestimmte Glaubensvorstellungen, die du auf die Gesellschaft, die Stadt und die Zukunft projizierst? Deine Arbeit ist doch die medial vermittelte Form deines Glaubens über die Welt der Zukunft.

Lebbeus Woods: Die Welt der Gegenwart!

Kyong Park: Ich denke, daß in dem Kontext, in dem du arbeitest, und auch, was die Krise betrifft, auf die deine Arbeiten ja eine Antwort darstellen – es natürlich in deinen Projekten um die Gegenwart geht. Aber projektieren, an Projekten arbeiten, wie du gesagt hast – das heißt doch, in der Gegenwart, in der Vergangenheit für die Zukunft arbeiten.

Daniela Zyman: Für eine kreativere, komplexere, offenere Zukunft …

Zum Abschluß möchte ich mich bei allen Teilnehmern dieser Veranstaltung bedanken. Die heutigen Gespräche haben, meine ich, einmal mehr und sehr deutlich bewiesen, daß das Vorurteil, daß Künstler nicht über ihre Ideen und Konzepte sprechen wollen, überhaupt nicht zutrifft. Alle hier am Podium haben sehr ausführlich und genau Stellung bezogen und uns dadurch einen tieferen Einblick in ihre Anliegen und Positionen angesichts einer komplexen und verwirrenden Welt gewinnen lassen. Sie haben ihr Bestreben formuliert, am Gefüge des Lebens, der Gesellschaft teilzunehmen – und das ist für mich eine sehr überzeugende Position. Danke.

1 Ziva Freiman bezieht sich auf Le Corbusiers Kapelle Notre Dame du Haut, die der Architekt von 1950-1955 auf einem Hügel oberhalb von Ronchamp (Haute-Saône, Frankreich) erbaute.

2 Gemeint ist amerikanische Durchschnittsarchitektur, die durchaus im Detail außergewöhnliche Qualität hervorzubringen vermag.

CHRIS BURDEN

Born in Boston, Massachusetts, 1946. Travelling with his family, he spent most of his youth in Europe and in the Far East before he moved to California in 1965. After attending Pomona College in Claremont he began to study architecture, physics and visual arts in 1969 and graduated from the University of California in Irvine with *Five Day Locker Piece* (see note 2) in 1971. This performance, the first of over eighty closely connected with the body art movement of the seventies, already anticipated two central elements of Burden's work: the self-defying use of his own body and the renunciation of the object. By using an existing campus locker instead of creating a container for this particular purpose, the action alone and not the object constituted *Five Day Locker Piece* as a work of art. More radical than Vito Acconci and Dennis Oppenheim in this conviction that art must have an element of risk, Burden exposed himself to emotional and physical extremes, thus forcing the observer to confront violence, social brutality, and execution of power as well as his own fears and aggressions.

Until 1977 Burden focussed on performances some of which were either connected with an installation or realized within the frame of one. Intended to break the passive attitude of the audience, the extremes Burden exposed himself to aimed at irritation and confrontation with those forms of brutality and power that determine our everyday lives as exemplified by *Shoot* (see note 4) and *Transfixed* (1974). The latter consisted of a performance during which the artist was crucified to the roof of a Volkswagen with its engine howling in place of the victim. Burden's art was especially concerned with overcoming minimalism predominant in these days and finding a form insisting on participation rather than on contemplation.

As the radical and often spectacular character of his early performances gave rise to an increasing misunderstanding of their substantial social criticism and aesthetic position in favour of sensationalism, Burden turned to installations not involving his body in 1977. Yet war, violence, and destruction remained the central subjects in a series of highly vivid installations, disturbingly direct in their ways. The arsenals assembled for *The Reason of the Neutron-Bomb* and *All the Submarines of the United States of America* (see note 5) may be regarded as two of the most significant examples in this regard. *The Tale of Two Cities*, an installation realized in various forms since 1981, represents a minia-

CHRIS BURDEN

1946 in Boston, Massachusetts, geboren, verbringt Chris Burden seine Jugend vor allem in Europa und im Fernen Osten auf Reisen mit seiner Familie. 1965 übersiedelt er nach Kalifornien und besucht bis 1969 das Pomona College in Claremont. Er studiert Architektur, Physik und bildende Kunst und schließt 1971 die University of California in Irvine ab. Seine Abschlußarbeit *Five Day Locker Piece* (vgl. FN 2) verweist schon auf zwei wichtige Elemente seiner frühen Body-art-Projekte: der bedingungslose Einsatz des eigenen Körpers und die Abkehr vom Objekt. Durch die Verwendung eines vorgefundenen Behälters an Stelle eines extra angefertigten wird einzig die Aktion und nicht das Objekt zum Kunstwerk. *Five Day Locker Piece* ist die erste von über 80 Performances, die in engem Zusammenhang zur Body-art-Bewegung der siebziger Jahre stehen. Radikaler als Vito Acconci und Dennis Oppenheim in seiner Überzeugung, Kunst müsse riskant sein, setzt Burden sich psychischen und physischen Extremsituationen aus und zwingt so den Zuschauer, sich mit dem Anblick realer Gewalt, gesellschaftlicher Brutalität und Machtausübung und mit den dadurch ausgelösten eigenen Ängsten und Aggressionen auseinanderzusetzen.

Bis 1977 macht Burden vorwiegend Performances, die z. T. mit einer Installation verbunden sind oder im Rahmen einer Installation stattfinden. Die Passivität des Publikums bekämpfend, zielen die Grenzsituationen, denen Burden sich hier aussetzt, auf Verstörung und Konfrontation mit jenen Formen von Brutalität und Macht, die unseren Alltag prägen. Dafür stehen drastische Aktionen wie *Shoot* (vgl. FN 4) oder *Trans-fixed* (1974), während der sich Burden auf dem Dach eines Volkswagens, dessen aufheulender Motor stellvertretend für das Opfer schreit, kreuzigen läßt. Ein besonderes Anliegen von Burdens Kunst ist es in dieser Phase, aus dem Minimalismus auszubrechen und zu einer Form zu finden, die statt einer Betrachtung eine Partizipation einfordert.

Da die radikale und oftmals spektakuläre Form seiner frühen Performances dazu führte, daß deren gesellschaftskritischer und ästhetischer Gehalt mehr und mehr zugunsten eines Sensationalismus vernachlässigt wurde, ging Burden ab 1977 zu Installationen über, in die der Körper des Künstlers nicht mehr involviert war. Auch hier bleiben Krieg, Gewalt und Vernichtung zentrale Themen, denen sich der Künstler mittels höchst anschaulicher, in ihrer Direktheit beunruhigenden Installationen annähert. Exemplarisch sind die in *The Reason of the Neutron-Bomb* und *All the Submarines of the United States of America* (vgl. FN 5) versammel-

ture reconstruction of two city states waging war against each other with 5000 war toys made in the USA, Japan, and Europe. The details of the apocalyptical warscape built upon sand can only be perceived through a telescope, which emphasizes the character of the installation as a materialization of the electronic abstractions of war in the years of the Reagan administration. Burden's latest important installation was *Medusa's Head* (1990), a kind of war-meteorite fixed to the ceiling with more than four meters in diameter and weighing five tons. Its surface consisted of a wild and yet precisely worked layer of stone, metal and plastic covered with a net of rails and motionless toy trains that suggested either technological disaster and destruction of the earth's surface or a sumptuously monstrous alien element.

The examination of the aesthetic possibilities of light focussing on the limits of human capacity and the extremes of perception is another recurring subject. The performance *White Light/White Heat* (1975) for example could, optically speaking, only be perceived as a light installation since there was no place in the gallery from which one could view the platform where the artist lay without eating and speaking for the twenty-two days of the exhibition. *The Fist of Light* (see note 7), one of Burden's most recent installations, continued to explore the subject by overstraining the limits of perception and creating a paradoxical visual phenomenon surpassing perception.

Burden's aesthetic language has always been a violent language, sparing neither the artist's mind and body nor his audience and allowing no easy way out because of its vivid and immediate character. This is why it succeeds in revealing the inescapable but never explicit violence of today's social and political structures of power.

Chris Burden has been teaching as a professor for "New Genre" at the University of California in Los Angeles since 1978.

Solo Exhibitions (selection)

1994 *LAPD Uniforms and America's Darker Moments,* The Fabric Workshop, Philadelphia, Pennsylvania
LAPD Uniforms, America's Darker Moments, Small Guns, Gagosian Gallery, New York
Galerie Anne de Villepoix, Paris, France

1993 Miller Nordenhake, Cologne, Germany
Medusa's Head, Gagosian Gallery, New York

ten Arsenale, oder auch die seit 1981 in verschiedenen Formen gefertigte Instal-
lation *The Tale of Two Cities,* eine miniaturisierte Rekonstruktion zweier Stadt-
staaten, die sich mit 5000 Kriegsspielzeugen aus den U.S.A., Japan und Europa
bekriegen. Die auf einer Sandlandschaft aufgebaute apokalyptische Kriegsszene-
rie ist in ihren Details für den Betrachter nur mehr durch ein Fernrohr rezipier-
bar und versteht sich als Materialisierung der in Abstraktionen verharmlosten
elektronischen Kriegsvisionen der Reagan-Ära. Seine letzte große »Kriegs«-In-
stallation ist *Medusa's Head* (1990), eine Art Meteorit von über 4 Metern
Durchmesser und 5 Tonnen Gewicht, der an der Raumdecke befestigt wird. Sei-
ne Oberfläche besteht aus einer wüsten und doch detailgenau gearbeiteten
Schicht aus Stein, Metall und Plastik, die von einem Netz aus Schienen und still-
stehenden Zügen diverser Spielzeugeisenbahnen überzogen ist und ein technolo-
gisches Desaster auf einer zerstörten Erdoberfläche oder einen üppig-monströ-
sen Fremdkörper suggeriert.

Auch die Arbeit mit den ästhetischen Möglichkeiten des Lichts ist ein wieder-
kehrendes Thema in Burdens Werk, in dessen Zentrum die Grenzen der mensch-
lichen Belastbarkeit oder Extrembereiche der Wahrnehmung stehen. So in der
Performance *White Light/White Heat* (1975), die für das Publikum optisch nur
als Lichtinstallation wahrnehmbar war, da die Plattform, auf der der Künstler die
22 Tage der Ausstellung lang ohne zu essen, zu sprechen oder herabzusteigen
lag, von keinem Punkt der Galerie aus einsehbar war. Weitergeführt wurde diese
Auseinandersetzung in einer seiner neuesten Installationen, *The Fist of Light*
(vgl. FN 7), die in ihrer Überreizung der Wahrnehmungsgrenzen ein nicht mehr
rezipierbares paradoxes visuelles Phänomen erzeugt.

Chris Burdens ästhetische Sprache war und ist in all ihren Ausformungen eine
Sprache der Gewalt, die weder Geist und Körper des Künstlers noch ihr Publi-
kum schont und die in ihrer Anschaulichkeit und Unmittelbarkeit keine Aus-
flüchte zuläßt – und der es eben dadurch gelingt, die ebenso unentrinnbare, sich
aber niemals deklarierende Gewalttätigkeit der sozialen und politischen Macht-
verhältnisse zu entschleiern. Seit 1978 lehrt Chris Burden an der University of
California, Los Angeles und ist dort Professor für Neue Kunstgattungen.

Einzelausstellungen (Auswahl)

1994 *LAPD Uniforms and America's Darker Moments,* The Fabric Workshop,
 Philadelphia, Pennsylvania

 LAPD Uniforms, America's Darker Moments, Small Guns, Gagosian

1992 Lannan Foundation, Los Angeles, California

1991 Whitechapel Art Gallery, London

Medusa's Head, The Brooklyn Museum, Brooklyn, New York

1990 *Samson,* Daniel Buchholz Gallery, Cologne, Germany

1989 Institute of Contemporary Art, Boston, Massachusetts

1988 *A Twenty Year Survey,* Newport Harbor Art Museum, Newport Beach, California

1987 L. A. C. E., Los Angeles, California

All the Submarines of the United States of America, Hoffman/Borman Gallery, Santa Monica, California

1986 Rosamund Felsen Gallery, Los Angeles, California

1985 Lowe Art Museum, Miami, Florida

1984 Rosamund Felsen Gallery, Los Angeles, California

1983 Ronald Feldman Fine Arts, New York

1980 Whitney Museum of American Art, Film & Video Dpt., New York

1979 Rosamund Felsen Gallery, Los Angeles, California

1977 Ronald Feldman Fine Arts, New York

1975 Stichting De Appel Museum, Amsterdam

Galleria Schema, Florence, Italy

1974 Contemporary Arts Center, Cincinnati, Ohio

Group Exhibitions (selection)

1994 *Hors limites,* Centre Pompidou, Paris, France

Outside the Frame: Performance and the Object, Cleveland Center for Contemporary Art, Cleveland, Ohio

1993 *Biennial Exhibition,* Whitney Museum of American Art, New York

Co-Conspirators, James Corcoran Gallery, Santa Monica, California

1992 *LAX,* Krinzinger Gallery, Vienna, Austria

Dislocations, Museum of Modern Art, New York

Helter Skelter, Museum of Contemporary Art, Los Angeles, California

1990 *Image World: Art and Media Culture,* Whitney Museum of American Art, New York

1989 *Biennial Exhibition,* Whitney Museum of American Art, New York

1988 *Committed to Print,* Museum of Modern Art, New York

Identity: Representation of Self, Whitney Museum of American Art, New York

Gallery, New York

Galerie Anne de Villepoix, Paris

1993 Miller Nordenhake, Köln

Medusa's Head, Gagosian Gallery, New York

1992 Lannan Foundation, Los Angeles, Kalifornien

1991 Whitechapel Art Gallery, London

Medusa's Head, The Brooklyn Museum, Brooklyn, New York

1990 *Samson,* Daniel Buchholz Galerie, Köln

1989 Institute of Contemporary Art, Boston, Massachusetts

1988 *A Twenty Year Survey,* Newport Harbor Art Museum, Newport Beach, Kalifornien

1987 L.A.C.E., Los Angeles, Kalifornien

All the Submarines of the United States of America, Hoffman/Borman Gallery, Santa Monica, Kalifornien

1986 Rosamund Felsen Gallery, Los Angeles, Kalifornien

1985 Lowe Art Museum, Miami, Florida

1984 Rosamund Felsen Gallery, Los Angeles, Kalifornien

1983 Ronald Feldman Fine Arts, New York

1980 Whitney Museum of American Art, Film & Video Dpt., New York

1979 Rosamund Felsen Gallery, Los Angeles, Kalifornien

1977 Ronald Feldman Fine Arts, New York

1975 Stichting De Appel Museum, Amsterdam

Galleria Schema, Florenz

1974 Contemporary Arts Center, Cincinnati, Ohio

Gruppenausstellungen (Auswahl)

1994 *Hors limites,* Centre Pompidou, Paris

Outside the Frame: Performance and the Object, Cleveland Center for Contemporary Art, Cleveland, Ohio

1993 *Biennial Exhibition,* Whitney Museum of American Art, New York

Co-Conspirators, James Corcoran Gallery, Santa Monica, Kalifornien

1992 *LAX,* Galerie Krinzinger, Wien

Dislocations, Museum of Modern Art, New York

Helter Skelter, Museum of Contemporary Art, Los Angeles

1990 *Image World: Art and Media Culture,* Whitney Museum of American Art, New York

1986 *Inaugural Exhibition,* Museum of Contemporary Art, Los Angeles, California

1985 *Recent Kinetic Sculpture,* Whitney Museum of American Art, New York

1984 *Content: A contemporary Focus 1974–1984,* Hirshhorn Museum and Sculpture Garden, Smithsonian Institution, Washington, D. C.

1983 *International Performance Festival,* Rotterdam

1982 War Games, Ronald Feldman Fine Arts, New York

1981 *Sculpture in California 1975–1980,* San Diego Museum of Art, San Diego, California
The Museum as Site, Sixteen Projects, Los Angeles County Museum of Art, Los Angeles, California

1980 *Contemporary Art in Southern California,* High Museum of Art, Atlanta, Georgia

1977 *Biennial Exhibition,* Whitney Museum of American Art, New York
documenta 6, Kassel, Germany

1975 *Via Los Angeles,* Portland Center for the Visual Arts, Portland, Oregon

1971 *Body Movements,* La Jolla Museum of Contemporary Art, La Jolla, California

Films, video and audio recordings

1984 *Beam Drop.* Film, 6 minutes

1983 *Cost-Effective Micro-Weaponry That Works.* Video, 2 minutes

1982 *Fire by Friction.* Video, 2 minutes

1980 *Chris Burden: "The Big Wheel".* Video, colour, 29 minutes

1979 *Send Me Your Money.* Audio
Wiretap. Audio
The Big Wrench. Video, 15 minutes

1978 *The Citadel.* Audio

1977 *Full Financial Disclosure.* Commercial video, colour, 39 minutes

1975 *Car Nut.* Video, b/w, 25 minutes
Guru for Detroit. Video, b/w, 25 minutes
Art and Technology. Video, b/w, 25 minutes
Chris Burden. Interview with Willoughby Sharp, video, b/w, 30 minutes
Selections 1971–74. Videos, colour and b/w, 36 minutes

1974 *T.V. Interview.* Video, colour, 30 minutes

1989 *Biennial Exhibition,* Whitney Museum of American Art, New York

1988 *Committed to Print,* Museum of Modern Art, New York

Identity: Representation of Self, Whitney Museum of American Art, New York

1986 *Inaugural Exhibition,* Museum of Contemporary Art, Los Angeles

1985 *Recent Kinetic Sculpture,* Whitney Museum of American Art, New York

1984 *Content: A contemporary Focus 1974-1984,* Hirshhorn Museum and Sculpture Garden, Smithsonian Institution, Washington, D.C.

1983 *International Performance Festival,* Rotterdam

1982 *War Games,* Ronald Feldman Fine Arts, New York

1981 *Sculpture in California 1975-1980,* San Diego Museum of Art, San Diego

The Museum as Site, Sixteen Projects, Los Angeles County Museum of Art, L.A.

1980 *Contemporary Art in Southern California,* High Museum of Art, Atlanta

1977 *Biennial Exhibition,* Whitney Museum of American Art, New York

documenta 6, Kassel

1975 *Via Los Angeles,* Portland Center for the Visual Arts, Portland, Oregon

1971 *Body Movements,* La Jolla Museum of Contemporary Art, La Jolla, Kalifornien

Film, Video- und Audioaufnahmen

1984 *Beam Drop.* Film, 6 Minuten

1983 *Cost-Effective Micro-Weaponry That Works.* Video, 2 Minuten

1982 *Fire by Friction.* Video, 2 Minuten

1980 *Chris Burden: "The Big Wheel".* Video, Farbe, 29 Minuten

1979 *Send Me Your Money.* Audio

Wiretap. Audio

The Big Wrench. Video, 15 Minuten

1978 *The Citadel.* Audio

1977 *Full Financial Disclosure.* Kommerzielles Video, Farbe, 39 Minuten

1975 *Car Nut.* Video s/w, 25 Minuten

Guru for Detroit. Video s/w, 25 Minuten

Art and Technology. Video s/w, 25 Minuten

Chris Burden. Interview mit Willoughby Sharp, Video s/w, 30 Minuten

Selections 1971-74. Videos Farbe und s/w, 36 Minuten

1974 *T.V. Interview.* Video, Farbe, 30 Minuten

KIKI SMITH

Born 1954 in Nuremberg, Germany, Kiki Smith lives and works in New York. In the seventies, she was a member of COLAB (Collaborative Projects, Inc.), a New York artists group, which had a basic formative influence on her. The group articulated itself in terms of its politically committed opposition to the established art industry and focussed on the issues of sex, money, power, and racism, but also explicitly criticized American foreign policy. The group introduced itself to the public in the legendary "Times Square Show" of 1980, when more than a hundred artists, with Keith Haring, Kenny Scharf, John Ahearn and Kiki Smith among them, declared war on the clean and self-referential art establishment with often violent, direct, and sometimes shocking forms of expression.

Since the "Times Square Show" Kiki Smith has almost exclusively concentrated on the various aspects of the human body, her experience in her work as a medical assistant at an emergency ward in 1985 being of crucial influence. Radically antidualistic in her thinking, Kiki Smith questions all traditional mind/body dichotomies and rejects their underlying hierarchic structures in order to allow for more open and complex relations between the psychological and the physical. Shell and content, inside and outside, form and materiality are therefore recurring subjects of her work, for example in an installation consisting of a number of empty vessels with only the labels revealing their contents as the various body fluids. Intestines formed of corrugated metal and skins made of paper are some of the aspects in her attempt to render the body beyond all conventional forms and to bring into accord representation, substance and material without ever losing sight of the material's specific form – often being "of low quality", that is forgotten or rejected by European art, like wax or paper.

Focussing on the body, Kiki Smith is primarily interested in its tabooed, invisible and suppressed aspects, from where the immanent political and social contents of her work stems: sex, illness, age, and decay, excrements and secretions, digestion, menstruation, and masturbation are being treated in a depersonalized, objective as well as in an intimately personal way. By dealing with tabooed functions and zones of the body and autoerotic sexual practices, she reveals the hidden and exposes the absurdity of traditional social and religious values.

By confronting the issue of mortality and taking the body apart into its single

KIKI SMITH

1954 in Nürnberg geboren, lebt und arbeitet Kiki Smith in New York. Ihre ursprüngliche künstlerische Prägung erhielt sie als Mitglied der New Yorker Künstlergruppierung COLAB (Collaborative Projects, Inc.) in den siebziger Jahren, die sich als eine politisch engagierte Gegenbewegung zum etablierten Kunstmarkt verstand. Sex, Geld, Rassismus, Macht und Gewalt, aber auch explizit kritische Stellungnahmen zur amerikanischen Außenpolitik waren die Themen der COLAB, die sich in der berüchtigten »Times Square Show« von 1980 öffentlich darstellte. Über 100 Künstler – darunter Keith Haring, Kenny Scharf, John Ahearn und auch Kiki Smith - artikulierten mit oftmals heftigen, direkten, auch schockierenden Ausdrucksmitteln ihre Form des Engagements, die sich gegen den sauberen und selbstreferentiellen Kunstbetrieb wandte.

Seit der »Times Square Show« beschäftigt sich Smith fast ausschließlich mit den verschiedenen Aspekten der menschlichen Körperlichkeit, wobei ihre Arbeit als medizinische Unfallassistentin 1985 eine wichtige Erfahrung darstellt. Radikal antidualistisch, stellt Smith alle herkömmlichen Geist/Körper-Dichotomien in Frage und wendet sich gegen das hierarchische Denken, das ihnen zugrundeliegt, um ein offeneres und vielschichtigeres Bezugssystem zwischen Psyche und Physis zuzulassen. Hülle und Inhalt, Innen und Außen, Form und Materialität sind demnach wiederkehrende Themen ihrer Arbeit – so in einer Installation von leeren Gefäßen, die nur durch Beschriftungen als Behältnisse der verschiedenen Körperflüssigkeiten ausgewiesen werden. Die aus verrostetem Metall gefertigten Gedärme oder die papierenen Körperhüllen sind Aspekte ihres Versuchs, Darstellung, Inhalt und Materialien in Einklang zu bringen und so Körperlichkeit jenseits konventioneller Darstellungsformen zu visualisieren, wobei sie stets im Bewußtsein der spezifischen Eigenschaften der verwendeten Materialien – oft ebenfalls »nebensächliche«, in der europäischen Kunst vergessene oder abgelehnte wie Wachs oder Papier – arbeitet.

Wenn Kiki Smith den Körper in das Zentrum ihrer Arbeit stellt, so geht es ihr vor allem um dessen tabuisierte, unsichtbare und verdrängte Dimensionen, wodurch ihre Werke implizit zu gesellschaftspolitischen Stellungnahmen werden: Geschlecht, Krankheit, Alter und Verfall, Exkremente und Sekrete, Verdauung, Menstruation und Masturbation werden in zugleich depersonalisiert objektiver und intim subjektiver Weise dargestellt. Durch das Aufgreifen tabuisierter Körperfunktionen und -zonen oder autoerotischer sexueller Praktiken enthüllt sie

components, Kiki Smith has made the cycle of nature her subject. Particularly female issues like conception, pregnancy, embryonic life, and birth as well as the way the female body is treated by society have gradually gained a more and more prominent position. Her recent works deal with the dangers the individual is exposed to in a social context increasingly hostile to the body: with the body's weakness in regard to AIDS and its social and psychological consequences. Now loss of control, the risk of openess, the trust in the process of creation, and the increasing dependence of the body when in extremes meet with loneliness, segregation, injury. Provocative and critical of society, but also full of humour and tenderness, Kiki Smith's work draws its specific strength from the tension between naturalism and enigmatic allusion, from its twofold quality as a depiction of social reality and a revelation of the most intimate dreams.

Solo Exhibitions (selection)

1994 Louisiana Museum, Humlebaek, Denmark
 University Art Museum, Santa Barbara, California
 Israel Museum, Jerusalem
1993 Fawbush Gallery, New York
 Anthony D'Offay Gallery, London
 Wexner Center for the Arts, Columbus, Ohio
 Phoenix Art Museum, Phoenix, Arizona
1992 Fawbush Gallery, New York
 MAK-Austrian Museum of Applied Arts, Vienna
 Moderna Museet, Stockholm, Sweden
 Bonner Kunstverein, Bonn, Germany
 Fricke Gallery, Düsseldorf, Germany
1991 Institute of Contemporary Art, Amsterdam
 University Art Museum, Berkeley, California
 Corcoran Gallery of Art, Washington, D. C.
1990 Museum of Modern Art, New York
 Centre d'Art Contemporain, Geneva, Switzerland
 Fawbush Gallery, New York
 Institute for Art and Urban Resources at The Clocktower, New York
1989 Center for the Arts, Wesleyan University, Middletown, Connecticut
 Dallas Museum of Art, Dallas, Texas

Verborgenes und demaskiert die Absurdität von gesellschaftlich und religiös tradierten Normen.

Über ihre Auseinandersetzung mit der Sterblichkeit und dem Zerlegen des Körpers in seine Einzelteile gelangt Kiki Smith zu einer Thematisierung des Kreislaufs der Natur, und spezifisch weibliche Themen wie Empfängnis, Schwangerschaft, embryonales Leben und Geburt sowie der gesellschaftliche Umgang mit dem Körper der Frau treten in den Vordergrund. Ihre neueren Arbeiten beschäftigen sich mit den Gefahren, denen wir in einer zunehmend körperfeindlichen Gesellschaft ausgesetzt sind: die Schwäche des Körpers angesichts von Aids, dessen soziale, psychologische und sexuelle Konsequenzen. Dem Verlust von Kontrolle, dem Risiko des Sich-Öffnens, dem Vertrauen in den Kreationsprozeß, der Verselbständigung des Körpers in Extremsituationen stehen nunmehr Vereinsamung, Ausgrenzung, Verletzung gegenüber. Provokant und gesellschaftskritisch, zugleich aber humorvoll und zärtlich beziehen Kiki Smiths Arbeiten ihre eigentümliche Kraft aus dem Spannungsverhältnis zwischen Naturalismus und rätselhafter Suggestion, aus ihrer doppelten Qualität als Erzählungen sozialer Realitäten und Preisgabe intimster Traumbilder.

Einzelausstellungen (Auswahl)

1994 Louisiana Museum, Humlebaek, Dänemark
University Art Museum, Santa Barbara, Kalifornien
Israel Museum, Jerusalem

1993 Fawbush Gallery, New York
Anthony D'Offay Gallery, London
Wexner Center for the Arts, Columbus, Ohio
Phoenix Art Museum, Phoenix, Arizona

1992 Fawbush Gallery, New York
MAK-Österreichisches Museum für angewandte Kunst, Wien
Moderna Museet, Stockholm
Bonner Kunstverein, Bonn
Galerie Fricke, Düsseldorf

1991 Institute of Contemporary Art, Amsterdam
University Art Museum, Berkeley, Kalifornien
Corcoran Gallery of Art, Washington, D.C.

1990 Museum of Modern Art, New York

Centre d'Art Contemporain, Genf

1988 Fawbush Gallery, New York
1982 The Kitchen, New York

Group Exhibitions (selection)

1993 *Aperto,* Biennale di Venezia, Venice, Italy
 Biennial Exhibition, Whitney Museum of American Art, New York
 PROSPECT 93, Frankfurter Kunstverein, Frankfort, Germany
 Human Factor: Figurative Sculptures Reconsidered, Albuquerque
 Museum of Art, Albuquerque, New Mexico
1992 *Recent Acquisitions,* San Diego Museum of Art, La Jolla, California
 Acquisitions of the 90s, Whitney Museum of American Art, New York
 Strange Behaviour, Anthony D'Offay Gallery, London
 Désordres, Galerie Nationale du Jeu de Paume, Paris
1991 *The Interrupted Life,* New Museum of Contemporary Art, New York
 Biennial Exhibition, Whitney Museum of American Art, New York
 Body, Legs, Heads ... and special parts, Kunstverein Münster,
 Münster, Germany
1990 *Portraits,* P. S. 1, Institute for Art and Urban Resources, Long Island City,
 New York
 Recent Acquistions, Corcoran Art Gallery, Washington, D. C.
 Figuring the Body, Museum of Fine Arts, Boston, Massachusetts
 Group Material: AIDS Timeline, Wadsworth Athenaeum, Hartford,
 Connecticut
1989 *Projects and Portfolios,* The Brooklyn Museum, New York
1988 *Committed to Print,* The Museum of Modern Art, New York
 In Bloom, IBM Gallery, New York
 A Choice, curated by Fred Wagemans, Kunstrai, Amsterdam
1987 *Emotope,* organized by Büro Berlin, Berlin, Germany
 Kiki Smith: Drawings, Piezo Electric Gallery, New York
1986 *Kiki Smith, Art Salon,* DeFacto, New York
 Momento Mori, Centro Cultural de Arte, Polanco, Mexico City
1985 *Male Sexuality,* Art City, New York
1984 *Women in New York,* Engstrom Gallery, Stockholm, Sweden
 Modern Masks, Whitney Museum of American Art, New York
1983 *Emergence: New York from the Lower East Side,* Susan Caldwell Gal-
 lery, New York

Fawbush Gallery, New York

Institute for Art and Urban Resources at The Clocktower, New York

1989 Center for the Arts, Wesleyan University, Middletown, Connecticut

Dallas Museum of Art, Dallas, Texas

1988 Fawbush Gallery, New York

1982 The Kitchen, New York

Gruppenausstellungen (Auswahl)

1993 *Aperto,* Biennale di Venezia, Venedig

Biennial Exhibition, Whitney Museum of American Art, New York

PROSPECT 93, Frankfurter Kunstverein, Frankfurt

Human Factor: Figurative Sculptures Reconsidered, Albuquerque

Museum of Art, Albuquerque, New Mexico

1992 *Recent Acquisitions,* San Diego Museum of Art, La Jolla, Kalifornien

Acquisitions of the 90s, Whitney Museum of American Art, New York

Strange Behaviour, Anthony D'Offay Gallery, London

Désordres, Galerie Nationale du Jeu de Paume, Paris

1991 *The Interrupted Life,* New Museum of Contemporary Art, New York

Biennial Exhibition, Whitney Museum of American Art, New York

Body, Legs, Heads ... and special parts, Kunstverein Münster

1990 *Portraits,* P.S.1, Institute for Art and Urban Resources, Long Island City, New York

Recent Acquisitions, Corcoran Art Gallery, Washington, D.C.

Figuring the Body, Museum of Fine Arts, Boston, Massachusetts

Group Material: AIDS Timeline, Wadsworth Athenaeum, Hartford, Connecticut

1989 *Projects and Portfolios,* The Brooklyn Museum, New York

1988 *Committed to Print,* The Museum of Modern Art, New York

In Bloom, IBM Gallery, New York

A Choice, curated by Fred Wagemans, Kunstrai, Amsterdam

1987 *Emotope,* organisiert vom Büro-Berlin, Berlin

Kiki Smith: Drawings, Piezo Electric Gallery, New York

1986 *Kiki Smith, Art Salon,* DeFacto, New York

Momento Mori, Centro Cultural de Arte, Polanco, Mexiko, D. F.

1985 *Male Sexuality,* Art City, New York

1984 *Women in New York,* Galerie Engstrom, Stockholm

Island of Negative Utopia, The Kitchen, New York

1982 *COLAB in Chicago,* Chicago, Illinois

Fashion Moda Store, documenta 7, Kassel, Germany

1981 *TEUGUM COLAB,* Geneva, Switzerland

Artist Space, New York

New York – New Wave, P. S. 1, Institute for Art and Urban Resources, Long Island City, New York

1980 *A More Store,* COLAB, New York

Times Square Show, New York

Modern Masks, Whitney Museum of American Art, New York

1983 *Emergence: New York from the Lower East Side,* Susan Caldwell Gallery, New York

Island of Negative Utopia, The Kitchen, New York

1982 *COLAB in Chicago,* Chicago, Illinois

Fashion Moda Store, documenta 7, Kassel

1981 *TEUGUM COLAB,* Genf

Artist Space, New York

New York – New Wave, P.S.1, Institute for Art and Urban Resources, Long Island City, New York

1980 *A More Store,* COLAB, New York

Times Square Show, New York

JAMES TURRELL

Born in Los Angeles, California, 1943, James Turrell studied psychology and mathematics at Pomona College, Claremont, California. Completing his studies of the arts he graduated from the University of California in Irvine in 1965/66 and from Claremont Graduate School in 1973.

Turrell has been interested in the phenomenon of light since the sixties, originally focussing on scientific approaches and aspects of perceptual psychology rather than on its aesthetic qualities. This especially holds good for the *Art & Technology Program* Turrell took part in together with Robert Irwin in 1968. By introducing artists to the research teams of various companies, the project, which was organized by the University of California in collaboration with the Los Angeles County Museum, aimed at bringing together artistic and scientific creativity. Cooperating with the *Garrett Aerospace Corporation,* Turrell and Irwin got to know the psychologist Edward Wortz. Turrell included the psychologist's research into the changes of perception experienced by astronauts in outer space into his aesthetic-scientific experiments. Later, light installations directly translated the results of those years' investigations: in his *Ganzfelds* realized in the seventies for example, Turrell created spaces that became bodies of light which the visitor could actually enter.

Turrell increasingly dedicated himself to exploring and making conscious the limits of perception. He primarily works with the viewer's mechanism of perception which he deliberately examines, manipulates and sometimes diverts. Traditional patterns of seeing and thinking are replaced by new, yet archaic spaces of experience and perception. It is never the object that constitutes the work of art: the aesthetic experience emerges within the viewer's world of perception.

In his studio experiments in the late sixties Turrell worked with projections of artificial light to create geometrical forms in existing spaces. In 1966 Turrell rented the *Mendota Hotel* in Ocean Park, California, and used its rooms as his studio and exhibition spaces, working mainly with natural light. He controlled and manipulated the light entering through holes in the blinds, the doors, and the windows and through openings in the ceilings and walls, the change of light during the day and external artificial sources of light creating additional variations. Continuing his investigations, Turrell discovered how to restructure a room by means of artificial light: in his *Wedgeworks* a partition panel was positioned

JAMES TURRELL

1943 in Los Angeles geboren, studiert James Turrell bis 1965 Psychologie und Mathematik am Pomona College, Claremont, Kalifornien, und schließt seine Kunststudien 1965/66 an der University of California in Irvine und 1973 an der Claremont Graduate School ab.

Seit den sechziger Jahren setzt Turrell sich mit dem Phänomen des Lichts auseinander, wobei er zunächst weniger von ästhetischen als von wissenschaftlichen und wahrnehmungspsychologischen Ansätzen ausgeht. In diesem Zusammenhang ist das *Art & Technology Program* von Bedeutung, an dem Turrell 1968 gemeinsam mit Robert Irwin teilnahm. Das Ziel dieses von der University of California und dem Los Angeles County Museum organisierten Projekts war es, Künstler mit den Forschungsteams verschiedener Firmen in Kontakt zu bringen, um so künstlerische mit wissenschaftlicher Kreativität zu verknüpfen. Im Zuge ihrer Zusammenarbeit mit dem Raumfahrtunternehmen *Garrett Aerospace Corporation* trafen Turrell und Irwin den Psychologen Edward Wortz, dessen mit Astronauten durchgeführte Untersuchungen über veränderte Wahrnehmung im Weltraum Turrell in seine ästhetisch-wissenschaftlichen Experimente miteinbezog. Spätere Lichtinstallationen verstehen sich als konkrete Umsetzungen der damaligen Forschungsergebnisse, so z. B. Turrells *Ganzfelder* aus den 70er Jahren, in denen Räume zu betretbaren Lichtkörpern werden.

Die Erforschung und Bewußtmachung der Grenzen der Wahrnehmung werden zunehmend zu zentralen Anliegen Turrells. Seine Untersuchungen gelten aber nicht nur dem Licht, sondern vor allem den Perzeptionsmechanismen des Betrachters, die gezielt überprüft, thematisiert und zum Teil irregeleitet werden. Gewohnte Seh- und Denkmuster werden verändert und neue, zugleich archaische Erlebnis- und Wahrnehmungsräume geschaffen. Das Kunstwerk ist hierbei niemals der Gegenstand, sondern es entsteht gleichsam in der Wahrnehmung des Betrachters.

In seinen frühen Atelierexperimenten Ende der sechziger Jahre schafft Turrell durch Projektionen mit künstlichem Licht geometrische Formen in bestehenden Räumen. Im *Mendota Hotel* in Ocean Park, Kalifornien, einem 1966 angemieteten ehemaligen Hotel, das Turrell als Atelier und Ausstellungsort benützt, arbeitet er mit natürlichem Licht: Durch Löcher in Fensterrollos, Tür- und Fensteröffnungen sowie durch Öffnungen in Decken und Wänden läßt er gezielt kontrolliertes und manipuliertes Licht in die Räume einfallen, wobei sich im

in the corner of a room at an oblique angle like a wedge, a fluorescent light tube installed behind it lighting exactly the opposite corner. This made the room seem to be divided into two parts by a wall of light. Following up the experiments in the *Mendota Hotel,* Turrell continued to explore the interaction of light between the inside and the outside. This resulted in several variations of *Skyspaces,* partly commissioned by the Italian collector Giuseppe Panza di Biumo. These "light works" resulted in a transformation of existing buildings, with structural sections and other "skywindows" permitting an immediate perception of the skies' continually changing light qualities.

The *Roden Crater Project* represents Turrell's principal work. The first plans and models go back as far as 1974, and the works are still ongoing. Turrell could not begin to carry out his ideas before 1977 when he succeeded in acquiring the secluded site of the extinct volcano north-east of Flagstaff, Arizona. The interplay betwen volcanic landscape and celestial phenomena in the area forms an ideal stage for the artist's investigations of space, light, and time, the determining elments of this project. Turrell aligned the elaborate network of chambers and passageways crisscrossing the volcano with celestial constellations, the incidence of light, and the astrological conditions of the site. The chambers capture and create various light phenomena – projections reminiscent of a camera obscura, *Ganzfelds,* planetary figurations. The relevant models, drawings, and plans have been documented in *Deep Sky* (1985) and *Mapping Spaces* (1987).

Turrell's *Irish Sky Garden* represents a project of similar dimensions which is also still in progress. This project became possible thanks to the initiative of the Zurich art dealer Veith Turske, who in 1987 acquired the *Liss Ard Nature Reserve* near Skibbereen in West Cork, Ireland, an area of about 185 acres. This recent landscape project is based on four "Observation Spaces" the artist developed from existing natural land formations: an elliptical crater, a gently curved mound, a pyramid, and a wall enclosing some pastureland. From these places one can observe the sky and the interplay of cloud and star formations changing according to the time of the day and the season of the year. After concluding the project the whole Liss Ard area is to become an ecological reserve providing possibilities for scientific investigations as well as for experiencing the site's complex space and light structures.

In recent years James Turrell has again and again taken up the results of the *Art & Technology Program* investigations and created for the first time several

Tagesverlauf und durch externe künstliche Lichtquellen bei Nacht zusätzliche Variationen ergeben. In der Weiterführung seiner Forschungen entdeckt Turrell die Möglichkeit, mit künstlichem Licht einen konkreten Raum neu zu gliedern: In seinen *Wedgeworks* (Keilarbeiten) plazierte er Trennwände »keilartig« schräg in eine Raumecke und brachte fluoreszierende Röhren dahinter so an, daß das Licht in die gegenüberliegende Ecke fiel. So entsteht der Eindruck, der Raum sei durch eine Wand aus Licht in zwei Teile gegliedert. Ausgehend von den Erfahrungen im *Mendota Hotel* beschäftigt sich Turrell Anfang der siebziger Jahre weiter mit der Licht-Interaktion zwischen Innenraum und Außenraum. Es entstehen, zum Teil im Auftrag des italienischen Sammlers Giuseppe Panza di Biumo, verschiedene Varianten der *Skyspaces* – Lichtarbeiten, bei denen in bestehende Baulichkeiten mittels struktureller Schnitte und anderer »Himmelsfenster« so eingegriffen wird, daß eine direkte Wahrnehmung der sich ständig verändernden Lichtqualität des Himmels möglich wird.

Turrells künstlerisches Hauptwerk ist das *Roden Crater Project*, dessen erste Pläne und Modelle auf 1974 zurückgehen und das bis heute nicht abgeschlossen ist. Mit der Realisierung dieses Projekts begann Turrell aber erst 1977, als es ihm gelang, den Roden Crater, einen erloschenenen, isoliert gelegenen Vulkan bei Flagstaff, Arizona, zu erwerben. Im Zusammenspiel von vulkanischer Landschaft und Himmelsphänomenen wird hier die Interaktion von Raum, Licht und Zeit, die Turrells ganze Arbeit bestimmt, wahrnehmbar. Ein elaboriertes Netzwerk von Kammern und Gängen, deren Anlage Turrell an den Himmelsrichtungen, dem natürlichen Lichteinfall und an astrologischen Berechnungen orientiert, durchzieht den Vulkan. Die Kammern sind so angelegt, daß sie verschiedene Lichtphänomene einzufangen oder zu schaffen imstande sind: Projektionen in der Art einer Camera Obscura, *Ganzfelder*, Gestirnkonstellationen. Die Modelle, Zeichnungen und Entwürfe sind in *Deep Sky,* 1985, und *Mapping Spaces,* 1987, dokumentiert.

Ein in seinen Dimensionen vergleichbares Projekt ist der ebenfalls noch nicht vollendete *Irish Sky Garden*. Seine Realisierung verdankt er einer Initiative des Zürcher Kunsthändlers Veith Turske, der 1989 das 75 Hektar große Gebiet des Wildreservats und Naturparks *Liss Ard* in der Nähe von Skibbereen in West Cork, Irland, erwirbt und James Turrell ermöglicht, hier sein Landschaftsprojekt zu entwickeln. Der *Sky Garden* besteht aus vier vorgefundenen, aus der Landschaft herausgearbeiteten »Observationsräumen«: einem elliptisch geformten Krater, einem sanft gerundeten Hügel, einer Pyramide und einer Umfriedung,

installations that are transportable and not site specific: the *Perceptual Cells*. One of the most important groups of works in this context is his series of *Telephone Booths:* the visitor enters the booth, closes the door and experiences an optic and acoustic event planned in all details and often open to manipulation by the visitor himself.

James Turrell lives in Flagstaff, Arizona, and in Inishkame, Ireland.

Solo Exhibitions (selection)

1994 Barbara Gladstone Gallery, New York

Crawford Municipal Art Gallery, Cork, Ireland

Paris Opera, Atelier Theatre & Musique, Nanterre, France

1993 Ace Gallery, Los Angeles, California

Hayward Gallery, London, England

Institute of Contemporary Art, Philadelphia, Pennsylvania

1992 Belvedere, Prague

Secession Vienna, Austria

Kunstverein für die Rheinlande und Westfalen, Düsseldorf, Germany (permanent installation)

Musée d'Art Contemporain, Lyon, France

Isy Brachot Gallery, Brussels

Israel Museum, Jerusalem (permanent installation)

1991 Kunstmuseum Bern, Switzerland

Anthony D'Offay Gallery, London

Carpenter Center, Harvard University, Cambridge, Massachusetts

1990 Froment & Putman Gallery, Paris

Newport Harbor Art Museum, Rondo, Newport Beach, California

Stein-Gladstone Gallery, New York

P.S.1, Institute for Art and Urban Resources, Long Island City, New York

La Jolla Museum of Contemporary Art, La Jolla, California

The Museum of Modern Art, New York

Turske & Turske, Zurich, Switzerland

1989 Florida State University Gallery, Tallahassee, Florida

Musée d'Art Comtemporain, Nîmes, France

Security Pacific Gallery, Costa Mesa, California

1988 Jean Bernier Gallery, Athens, Greece

1987 Kunsthalle Basel, Basle, Switzerland

von denen aus der Himmel und das im jahres- und tageszeitlichen Rhythmus sich ändernde Wechselspiel von Wolken- und Gestirnformationen beobachtet und erlebt werden kann. Der gesamte *Liss Ard-Naturpark* wird nach seiner Fertigstellung ökologisches Schutzgebiet, naturwissenschaftlicher Forschungsbereich und Ort komplexen Raum- und Lichterlebens in einem sein.

In den letzten Jahren hat James Turrell zunehmend auf die Forschungsergebnisse des *Art & Technology Program* zurückgegriffen und erstmals nicht ortsspezifische transportable Wahrnehmungsräume geschaffen: die *Perceptual Cells.* Eine wichtige Serie innerhalb der Wahrnehmungszellen sind die *Telephone Booths,* in die der Betrachter wie in eine Telephonzelle eintritt, die Türe schließt und einem genau kalkulierten, oft von ihm selbst beeinflußbaren optischen und auditiven Erlebnis ausgesetzt ist.

James Turrell lebt heute in Flagstaff in Arizona, USA, und in Inishkame, Irland.

Einzelausstellungen (Auswahl)

1994 Barbara Gladstone Gallery, New York
Crawford Municipal Art Gallery, Cork, Irland
Paris Opera, Atelier Theatre & Musique, Nanterre, Frankreich

1993 Ace Gallery, Los Angeles, Kalifornien
Hayward Gallery, London, England
Institute of Contemporary Art, Philadelphia, Pennsylvania

1992 Belvedere, Prag
Wiener Secession, Wien
Kunstverein für die Rheinlande und Westfalen, Düsseldorf (Permanente Installation)
Musée d'Art Contemporain, Lyon
Isy Brachot Gallery, Brüssel
Israel Museum, Jerusalem (Permanente Installation)

1991 Kunstmuseum, Bern
Anthony D'Offay Gallery, London
Carpenter Center, Harvard University, Cambridge, Massachusetts

1990 Galerie Froment & Putman, Paris
Newport Harbor Art Museum, Rondo, Newport Beach, Kalifornien
Stein-Gladstone Gallery, New York
P.S.1, Institute for Art and Urban Resources, Long Island City, New York
La Jolla Museum of Contemporary Art, La Jolla, Kalifornien

University Art Gallery, University of California, Riverside, California
1986 Marian Goodman Gallery, Multiples Inc., New York
 P.S.1, Institute for Art and Urban Resources, Long Island City, New York
 Center for Contemporary Art, Santa Fe, New Mexico
1985 Museum for Contemporary Art, Los Angeles, California
1984 Flow Ace Gallery, Los Angeles, California
1983 Hayden Gallery, Massachusetts Institute of Technology, Boston,
 Massachusetts
 Flow Ace Gallery, Los Angeles, California
 ARC, Musée National d'Art Moderne, Paris
1982 Center of Contemporary Art, Seattle, Washington
1981 Leo Castelli Gallery, New York
1980 Whitney Museum of American Art, New York
1976 Stedelijk Museum, Amsterdam

Group Exhibitions (selection)
1994 Lannan Foundation, Los Angeles, California
 New Acquisitions, Museum of Modern Art, New York
 Lisboa 94 Capital Europeia da Cultura: The Day after Tomorrow,
 Centro Cultural de Belem, Lisboa
 Landscape as Metaphor, Denver Art Museum, Denver, Colorado
 (permanent installation)
 National Gallery of Art, Washington, D.C.
1993 *Mediale,* Kunsthalle, Hamburg
 Amerikanische Kunst im 20. Jahrhundert, Martin-Gropius Bau, Berlin
 Biennale d'Art Contemporain, Lyon
 American Art of the 20th Century, Royal Academy of Art, London
1992 Stein-Gladstone, New York
 Kunsthalle Basel, Basel, Switzerland
 Santa Monica Museum of Art, California
1991 Museum of Contemporary Art, Los Angeles, California
 Museum für Moderne Kunst, Frankfort, Germany
 Cora Hölzl Gallery, Düsseldorf, Germany
 Reynolds / Minor Gallery, Richmond, Virginia
1990 Musée d'Art Contemporain de Montréal, Québec, Canada
 Musée d'Art Moderne de la Ville de Paris, Paris

The Museum of Modern Art, New York

Turske & Turske, Zürich

1989 Florida State University Gallery, Tallahassee, Florida

Musée d'Art Contemporain, Nîmes

Security Pacific Gallery, Costa Mesa, Kalifornien

1988 Jean Bernier Gallery, Athen

1987 Kunsthalle Basel, Basel

University Art Gallery, University of California, Riverside, Kalifornien

1986 Marian Goodman Gallery, Multiples Inc., New York

P.S.1, Institute for Art and Urban Resources, Long Island City, New York

Center for Contemporary Art, Santa Fe, New Mexico

1985 Museum for Contemporary Art, Los Angeles, Kalifornien

1984 Flow Ace Gallery, Los Angeles, Kalifornien

1983 Hayden Gallery, Massachusetts Institute of Technology, Boston, Massachusetts

Flow Ace Gallery, Los Angeles, Kalifornien

ARC, Musée National d'Art Moderne, Paris

1982 Center of Contemporary Art, Seattle, Washington

1981 Leo Castelli Gallery, New York

1980 Whitney Museum of American Art, New York

1976 Stedelijk Museum, Amsterdam

Gruppenausstellungen (Auswahl)

1994 Lannan Foundation, Los Angeles, Kalifornien

New Acquisitions, Museum of Modern Art, New York

Lisboa 94 Capital Europeia da Cultura: The Day after Tomorrow, Centro Cultural de Belem, Lissabon

Landscape as Metaphor, Denver Art Museum, Denver, Colorado (Permanente Installation)

National Gallery of Art, Washington, D.C.

1993 *Mediale,* Kunsthalle, Hamburg

Amerikanische Kunst im 20. Jahrhundert, Martin-Gropius Bau, Berlin

Biennale d'Art Contemporain, Lyon

American Art of the 20th Century, Royal Academy of Art, London

1992 Stein-Gladstone, New York

Kunsthalle Basel, Basel

1989 The Guggenheim Museum, New York
Ace Contemporary Exhibitions, Los Angeles, California
Museum of Contemporary Art, Los Angeles, California
1987 Centre International d'Art Contemporain de Montréal, Québec, Canada
Walker Art Center, Minneapolis, Minnesota
Arte Ambientale, Rimini, Italy
1986 Hirshhorn Museum and Sculpture Garden, Washington D. C.
The Brooklyn Museum, New York
Centre International d'Art Contemporain de Montréal, Québec, Canada
Cirrus Gallery, Los Angeles, California
1985 Ecole des Beaux-Arts, Paris
San Francisco Museum of Modern Art, San Francisco, California
Städelsches Kunstinstitut, Frankfort, Germany
1983 The Ritter Art Gallery, Florida Atlantic University, Boca Raton, Florida
1982 The Art Institute of Chicago, Chicago, Illinois
College of Art & Architecture, University of Idaho, Moscow, Idaho
1981 Louisiana Museum of Modern Art, Humblebaek, Denmark
Kunsthalle Basel, Basle, Switzerland
1975 University of California, Irvine, California
La Jolla Museum of Contemporary Art, La Jolla, California

Santa Monica Museum of Art, Kalifornien
1991 Museum of Contemporary Art, Los Angeles, Kalifornien
Museum für Moderne Kunst, Frankfurt
Galerie Cora Hölzl, Düsseldorf
Reynolds/Minor Gallery, Richmond, Virginia
1990 Musée d'Art Contemporain de Montréal, Québec
Musée d'Art Moderne de la Ville de Paris
1989 The Guggenheim Museum, New York
Ace Contemporary Exhibitions, Los Angeles, Kalifornien
Museum of Contemporary Art, Los Angeles, Kalifornien
1987 Centre International d'Art Contemporain de Montreal, Quebec
Walker Art Center, Minneapolis, Minnesota
Arte Ambientale, Rimini
1986 Hirshhorn Museum and Sculpture Garden, Washington D.C.
The Brooklyn Museum, New York
Centre International d'Art Contemporain de Montréal, Québec
Cirrus Gallery, Los Angeles, Kalifornien
1985 Ecole des Beaux-Arts, Paris
San Francisco Museum of Modern Art, San Francisco, Kalifornien
Städelsches Kunstinstitut, Frankfurt
1983 The Ritter Art Gallery, Florida Atlantic University, Boca Raton, Florida
1982 The Art Institute of Chicago, Chicago, Illinois
College of Art & Architecture, University of Idaho, Moscow, Idaho
1981 Louisiana Museum of Modern Art, Humlebaek, Dänemark
Kunsthalle Basel, Basel
1975 University of California, Irvine, Kalifornien
La Jolla Museum of Contemporary Art, La Jolla, Kalifornien

FRANZ WEST

"I was born in 1946 and I have an ordinary curriculum until I entered high school. Then I started to change schools more frequently – then boarding schools – and dropped out in 1965 on the advise of a friend to join the Beat Generation and travel in the Middle East. Between 1968 and 1970 I had to undergo several spells in asylums and prisons because of drug consumption [...] Between 1971 and 1976 I tried my hand at color combinations inspired by music (almost exclusively interpretations by G. Souzay and K. Berberian) and began to get interested in the Viennese art of those days. R. Priessnitz started to provide me with literary hints in 1974, and I studied with professor Gironcoli from 1977 to 1982. Retreat in 1980, occasional cooperation with other artists like F. Koglmann, Szeni, de Cohen, Kobo and R. Polansky."

While West's "figurative" sculptures – the "lemures", as he also calls them – still represent coarse, fragile creatures, objects of art in the classical sense (e. g. *Laune* ["Whim"], 1986, or *Visite* ["House Call"], 1987), most of his other works transcend this function. They are to be understood as materializations of psychological processes and instigate the processes of thinking and working.

This is why "Benützen" (*using*) and "Be-sitzen" (*sitting on*) have become the central categories of reception since the early eighties; installed on pedestals, West's seating objects challenge the visitor to cross the frontier between his space and the space traditionally reserved for the work of art and invite him to sit down. The series of objects *Paßstücke* ("Fitting Pieces") still goes one step further: the works, made of plaster, aluminium, cardboard, wood, wire, and similar "found" materials typical for West, are formed to fit the human body and are to be used and worn. When using the pieces the visitor is not only forced to take up a preconceived position, but also participates in the actionist's or body-artist's experience. West's *Paßstücke* more than invite a certain predetermined way of use: by provoking yet unexperienced movement sequences they generate new performances and works of art through the participation of the user. These objects succeed in bridging the gap between the visual and applied arts, a distinction also challenged by his seating objects made of edged metal welded together. Though evoking their seating function by appealing to the forms of the human body, they reject all requests for comfort which would threaten the artistic presence of the object.

West's interest in working with fragments and things found also becomes ap-

»Ich kam 1946 zur Welt und nahm den üblichen Werdegang zum Gymnasium. Dann wechselte ich öfters die Schulen, später die Internate und beendete 1965 auf Anraten eines Freundes meine Schulbesuche und wendete mich der ›Beat-Generation‹ zu, bereiste den Nahen Osten und hatte mich zwischen 1968 und 70 wegen Drogengenusses wiederholt Entwöhnungskuren und Gefängnisaufenthalten zu unterziehen. (...) 1971 bis 76 versuchte ich regelmäßig Farbkombinationen zu Musik (fast ausschließlich Interpretationen von G. Souzay und K. Berberian) und begann mich für die Wiener Gegenwartskunst zu interessieren. Ab 1974 bekam ich von R. Priessnitz Literaturhinweise, studierte von 1977 bis 1982 bei Prof. Gironcoli. 1980 Retirade, gelegentliche Zusammenarbeit mit anderen Künstlern wie F. Koglmann, Szeni, de Cohen, Kobo und R. Polansky.«

Sind Wests »bildhafte« Skulpturen, die er auch als »Lemuren« bezeichnet , noch grobe, brüchige, meist aus Papiermaché gefertigte Wesen, Kunst-Objekte im klassischen Sinn (etwa *Laune,* 1986, oder *Visite,* 1987), so begnügen sich die meisten anderen Arbeiten nicht mit dieser Funktion. Als Materialisierungen psychischer Vorgänge präsentieren sie sich als Appelle zu einem Prozeß des Weiterdenkens und Weiterarbeitens.

Seit den achtziger Jahren werden so das Benützen und vor allem das Be-sitzen zu zentralen Kategorien der Rezeption; Wests auf Podesten installierte Sitzgelegenheiten fordern den Besucher auf, die Grenze zwischen seinem Raum und demjenigen, der traditionell dem Kunstwerk vorbehalten ist, zu übertreten und auf den Sesseln Platz zu nehmen. Die Objektserie »Paßstücke« geht noch einen Schritt weiter: Aus Gips, Aluminium, Pappe, Holz, Draht und ähnlichen für West typischen »vorgefundenen« Materialien fertigt er Objekte, deren Form dem menschlichen Körper angepaßt ist und die benützt und getragen werden sollen. Der Gebrauch der »Paßstücke« zwingt den Besucher zu vorgeplanten Körperhaltungen und läßt ihn gleichzeitig am Erleben des Aktionisten oder Body-Artisten teilhaben. Denn die »Paßstücke« ermöglichen nicht nur eine Benützung, sondern fordern auch zu ungekannten Bewegungsabläufen heraus und erzeugen in der Partizipation je neue Aktionen und Kunstwerke. Durch ihre Berührbarkeit und Tragbarkeit überbrücken die »Paßstücke« die Grenze zwischen bildender und angewandter Kunst, die mit Wests meist aus kantigem Metall geschweißten Sesselobjekten ebenfalls in Frage gestellt wird. Wests Sessel evozieren ihre Funktion nur noch, indem sie an den menschlichen Körper appellieren, verwei-

parent in his erotic collages, mostly assemblages of reworked photographs. Another important source of inspiration for his work are a number of philosophical and literary writings, as for example in Ludwig Wittgenstein's "Tractatus" and texts by the "Wiener Gruppe" he often integrates into his projects.

Franz West has been teaching at the Städelschule in Frankfort since 1992, but still lives and works in Vienna.

Solo Exhibitions (selection)

1994 Sculpture Plaza, Museum of Contemporary Art, Los Angeles
1993 Moderna Galerija Ljubljana / Laibach, Slovenia
David Zwirner Gallery, New York
Gisela Capitain Gallery, Cologne, Germany
1992 Grässlin-Ehrhardt Gallery, Frankfort, Germany
Peter Pakesch Gallery, Vienna, Austria
1991 Max Hetzler Gallery, Cologne, Germany
Ealan Wingate, New York
Villa Arson, Nice, France
1990 Sala Boccioni (with Michelangelo Pistoletto), Milan, Italy
Bruges la Morte Gallery, Bruges, Belgium
Peter Pakesch Gallery, Vienna, Austria
Stichting De Appel Museum (with Otto Zitko), Amsterdam
1989 Haus Lange Museum, Krefeld, Germany
P.S.1, Institute for Art and Urban Resources, Long Island City, New York
Grässlin-Ehrhardt Gallery, Frankfort, Germany
Kunsthistorisches Museum Vienna, Austria
1988 Kunsthalle Bern, Switzerland
Isabella Kacprzak Gallery, Cologne, Germany
Peter Pakesch Gallery, Vienna, Austria
Schöne Aussicht, Portikus, Frankfort, Germany
1987 Secession Vienna, Austria
De Lege Ruimte, Bruges, Belgium
1986 Neue Galerie am Landesmuseum Joanneum, Graz, Austria
Peter Pakesch Gallery, Vienna, Austria
1985 Kunsthandlung Hummel, Vienna, Austria
1980 Galerie nächst St. Stephan, Vienna, Austria
Krinzinger Gallery, Innsbruck, Austria

gern sich aber Bequemlichkeitswünschen, hinter denen das künstlerisch gestalte-
te Objekt zu verschwinden droht.

Für Wests Auseinandersetzung mit Vorgefundenem und Fragmentarischem ste-
hen auch seine meist aus Photoübermalungen zusammengesetzten erotischen
Collagen. Wichtige Inspirationsquellen für Wests Arbeit sind außerdem ver-
schiedene philosophische oder literarische Texte wie Wittgensteins »Tractatus«
oder Texte aus dem Umfeld der »Wiener Gruppe«, die er oftmals mit seinen
Werken kombiniert.

Seit 1992 ist Franz West als Professor an der Städelschule, Frankfurt, tätig, er
lebt und arbeitet aber in Wien.

Einzelausstellungen (Auswahl)

1994 Sculpture Plaza, Museum of Contemporary Art, Los Angeles

1993 Moderna Galerija Ljubljana/Laibach, Slowenien
Galerie David Zwirner, New York
Galerie Gisela Capitain, Köln

1992 Galerie Grässlin-Ehrhardt, Frankfurt/Main
Galerie Peter Pakesch, Wien

1991 Galerie Max Hetzler, Köln
Ealan Wingate, New York
Villa Arson, Nizza

1990 Sala Boccioni (mit Michelangelo Pistoletto), Mailand
Galerie Bruges la Morte, Brügge
Galerie Peter Pakesch, Wien
Stichting De Appel Museum (mit Otto Zitko), Amsterdam

1989 Museum Haus Lange, Krefeld
P.S.1, Institute for Art and Urban Resources, Long Island City, New York
Galerie Grässlin-Ehrhardt, Frankfurt/Main
Kunsthistorisches Museum, Wien

1988 Kunsthalle, Bern
Galerie Isabella Kacprzak, Köln
Schöne Aussicht, Portikus, Frankfurt/Main

1987 Wiener Secession, Wien
De Lege Ruimte, Brugge

1986 Neue Galerie am Landesmuseum Joanneum, Graz
Galerie Peter Pakesch, Wien

1979 Forme Gallery, Frankfort, Germany
1978 Galerie nächst St. Stephan, Vienna, Austria
1977 Galerie nächst St. Stephan, Vienna, Austria

Group exhibitions (selection)
1994 *Kommentar zu Europa 1994,* Museum Moderner Kunst, Vienna, Austria
1993 *Museum auf Zeit,* Museum Fridericianum, Kassel, Germany
Spiegelsprung, Akademie der bildenden Künste, Vienna, Austria
Viaggio verso Citera, Biennale di Venezia, Casino Municipale,Venice, Italy
75 Jahre Kunsthalle Bern, Kunsthalle Bern, Switzerland
1992 *documenta IX,* Kassel, Germany
Identität Differenz, Neue Galerie, steirischer herbst, Graz, Austria
1991 *Metropolis,* Martin-Gropius-Bau, Berlin
Junge Kunst aus Österreich, Hamburger Kunstverein, Hamburg, Germany
Körper und Körper, Grazer Kunstverein im Stadtmuseum Graz, steirischer herbst, Graz, Austria
1990 *Bemalte Plastik I, II und III,* Kunsthandlung Hummel, Vienna, Austria
Sammlung Rudi Molacek, Neue Galerie am Landesmuseum Joanneum, Graz, Austria
Casino Fantasma, P.S.1, Institute for Art and Urban Resources, Long Island City, New York
1989 *Kunst der letzten 10 Jahre,* Museum Moderner Kunst, Vienna, Austria
1988 *Zeitlos,* Hamburger Bahnhof, Berlin
Aperto, Biennale di Venezia, Venice, Italy
1987 *Skulpturenprojekt Münster,* Westfälisches Landesmuseum, Münster, Germany
Aktuelle Kunst in Österreich, Europalia, Museum van Hedendaagse Kunst, Ghent, Belgium
Broken Neon, Forum Stadtpark, Graz, Austria
1986 *De Sculptura,* Messepalast Wien, Austria
Skulptur Sein, Kunsthalle Düsseldorf, Düsseldorf, Germany
1985 *Trigon 85,* steirischer herbst, Neue Galerie am Landesmuseum Joanneum, Graz
1981 *Westkunst,* Cologne, Germany

1985 Kunsthandlung Hummel, Wien

1980 Galerie Nächst St. Stephan, Wien

Galerie Krinzinger, Innsbruck

1979 Galerie Forme, Frankfurt /Main

1978 Galerie Nächst St. Stephan, Wien

1977 Galerie Nächst St. Stephan, Wien

Gruppenausstellungen (Auswahl)

1994 *Kommentar zu Europa 1994,* Museum Moderner Kunst, Wien

1993 *Museum auf Zeit,* Museum Fridericianum, Kassel

Spiegelsprung, Akademie der bildenden Künste, Wien

Viaggio verso Citera, Biennale di Venezia, Casino Municipale, Venedig

75 Jahre Kunsthalle Bern, Kunsthalle Bern

1992 *documenta IX,* Kassel

Identität Differenz, Neue Galerie, steirischer herbst, Graz

1991 *Metropolis,* Martin-Gropius-Bau, Berlin

Junge Kunst aus Österreich, Hamburger Kunstverein, Hamburg

Körper und Körper, Grazer Kunstverein im Stadtmuseum Graz, steirischer herbst, Graz

1990 *Bemalte Plastik I, II und III,* Kunsthandlung Hummel, Wien

Sammlung Rudi Molacek, Neue Galerie am Landesmuseum Joanneum, Graz

Casino Fantasma, P.S.1, Institute for Art and Urban Resources, Long Island City, New York

1989 *Kunst der letzten 10 Jahre,* Museum Moderner Kunst, Wien

1988 *Zeitlos,* Hamburger Bahnhof, Berlin

Aperto, Biennale di Venezia, Venedig

1987 *Skulpturenprojekt Münster,* Westfälisches Landesmuseum Münster

Aktuelle Kunst in Österreich, Europalia, Museum van Hedendaagse Kunst, Gent

Broken Neon, Forum Stadtpark, Graz

1986 *De Sculptura,* Messepalast Wien

Skulptur Sein, Kunsthalle Düsseldorf

1985 *Trigon 85,* steirischer herbst, Neue Galerie am Landesmuseum Joanneum, Graz

1981 *Westkunst,* Köln

LEBBEUS WOODS

Born in 1940, Lansing, Michigan, Lebbeus Woods went to the local Purdue School of Engineering and studied at the University of Illinois' School of Architecture in Champaign-Urbana. After finishing his education in 1964 he started to work for the architects Kevin Roche, John Dinkeloo and Associates' office, then still Eero Saarinnen and Associates. Mainly participating in the planning of several projects for John Deere and of the Ford Foundation administration building, he moved to New York in the late sixties in order to supervise the realization of the Ford Foundation project.

Defying his traditional education and his specific experience, Woods increasingly concentrated on experimental, utopian projects and the theory of architecture. In 1976 he gave up his professional career as an architect for good to dedicate himself to teaching at various American universities, among them the Pratt Institute, Harvard and Columbia Universities and the Cooper Union where he is visiting professor since 1988. This was also the year Woods, together with Olive Brown, founded the *Research Institute for Experimental Architecture* in New York which focusses on practically orientated research and supports experimental architecture and theory. During the seventies and eighties Woods' designs more and more clearly departed from functional constructions, developing into visionary projects integrating science, technology, philosophy and art into an holistic understanding of architecture.

Woods' designs for *AEON, Regions, A City, Sector 1576N* and *Cyclical City* from the eighties formulated detailed visions of ideal cities, projections of complex models of thinking alluding to both highly technical machineries and the poetic imaginary worlds of a golden age. In his colored pen-and-ink drawings, science fiction iconography is synthesized with the great utopian visions of human history and with kinetic force fields to form an "eternal architecture". But Woods' projects should not be misunderstood as an unwordly undertaking at all – they represent a precise counterstatement regarding today's political and social realities. His project *Underground Berlin* (1988) may be considered the most striking example in this respect: the design consists of a subterranean urban network whose inhabitants could effect the unification of the still divided city in an organic way. Its extension into *Berlin-Free-Zone* (see note 4) in 1990 refers to the new political landscape of the reunited, yet still divided Berlin, wich is the setting for the metaphoric "Free-Spaces" Woods inscribed into the

LEBBEUS WOODS

Geboren 1940 in Lansing, Michigan, studiert Lebbeus Woods an der dortigen Purdue School of Engineering und an der University of Illinois, School of Architecture in Champaign/Urbana. Nach Abschluß seiner Ausbildung 1964 arbeitet er zunächst im Architekturbüro Kevin Roche, John Dinkeloo and Associates, damals noch Eero Saarinen and Associates. Vor allem an den Projekten für John Deere und das Ford Foundation-Verwaltungsgebäude als Entwerfer beteiligt, übersiedelt er Ende der 60er Jahre nach New York, um die Bauaufsicht über die Realisierung des Ford-Foundation-Projekts zu übernehmen.

Seiner traditionellen Ausbildung und seinen konkreten Erfahrungen zum Trotz beschäftigt sich Woods mehr und mehr mit experimentellen, utopischen Projekten und mit Architekturtheorie. 1976 zieht er sich endgültig von seiner Tätigkeit als Berufsarchitekt zurück und widmet sich seiner Lehrtätigkeit an verschiedenen amerikanischen Universitäten, darunter am Pratt Institute, an der Harvard und Columbia University sowie seit 1988 als Gastprofessor an der Cooper Union. 1988 gründet Woods mit Olive Brown das New Yorker *Research Institute for Experimental Architecture,* das der praxisbezogenen Forschung und der Unterstützung experimenteller Architektur und Theorie gewidmet ist.

Woods' Entwürfe der siebziger und achtziger Jahre entfernen sich zusehends vom konkreten zweckgebundenen Bauvorhaben und entwickeln sich hin zu visionären Projekten, die Wissenschaft, Technik, Philosophie und Kunst in eine ganzheitliche Architekturauffassung integrieren.

Woods' Entwürfe zu *AEON, Regions, A City. Sector 1576N* oder *Cyclical City* aus den achtziger Jahren sind detailliert durchdachte Visionen von Idealstädten, Projektionen komplexer Denkmodelle, die zugleich von hochtechnisierten Maschinerien und von den poetischen Bilderwelten eines goldenen Zeitalters geprägt sind. Science-fiction-Ikonen vermengen sich in Woods kolorierten Federzeichnungen mit den großen Utopien der Menschheitsgeschichte und mit kinetischen Kraftfeldern zu einer »ewigen Zukunftsarchitektur«. Daß Woods Ideenarchitektur aber keineswegs weltfremd ist, sondern sich vielmehr als präziser Gegenentwurf zur politischen und sozialen Gegenwart versteht, zeigt sich beispielhaft in seinem Projekt *Underground Berlin* (1988) – einem Entwurf für ein unterirdisches urbanes Netzwerk, dessen Bewohner organisch die Vereinigung der damals noch getrennten Stadt bewirken könnten. 1990 zur *Berlin-Free-Zone* (vgl. FN 4) erweitert, bezieht sich das Projekt auf die neue politische

given structures. In *Zagreb-Free-Zone* of 1991 Woods again positions his projects exactly where the looming political contradictions erupt into a violent crisis. Characteristic of *Aerial Paris* (1989) are freely drifting kinetic housing cells projected into the sky of the French capital, their experimental architecture realizing the idea of "antigravity", the abolition of gravity, so crucial for the artist.

Woods considers it the architect's task to design spaces and urban structures reacting to the total of human conditions and opening up new potential for growth in a world devastated by violence, power, and ignorance. It is the notion of "heterarchy" that constitutes the center of Woods' thinking: a multiple, anti-authoritarian system based on a network of autonomous individuals forming a "kybernetic circus" that is capable of replacing the rigid and destructive hierarchy of power with an open and dynamic form of freedom.

Solo Exhibitions (selection)

1994 Seminary & Workshop: *Reconstruction and Resistance,* Sarajevo, Bosnia

1992 *Terra Nova: Drawings and Models of Lebbeus Woods,* MIT List Visual
Arts Center, Cambridge, Massachusetts

1991 *Architecture is a Political Act,* Gund Hall Gallery, Harvard University,
Cambridge, Massachusetts
Zagreb-Free-Zone, Museum for Applied Arts, Zagreb, Croatia
Berlin-Free-Zone, Aedes Gallery, Berlin

1989 *Terra Nova,* Fenster Galerie, Frankfort, Germany

1988 *Underground Berlin,* The Art and Architecture Exhibition Space (2AES),
San Francisco, California

1987 *Centricity: The Unified Urban Field,* Aedes Gallery, Berlin
Cyclical Cities, Rom Gallery, Oslo, Norway

1985 *Architecture: The Mythic Journey,* Indianapolis Museum of Art,
Indianapolis, Indiana
Origins, The Architectural Association, London

1984 *CENTERS: Three Public Building Projects,* StoreFront for Art and
Architecture, New York

1982 *AEON: The Architecture of Time,* Express / Network Gallery,
New York

Landschaft des wiedervereinigten, aber keineswegs einigen Berlin, in das Woods nun seine metaphorischen *Free-Spaces* einschreibt. Auch in *Zagreb-Free-Zone* von 1991 siedelt Woods seine Projekte genau an den Orten an, an denen die Widersprüche der Realität krisenhaft und gewalttätig aufbrechen. Ähnliches zeigt sich auch in *Aerial Paris* (1989), als Woods in den Himmel über Paris frei driftende kinetische Wohnzellen projektiert, deren experimentelle Architektur die für Woods zentrale Vorstellung der *antigravity,* der Aufhebung der Schwerkraft verwirklicht.

Die Aufgabe des Architekten sieht Woods im Entwerfen von Räumen und urbanen Strukturen, die auf die Gesamtheit menschlicher Lebensbedingungen reagieren und für diese in einer von Gewalt, Macht und Ignoranz verwüsteten Welt neue Entfaltungsmöglichkeiten schaffen. Im Zentrum seines Denkens steht der Begriff der "Heterarchie", jener multiplen anti-autoritären Herrschaftsform, die aus einem Netzwerk autonomer Individuen besteht, die gemeinsam jenen "kybernetischen Zirkus" bilden, der – so Woods – die unbeweglichen und zerstörerischen Machtstrukturen durch eine offene und dynamische Form der Freiheit zu ersetzen vermag.

Einzelausstellungen (Auswahl)

1994 Seminar & Workshop: *Reconstruction and Resistance,* Sarajevo, Bosnien

1992 *Terra Nova: Drawings and Models of Lebbeus Woods,* MIT List Visual Arts Center, Cambridge, Massachusetts

1991 *Architecture is a Political Act,* Gund Hall Gallery, Harvard University, Cambridge, Massachusetts
Zagreb-Free-Zone, Kunstgewerbemuseum Zagreb
Berlin-Free-Zone, Galerie Aedes, Berlin

1989 *Terra Nova,* Fenster Galerie, Frankfurt am Main

1988 *Underground Berlin,* The Art and Architecture Exhibition Space (2AES), San Francisco

1987 *Centricity: The Unified Urban Field,* Galerie Aedes, Berlin
Cyclical Cities, Rom Galerie, Oslo

1985 *Architecture: The Mythic Journey,* Indianapolis Museum of Art
Origins, The Architectural Association, London

1984 *CENTERS: Three Public Building Projects,* StoreFront for Art and Architecture, New York

1982 *AEON: The Architecture of Time,* Express/Network Gallery, New York

Group Exhibitions (selection)

1994 *Manifestos,* Centro nacional de Concervacion, Havanna, Cuba

1993 *At the Edge of Chaos: New Images of the World,* Louisiana Museum of Modern Art, Humlebaek, Denmark

1990 *RIAE – The first Conference,* Aedes Gallery, Berlin

1989 *Künstlerhäuser,* Deutsches Architekturmuseum, Frankfort, Germany
 Architecture et Utopie, Pavillon de l'Arsenal, Paris

1988 *Berlin: Denkmal oder Denkmodell,* Kunsthalle Berlin
 DMZ, StoreFront for Art and Architecture, New York

1987 *Zauber der Medusa,* Künstlerhaus Vienna, Austria

1986 *Vision der Moderne,* Deutsches Architekturmuseum, Frankfort, Germany

1984 *Adam's House in Paradise,* StoreFront for Art and Architecture, New York

1983 *Juxtapositions,* P. S. 1, Institute for Art and Urban Resources, Long Island City, New York

1980 *Young Architects,* Yale University School of Architecture Gallery, New Haven, Connecticut

Projects (selection)

1994 High Houses for Sarajevo 1993 War and Architecture Series 1991 Zagreb-Free-Zone, Free-Space Structures, Icebergs, Double Landscape (Vienna), Antigravity Houses 1990 Stations, Berlin-Free-Zone 1989 Aerial Paris, Solohouse 1988 Underground Berlin 1987 Centricity, Aerial Structures 1986 Cyclical Cities 1985 A City, Sector 1576N; Centre for New Technology 1984 Epicyclarium 1982/83 AEON 1981 Four Cities 1980 Einstein Tomb, Four Houses (second version) 1979 Four Ceremonial Constructions, City in Time 1978 Architecture-Sculpture-Painting Series 1977 Simultaneous City, Wall Fragments 1975 Four Houses 1974 Environmental Theatre

Gruppenausstellungen (Auswahl)

1994 *Manifestos – Positionen zum Aufbruch,* Centro nacional de Concervacion, Havanna, Cuba

1993 *At the Edge of Chaos: New Images of the World,* Louisiana Museum of Modern Art, Humlebaek, Dänemark

1990 *RIEA – The first Conference,* Galerie Aedes, Berlin

1989 *Künstlerhäuser,* Deutsches Architekturmuseum, Frankfurt am Main
Architecture et Utopie, Pavillon de l'Arsenal, Paris

1988 *Berlin: Denkmal oder Denkmodell,* Kunsthalle Berlin
DMZ, StoreFront for Art and Architecture, New York

1987 *Zauber der Medusa,* Künstlerhaus, Wien

1986 *Vision der Moderne,* Deutsches Architekturmuseum, Frankfurt/Main

1984 *Adam's House in Paradise,* StoreFront for Art and Architecture, New York

1983 *Juxtapositions,* P.S.1, Institute for Art and Urban Resources, Long Island City, New York

1980 *Young Architects,* Yale University School of Architecture Gallery, New Haven, Connecticut

Projekte (Auswahl)

1994 High Houses for Sarajevo 1993 War and Architecture Series 1991 Zagreb-Free-Zone, Free-Space Structures, Icebergs, Double Landscape (Vienna), Antigravity Houses 1990 Stations, Berlin-Free-Zone 1989 Aerial Paris, Solohouse 1988 Underground Berlin 1987 Centricity, Aerial Structures 1986 Cyclical Cities 1985 A City, Sector 1576N, Centre for New Technology 1984 Epiclarium 1982-83 AEON 1981 Four Cities 1980 Einstein Tomb, Four Houses (second version) 1979 Four Ceremonial Constructions, City in Time 1978 Architecture-Sculpture-Painting Series 1977 Simultaneous City, Wall fragments 1975 Four Houses 1974 Environmental Theatre

ZIVA FREIMAN

After studying architecture at the Technion-Israel and journalism at the University of New York, she was a freelance journalist in New York for some years and active as a freelance writer, designer and illustrator. Since 1989 she has been on the editorial staff of "Progressive Architecture", one of America's leading architecture magazines. Today she has the position of editor-in-chief, also in charge of the fields of interior design, background reporting, reviews, essays and interviews.

JOHANNES GACHNANG

Trained as a structural engineering draughtsman at the Zurich School of Commerce, he worked freelance in various architecture offices in Zurich, Berlin and Paris. Between 1974-82 he was director of the Kunsthalle, Bern. Several guest professorships, e. g. at the Academy of Fine Arts in Karlsruhe (1979/80) and at the Academy of Fine Arts in Vienna (1982-85). Memeber of the artistic advisory council of the *documenta 7* under the directorship of R. H. Fuchs. Since 1985 co-director of the Castello di Rivoli, Museum of Contemporary Art, near Turin.

JAN HOET

Since 1970 professor of art history at the University of Ghent, since 1975 director of the Museum of Contemporary Art in Ghent, 1986 curator of the Biennale of Venice „Aperto", 1987 adjudicator of the "L'age d'or", 1992 artistic director of the *documenta 9*. In 1992 awarded the "Victor Prize" (best organizer of cultural events). Numerous publications in magazines, lectures at cultural institutions, curatorial work. Lives in Ghent.

KYONG PARK

Founder and director of the international and interdisciplinary forum "Store-Front for Art and Architecture" in New York since 1982. Teaching at Southern Californian Institute of Architecture (Sci-Arc), the Rhode Island School of Design and at the City University, New York. Since 1992 "Strategic Architecture", an enterprise working on the creation of imaginary cultures, currently on the design and development of a "Nuclear Heritage Park", the first amuseument park based on thermonuclear weapons.

ZIVA FREIMAN

Studium der Architektur am Technion-Israel und Journalismusstudium an der University of New York. Einige Jahre war sie als freie Mitarbeiterin bei einem New Yorker Magazin und als freie Schriftstellerin, Designerin und Illustratorin tätig. Seit 1989 Tätigkeit für »Progressive Architecture«, eines der führenden amerikanischen Architekturmagazine, zunächst als Redaktionsmitglied, dann als Herausgeberin. Schwerpunktmäßig betreut sie die Bereiche für Interior Design, Hintergrundberichterstattung , Kritiken, Essays und Interviews.

JOHANNES GACHNANG

Nach dem Abschluß der Lehre als Hochbauzeichner an der Gewerbeschule in Zürich war er von 1958 bis 1967 als freier Mitarbeiter in verschiedenen Architektenbüros in Zürich, Paris und Berlin tätig. Zwischen 1974-82 war er Direktor der Kunsthalle Bern. Mehrere Gastprofessuren z.B. an der Akademie für bildende Künste in Karlsruhe (1979-80) und an der Akademie der bildenden Künste, Wien (1982 bis 1985). Mitglied des künstlerischen Beirats der *documenta 7* unter der Leitung von R. H. Fuchs. Seit 1985 Co-Direktor des Castello di Rivoli, Museum für zeitgenössische Kunst, bei Turin.

JAN HOET

Seit 1970 Professor für Kunstgeschichte an der Universität Gent, seit 1975 Direktor des dortigen Museums für Gegenwartskunst. 1986 Kurator der »Aperto« der Biennale von Venedig, 1987 Jurymitglied für den »L´Age d´Or«, 1992 künstlerischer Leiter der *documenta 9*. Im Jahr 1992 wurde ihm der »Victor-Preis« verliehen (bester Organisator von Kulturveranstaltungen) Zahlreiche Publikationen in Zeitschriften, Vorlesungen an Kulturinstitutionen, Kuratorentätigkeit. Lebt in Gent.

KYONG PARK

Gründer (1982) und Direktor des internationalen und interdisziplinären Forums »StoreFront for Art and Architecture«, New York. Lehrtätigkeit am Southern California Institute for Architecture (Sci-Arc), der Rhode Island School of Design und an der City University, New York. 1992 begann er mit »Strategic Architecture«, einem Unternehmen, das sich mit der Erschaffung imaginärer Kulturen beschäftigt. Zur Zeit arbeitet er an der Entwicklung und Gestaltung des

JOACHIM RIEDL

After studying english literature, sociology and psychology in Cambridge and Vienna, he became editor of the magazine "profil" in Vienna in 1973. Since 1980 he has been the America correspondent of "profil", based in New York, since 1985 editor of "Die Zeit", Hamburg, "Dossier" section, and reporter-at-large for "Süddeutsche Zeitung", Munich. Numerous publications, i. a. "VITA-Mozart", Hamburg 1990; "Das Geniale, das Gemeine – Versuch über Wien", Munich 1992.

»Nuclear Heritage Park«, des ersten auf thermonuklearen Waffen basierenden Vergnügungsparks.

JOACHIM RIEDL

Nach dem Studium der Anglistik, Soziologie und Psychologie in Cambridge und Wien wurde er 1973 Redakteur der Zeitschrift *profil* in Wien, für die er seit 1980 Amerika-Korrespondent mit Sitz New York ist; seit 1985 Redakteur für *Die Zeit,* Ressort »Dossier«, Hamburg, und seit 1990 Reporter-at-large, *Süddeutsche Zeitung, Magazin,* München. Zahlreiche Publikationen, u. a. »VITA-Mozart«, Hamburg 1990; »Das Geniale, das Gemeine – Versuch über Wien«, München 1992.

MAK-Vortragssaal/MAK Lecture Hall

27857 JMLS/16 —

R E I H E C A N T Z